SWAG 2

ROCK POSTERS OF THE '90s AND BEYOND

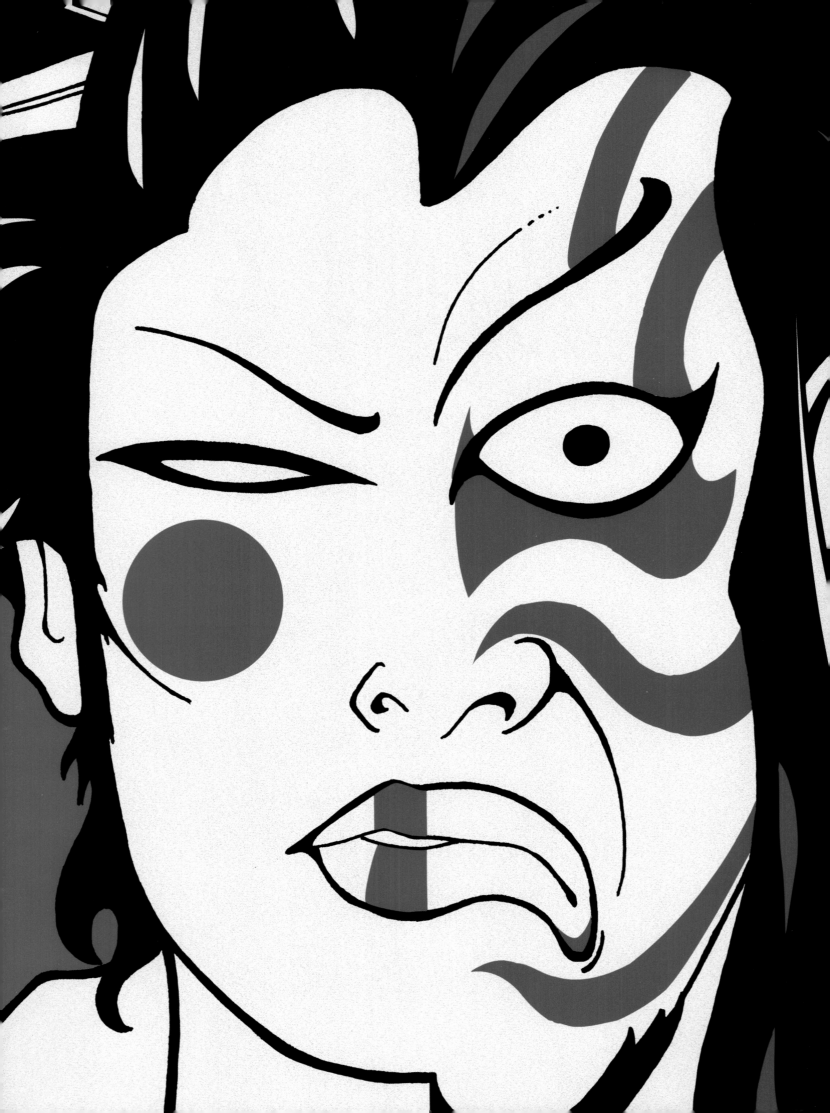

SWAG 2

ROCK POSTERS OF THE '90s AND BEYOND

BY SPENCER DRATE AND JUDITH SALAVETZ

FOREWORD BY NELS JACOBSON AND DIRK FOWLER

HARRY N. ABRAMS, INC., PUBLISHERS

Project Manager: Céline Moulard

Designer: Brady McNamara

Production Manager: Maria Pia Gramaglia

Cover illustration and typography: Hand Carved Graphics

Cover and endpaper designs: Spencer Drate and Judith Salavetz

Half-title page design: © Hand Carved Graphics

Frontispiece design: © Malleus

Copyright page design: © Wrecking Crew Studios

Acknowledgments page design: © Asterik Studio

Contents page design: © Billy Perkins

Frontispiece design: © EngineHouse13

Library of Congress Cataloging-in-Publication Data

Swag 2 : rock posters of the '90s and beyond / [compiled by] Spencer
Drate and Judith Salavetz ; foreword by Nels Jacobson and Dirk Fowler.
 p. cm.
 Includes bibliographical references and index.
 ISBN 0–8109–9235–3 (pbk. : alk. paper) 1. Rock music—
1991–2000—Posters. 2. Rock music—2001–2010—Posters.
I. Title: Swag two. II. Drate, Spencer. III. Salavetz, Judith.

ML3534.S902 2005
781.66'092'2—dc22 2005000285

Printed and bound in China

10 9 8 7 6 5 4 3 2 1

Harry N. Abrams, Inc.

100 Fifth Avenue

New York, N.Y. 10011

www.abramsbooks.com

Abrams is a subsidiary of

LA MARTINIÈRE
GROUPE

ACKNOWLEDGMENTS

Spencer and Judith would like to thank:
Harriet Whelchel, Céline Moulard,
Michael Walsh, and everyone at Abrams.
Nels Jacobson and Dirk Fowler for their
brilliant foreword; Jeff Kleinsmith;
Jim Fitzgerald; Ned Davis for his support
and wisdom; all the talented poster
artists; Hand Carved Graphics for their
spectacular cover; and Brady McNamara
for completing the vision.

Dedicated to Justin and Ariel

CONTENTS

SWAG 2

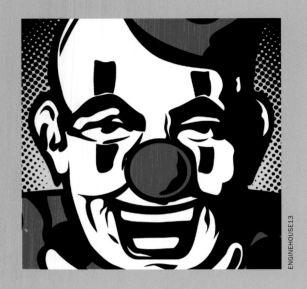

ENGINEHOUSE13

FOREWORD

The beat-up Toyota careened to a jerking, sputtering stop in front of the darkened record store. Guthrie and Wilco's "Hoodoo Voodoo" spilled from the car's open windows as the driver threw the car into park, jerked on his door handle, and leapt into the street. In one hand he held a stapler and a roll of cellophane packing tape; in the other he carried a large silk-screened concert poster. The smell of fresh ink filled the night air. So much so, in fact, that a moth circling the security light nearby was overcome by the sweet aroma and passed out, plummeting to the pavement with an inaudible thud and the barest hint of a smile on its tiny insect face. If the driver even noticed, he didn't seem to care.

Striding to a telephone pole festooned with torn paper and tattered scraps of cardboard, the driver held up the poster and pumped one, two, three, then four . . . and then several more staples through its soft paper flesh and into the splintered wood. Tucking the stapler under his arm, he circled the pole with a band of tape—catching the top edge of the poster to secure it even tighter. Before he was able to repeat the process for the bottom edge, a siren began to wail somewhere close by. He stopped, tape in midair, and listened for a moment. The source of the sound was growing closer. He ran back to his car, jumped in, and lurched away, catching the curb with his right front tire and rolling up and over the concrete with a bump and a rattle.

The siren grew louder. And no sooner had the Toyota disappeared than a wailing squad car raced past the record store—illuminating for a split second a man in the shadows on one side of the street, and a woman on the other—as its lights flashed red and blue and splashed off the store's large windows, and the windows of the other buildings, and the puddles, and the broken glass in the gutter. The chaos of flashing light spun wildly down the street and disappeared around a corner.

After the sound of the siren faded into the distance, first one figure and then the other bolted from the shadows and raced to the telephone pole. Each was brandishing a blade. They approached one another warily—circling slowly, with the pole between them. As the male figure juggled a wicked-looking switchblade from one hand to the other, he muttered under his breath, "Whaddaya got there, honey? What is that—is it a knife?"

"You know damn well what it is, Roger," she said dryly. "It's a screwdriver. You asked me to bring it."

"Great! A screwdriver is great! See if you can jimmy those staples out. You didn't bring a wire cutter or pliers or anything, did you? That actually might work better. I'll take care of the tape. Man, this is a nice poster. Who's the band?"

"Wilco, Roger . . . Wilco." She rolled her eyes as her answer hung in the air for a moment, then dropped to the pavement like an anesthetized moth.

MCCARTHY

Since the mid-1960s, variations of this scenario have been repeated day and night by college students and street punks, aging hippies, serious collectors, paper junkies, cavorting mobs of poster fanatics, and love-struck couples around the world. Wherever anyone with a love of live music and a marking pen feels compelled to express emotion by creating concert posters or handbills, someone will be collecting and coveting those creations. That's what this book is all about: a celebration of the enduring passion and power of rock music as it's been captured in printer's ink on paper. It's a book about posters—paper artifacts created to advertise concerts by particular bands on given dates at specific venues. It's a retrospective of the work done during the last decade and a half by fifty of today's most interesting rock-poster artists. To the extent that these posters have been designed as advertisements, they are by definition obsolete as soon as the event has taken place. They are disposable. They are ephemera. They are colorful paper novelties, one more kind of flashy flotsam and jetsam left in the wake of our consumer society, trash paper to herald and wrap an event in—swag.

But concert posters are more than this. Why else would posters that were given away free in the 1960s and 1970s—Fillmore and Family Dog posters from San Francisco, Grande Ballroom posters from Detroit, and Armadillo World Headquarters posters from deep in the heart of Texas—fetch hundreds, even thousands, of dollars today? Why else would artists work all day and night designing posters from which they themselves will see scant public recognition and little or no money? Because posters communicate more than the words on them say.

Posters are designed to be seen. In fact, the notion of writing at all about posters seems absurd. It's a poster, right? It's visual. Attempting to describe the look and the impact of a poster is no more feasible than trying to capture a musical performance in words. Seriously analyzing a visual experience is preposterous. You either like what you see or you don't. Why try to dissect it? Especially if it happens to be a concert poster. Can the standard set of design-school aesthetics, rules of typography, balance, and principles of gestalt psychology be applied to a concert poster? After all, what is it essentially? It serves an advertising function; it's intended to draw people to a musical event. At least that's supposedly why it was created in the first place. So, is it an advertisement? Or is it a piece of art?

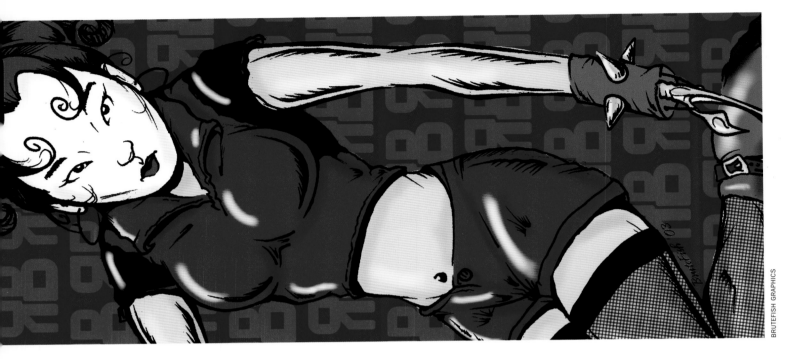

Some posters and handbills are, indeed, bald unmitigated advertising at its most crass—purely and simply text on paper and little more. Others, like many represented in this book, have greater aspirations and reach deeper meaning. They convey much more than the date and location of a concert. They say something about the human condition and about our culture at a specific moment in history. They are aesthetically pleasing and visually compelling. And, at a minimum, each and every one of them commemorates the performance of a band in tangible, touchable, viewable form.

That's why these posters are coveted and collected. That's what drives someone to snatch a poster from a telephone pole in the middle of the night, pull a poster from a light pole in broad daylight, take it home and gently, tediously remove the remnants of tape before hanging it above the couch. How many other advertisements can boast this kind of devotion? When was the last time you were flipping through a magazine at the doctor's office, spied an ad for a new dietary supplement, and thought to yourself, "I've gotta have this ad!" Rarely does anyone tear a page from the yellow pages, frame it, and proudly hang it on the living room wall. Yet people treasure rock music posters all the time.

Maybe this phenomenon has something to do with the fact that live music is, by its very nature, transitory. Each note hangs in the air for a moment or two and then disappears. It's only natural to want a poster that memorializes a particularly significant concert. And, of course, a concert might be significant for any number of reasons: the band put on an unusually fantastic show that night; a legendary guest sat in with them; you attended with someone special; or you got sick and puked all over the soundboard. Sure, you can always buy the band's album. You do buy it. But, as great as the music sounds, you just can't *see* it. Sometimes you've got to have a visual hook to accompany that music.

On their classic 1980s comedy album, *The Great White North*, Canadian beer-ophiles Bob and Doug McKenzie, aka Rick Moranis and Dave Thomas, encouraged us to look at the album cover while we listened to their besotted Canuckian hijinks. They instructed us to stare at their photos and imagine we were watching them on TV. Many people actually enhanced their listening enjoyment by doing so. Similarly, it's been reported that many were able to savor their Pink Floyd albums all the more when they were sitting cross-legged on the floor with the album covers spread around them, staring at each song title as the track was about to play; studying the photos of the band and thinking, "Man, those are cool pants" and then thinking, "It's a good thing I didn't say that out loud."

The proverbial "times," however, in the words of Bob Dylan, "they are a-changin'." Today's CD jewel boxes and inserts are not nearly as visually compelling as the full-size LP album covers they have replaced. And MP3s are even worse. Who among us stares spellbound at an icon on a screen while a song is playing? Who looks longingly at the tiny grayscale screen of an iPod, watching the monotonous scroll of digitized type and incomplete song titles? Visual art and music go together. It's natural to want to enhance the auditory experience with a visual—something that fits the band. Thus, whether they attended a concert or not, many folks want that Modest Mouse poster, that Primus poster, that Stevie Ray Vaughan or Jane's Addiction poster. They want that poster for no reason other than they love the damn band.

A photograph of a band's performance can also provide a powerful visual reference, but it records only a particular moment. It freezes that moment in time, recording for posterity no more or no less than exactly what was happening at that specific second. By contrast, a movie, videotape, or DVD can record a performance over time, but all remain primarily literal mediums that provide viewers with a sequence of events shot from a chosen angle. Such mediums must be viewed for a prolonged period of time to be fully appreciated. On the other hand, a poster can communicate with one image the spirit of a whole night, an entire concert, or a complete tour. While a good poster can be studied, pored over, and examined in detail, it also can be appreciated in an instant. In many cases, you get the essence of the band with one quick look.

Okay, sure, sometimes you aren't interested at all in a band. You'll grab a poster from a lamppost or a store window simply because you love the way it looks. If the show has happened already, you didn't go, and if it hasn't happened yet, you have no plans to go. Hey, how many times have you bought a CD simply because it had a great cover—figuring that if the band was cool enough to have that cover it must be worth listening to? So, this poster just looks great. You like looking at it. You want it around. You want to be associated with it. Because a poster is not just a way to display your passion for the music you love; it's also a way to assert your own visual style. Perhaps your passion is typography. You proudly display an Interpol poster that has the most beautifully proportioned sans serif font you've ever seen. Or maybe it's the skull on a Slayer poster that stares at you from every point in the room and perfectly complements the rest of your swanky décor. Whatever it is, whatever band is on it, you must have that poster. You need it.

For these reasons, and countless more, people have been tearing posters off poles and wooden hoardings, lifting them from windows, and even buying them if necessary, since 1966 and before. It was in February of that year that Wes Wilson penned the first poster of the numbered Family Dog series for Chet Helms. There had been posters and handbills before that, of course. Alton Kelley, for example, had created handbills for three early Family Dog dances in 1965. Similarly, the poster that many collectors cite as the fountainhead of the San Francisco–style was created in 1965; it's been dubbed "The Seed" and was created by Michael Ferguson and George Hunter of the Charlatans for their summer stint at the Red Dog Saloon in Silver City, Nevada. Moreover, boxing-style posters announcing that Elvis, or Fats Domino, or James Brown was coming to town had been around for years. But something fundamental changed when the Family Dog posters began appearing around the Bay Area in 1966 and when Bill Graham began commissioning similar posters for his Fillmore shows.

The kids who attended those dances and concerts started to recognize and identify with the unique look of the posters, their handmade style, and the flowing, stretching, twisting, sometimes hieroglyphic lettering that could be utterly incomprehensible to the uninitiated—to the Aunt Beas, Marcus Welbys, or Ward and June Cleavers who might happen upon them. The younger generation embraced the spirit of the posters created by Wilson and Kelley, Rick Griffin, Stanley Mouse, and Victor Moscoso, and the esoteric subversiveness of their posters that liberally appropriated familiar images from popular culture and previous eras and combined them into oversized instantly recognizable tribal calling cards. These five artists weren't the only ones shaping the early days of postering in San Francisco; many others contributed to the movement, including Bonnie MacLean, Bob Fried, Greg Irons, and Lee Conklin. Nor was San Francisco the only city where poster art was taking hold as an expression of the counter culture. In Austin, Texas, for example, posters that were vaguely similar to those seen in San Francisco began appearing in 1966 and 1967. By artists such as Gilbert Shelton, John Shelton, Tony Bell, and Jim Franklin, these posters advertised outdoor concerts produced by the Electric Grandmother or shows at the Vulcan Gas Company, Texas's first psychedelic venue.

But for poster aficionados, pilgrimages to Haight-Ashbury were de rigueur in those days. Gilbert Shelton left Austin and relocated to San Francisco in 1968 where he began publishing his Fabulous Furry Freak Brothers comics. Gary Grimshaw, who in 1966 and 1967 was cranking out memorable posters in Detroit for the Grande Ballroom, also moved to the Bay Area. So, too, did Mark Behrens, who cut his teeth in the late 1960s doing posters for Chicago's Kinetic Playground. By contrast, California-born Jim Phillips, whose work is included in this book (p. 121), found himself creating posters for East Coast venues in 1967. Although the Family Dog had begun to fade from the scene somewhat by 1969, The Fillmore and other San Francisco venues continued to sponsor posters by the early artists and countless others, including such influential poster designers as Randy Tuten and David Singer. Moreover, all across the country, rock clubs and promoters, and the poster artists who worked for them, continued to use posters both to advertise upcoming concerts and to address youthful disaffectedness through such universally understood themes as sex and drugs and rock and roll.

Back in Austin, the Armadillo World Headquarters supplanted the Vulcan Gas Company in 1970 as Texas's preeminent alternative venue. Over the next ten years it generated a delightfully Texas-flavored body of poster work by dozens of artists, including Micael Priest, Kerry Awn, Sam Yeates, Jim Harter (who'd also created posters for the Vulcan), and three other artists, each of whom is included in this book—Danny Garrett (p. 56), Guy Juke (p. 72), and Bill Narum (p. 111). One style of poster particularly identified with Austin and the 'Dillo is often referred to as the "cosmic cowboy" (tr. roper doper) style, after the Michael Martin Murphey song of the same name; the style is based on the poster's combination of Western visual clichés with hippie and drug-culture references. Outside the 'Dillo, Austin boasted a seemingly limitless landscape of other concert halls and live-music bars populated and serviced by an indigenous army of poster artists.

During the 1970s, 1980s and 1990s, with the possible exception of what was going on in Austin, the popularity of concert posters in general and their ability to represent the cutting edge of music culture never seemed to equal the impact they'd had in the late 1960s. At times posters became as predictable or overblown as rock music itself could be. With the rise of punk rock sensibilities in the late 1970s, however, the same immediacy, power, and relevance that characterized the psychedelic posters of the 1960s seemed to reappear for a time. Just as many punk bands championed a stripped-down-do-it-yourself-full-throttle approach, so, too, did the artists creating posters and handbills for those bands. In fact, it was often the bands themselves that were producing these pieces. What could be more true to the spirit of punk rock than inexpensive black-and-white handbills run off at the corner copy shop? Their text might be deftly rendered and legible, or it could be a splattering of angry scrawls. Their images might be twisted perversions of everyday objects, infantile doodles, intricate pen and ink illustrations, odd collages of familiar photos, bold broad-stroke caricatures, or just about anything or any combination of things; but whatever they looked like, they had to stand out from the slick, overly-processed look of everything else around, everything that had come before. It certainly didn't hurt if the posters or handbills were considered disturbing, perverted, even vaguely threatening by the Mindy McConnells, George Jeffersons, and Barnaby Joneses who might stumble across them.

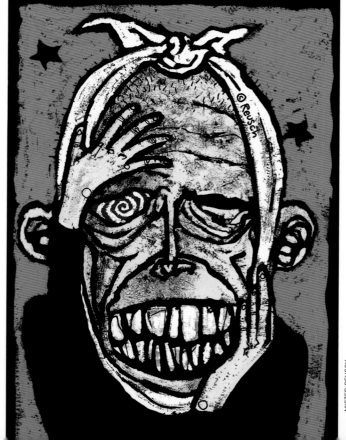

MISTER REUSCH

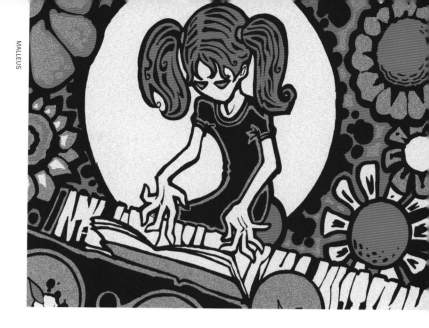

Such posters and handbills were created for clubs like CBGB in New York; Mabuhay Gardens, Savoy Tivoli, and Valencia Tool & Die in San Francisco; Raul's and Club Foot in Austin; the Bird in Seattle; Blackie's in Los Angeles; and innumerable other venues during the late 1970s and early 1980s. Artists such as Shawn Kerri, Gary Panter, Peter Belsito, James Stark, Penelope Houston, NOXX, John Seabury, Su Suttle, Art Chantry, and legions of others, named and nameless, produced potent handbills and posters during these years.

Throughout the 1980s and into the 1990s, other artists jumped on the concert poster bandwagon: Arminski, Coop, Emek, Hess, Jagmo, Kozik and Kuhn, to name just a few. Sometime around 1980 a poster collective calling itself the "Art Maggots" relocated from Eugene, Oregon, to Austin, where they joined the throngs already creating posters there. Jagmo (p. 67), who began creating his own posters in 1981, also commissioned the Art Maggots to design a couple of posters for Club Foot; and, early in Frank Kozik's career, he worked on a few projects with them. Meanwhile, in Detroit in the mid-1980s, Mark Arminski began creating his first concert screenprints, foreshadowing the eventual widespread popularity of silk-screened rock posters. A few years later, Kozik, who contributed as much as anyone to the emphasis today on screen-printing and bright colors, bounced back and forth between Austin and California until he finally settled in San Francisco in the early 1990s. About that same time, Derek Hess began creating his distinctively sketchy concert posters in Cleveland. Coop, overlord of smoking devils and devil girls, moved from Oklahoma to Los Angeles. Emek, also in L.A., was just beginning to create his trademark "thinking man's" rock posters, and Lindsey Kuhn, who had been screen-printing posters in Austin for several years, moved in the late 1990s to Dallas and then Denver. No quick rundown of the 1980s and 1990s can reflect everything that was going on or everyone who was making posters then. Beginning in the late 1960s, and then more and more each year after that, the tribe of rock-poster artists just kept growing. By the late 1990s, far too many artists were creating posters to name them all, and almost any list, no matter how apparently exhaustive, would inevitably leave out many poster artists worth mentioning.

Hundreds more talented poster folk came into their own with the dawning of the new millennium. Some had been creating posters throughout the 1990s and before, others were new to the field. Artists like Asterik Studio (p. 21) and 33rpm's Andrio Abero (p. 18) picked up the torch lit by Jeff Kleinsmith and Art Chantry, and they continue to ensure Seattle's place in the geographical pantheon of music poster history. The continuing rise in popularity of indie record labels and college radio laid the groundwork for followers of the genre like Methane Studios (p. 97), Lil Tuffy (p. 79) and Justin Walsh (p. 149). And though the mainstream music connoisseur may not recognize bands such as Death Cab for Cutie, artists like Jason Munn (p. 109) and those who make up The Decoder Ring Design Concern (p. 38) most assuredly do. They know the music, they know the fans of the music, and they know how to design posters that speak directly to those fans. Some artists such as Ron Liberti (p. 77) and Jay Vollmar (p. 144) refuse to let the DIY photocopy aesthetic die, and they give it new life in the form of beautifully colored textural screenprints. Others, including Jason Cooper (p. 34), EngineHouse13 (p. 45), and Wrecking Crew Studios (p. 156) stay loyal to the original rock poster aesthetic and carry on the tradition begun by those who came so many years before them. Some like Jared Connor (p. 30), Billy Perkins (p. 118), and Jamie R. Ward (p. 152) help to "keep Austin weird" and maintain its place on the cutting edge of concert poster art. Tara McPherson (p. 91), Michael Michael Motorcycle (p. 100), and Mister Reusch (p. 103) amaze us with their distinctive drawing styles and unflagging imaginations. Still others, such as Dirk Fowler (p. 48), Dan McCarthy (p. 88) and Kevin Mercer of Largemammal Print (p. 94), seem to have tapped into a rich, long-forgotten stylistic vein freighted with white space and flat color that was once identified with Saul Bass, Paul Rand, and the giants of the 1950s. Artists such as Malleus (p. 85) from Italy and Leviathan (p. 74) from Spain remind us that the rock-poster phenomenon is not purely American.

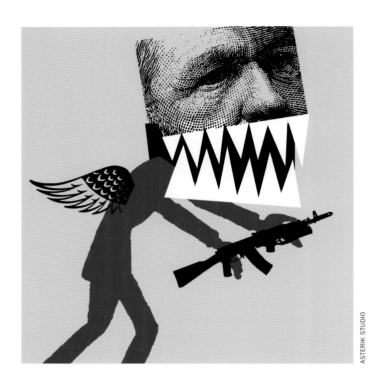

Today more artists are creating concert posters than ever before, and this increase in the ranks has been matched by an explosion of public interest in owning poster art. More people than ever before are collecting it—high-dollar 1960s and 1970s posters, newly minted silkscreen prints and lithographs, and everything in between. The website gigposters.com boasts tens of thousands of posters in its archive, and it's adding posters at the rate of hundreds a week. Perhaps not since the early part of the last century when the movements of Art Nouveau, the German Sachplakat, Russian Constructivism, and dozens of other Avant Garde styles and -isms all coalesced into a mass of poster mayhem, have we seen this much expression on paper. In the 2004 issue of *print* magazine's regional design annual, more than 150 of the 1,000 or so pieces published were concert posters. Rarely has this much respect and attention been paid to concert posters in the mainstream world of graphic design.

So why this boom? Why now when so many digital-age doomsayers and prophets have proclaimed that "print is dead"? How many times in the 1990s were we told that computers had sounded the death knell for print on paper? Judging by the current and growing popularity of concert posters, it appears that such rumors of the demise of print were "greatly exaggerated"—or digitally enhanced perchance. It's true that computers and the Internet have had an impact on poster production; but their impact has been predominantly positive. The advent of graphic-design software such as Photoshop, Quark, and Illustrator, has greatly reduced the time necessary to complete a project. Such programs are also much more forgiving than pen and ink when the design needs to be changed or another band needs to be added to the lineup. That is not to say the computer has taken over completely as a means of creation. One need only glance at the work of artists like Tyler Stout (p. 138) or Lonny Unitus (p. 82) to see that for them the computer is merely a composing tool. The pencil, pen, and X-acto knife still reign supreme in the poster world.

The Internet has most definitely been instrumental in increasing demand for rock posters. In the past, the only way you could see a poster was in person or in a magazine or book such as this one. Poster design was regional, and only limited cross-pollination between geographically isolated poster communities was possible. There has always been considerable interaction between San Francisco, Austin, Detroit, Seattle, and other cities with active live-music scenes, but the primary influences on most poster artists and collectors was local. The Internet has changed all that. Whether you're living in Anchorage or Kathmandu or circling the earth in the International Space Station, you can access thousands and thousands of concert poster designs from all over the world in an instant, simply by visiting gigposters.com, expressobeans.com, classicposters.com, or any number of other poster sites currently on the Web. Such unprecedented access serves to reshuffle the status quo every day as new designs are posted and commented on, praised, criticized, imitated, and sought after. In this way, the poster artist's universe of influences has been exponentially expanded. And the ranks of those creating posters has expanded as well, because every so often the computerized cornucopia of posters inspires a new person to jump into the fray and create their own poster art.

So what prompts a person to begin designing posters? It's axiomatic that it is not the money. And just as there is little money to be made in poster making, there is also little fame. If you stopped 100 random people on the street, maybe three or four people might recognize the name Kozik. Probably half would know the name Von Dutch. Although Dutch was never technically a poster artist, his classic hot-rod pinstriping style and the flying eyeball with which he is often credited has influenced generations of poster artists. Those people who did recognize the name Von Dutch would most likely know it only as the name embroidered on the trucker hat worn by their favorite pop star. By the same token, if you asked 100 people who Victor Moscoso is, chances are not one of them would be able to tell you he is one of the most celebrated poster artists alive. Creating poster art is an unlikely way to get rich or famous.

Some poster artists got their start because they had a connection with a particular band or venue. A surprising number of good poster artists are also talented musicians, and vice versa. Often they began designing posters and handbills to promote their own bands. The connection is natural and obvious. Some artists began designing posters because they were fans of a particular band. Or because it was a good way to get into the show for free. Often, if you design posters for a club or promoter, you are considered one of the team and can routinely gain admission to sound check and backstage areas after the show. Such perks don't pay the bills, but they're added incentive for serious music fans.

For other poster artists, a particular band or venue isn't their focus; it's the act of creation itself and the resulting original poster that they appreciate. Designing any kind of poster would be fine, but rock posters are simply more fulfilling and fun. Some of these designers had or still have straight jobs—positions with conservative commercial agencies. For them, perhaps it's the need to get back to why most of us in the graphic arts field got into it in the first place, to make art. These freelance poster designers want to make things that people appreciate. They tire of spending hours or even days designing a direct mail piece that most people are going to toss into the garbage after a quick glance. If they have to make one more newspaper ad for a hospital, they're going to need to be admitted themselves. They want to make things that people want to keep. They love the idea of sitting down with a clean piece of paper and a pencil and creating something that will last. They want to feel the fresh ink being pushed through a screen with a squeegee. They long to hear the words "Dude, that rocks!" instead of "Can you just make the type a little larger?" or "Can our logo have a metallic 3-D look like the one at the beginning of the movies?"

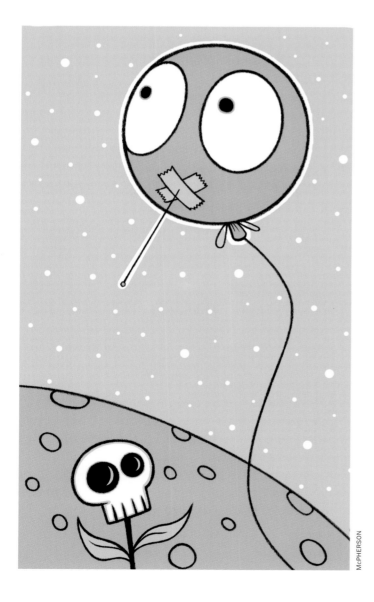

McPHERSON

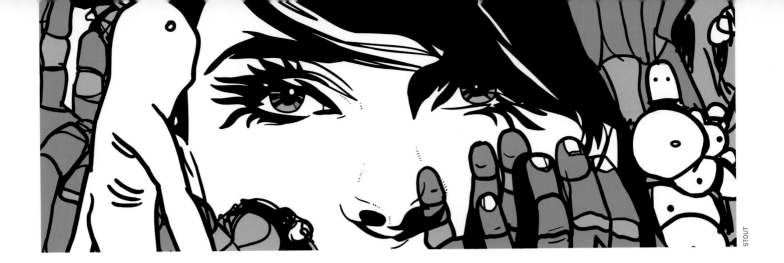

What all these poster artists share in common is passion—for music, for posters. Why else would someone stay up all night in a garage, meticulously registering and hand pulling fifty screenprints for a band no one has heard of? Printing with metallic inks on recycled paper only to find that paper riddled with staples and plastered to a construction wall the next day? It must be love. These folks need to make posters as badly as they need to hear music. Good music is something you can feel. You can taste it. It's like food. You need it—you've got to have it. It sustains you. The same can be said of a good music poster.

In a recent lecture at Texas Tech University, poster artist Jeff Kleinsmith of Patent Pending Industries (p. 112) amazed a group of young design students when he described his high school obsession with tracing (for hours) the logos of bands such as Black Flag from their album covers and then displaying the traced logos on notebooks and lockers. Many other poster artists started the same way. At first it's an innocent expression of love for the music. Then one day a classmate says, "Dude, that's awesome, can you make a KISS one for me?" "Uh, sorry man . . . I only do stuff for bands I really like," is the reply. And thus a poster artist is born. Perhaps, given that album covers are now obsolete, a precocious member of the next generation of poster artists will find herself tracing a logo or illustration from a poster created by one of the artists in this book.

That member of the next generation also may eventually engage with colleagues in some of the same discussions about authenticity, and meaning, and suitability of subject matter that consume today's poster makers. The debate among poster artists about what is appropriate is never-ending. What makes a true "rock" poster? Is it a realistic portrait of the performer in action? Is it classic rock and roll imagery such as depictions of death, flames and skulls, cars, or the scantily clad women that someone like Stainboy (p. 134) does so well? Or is it the current "designer" look that relies on graphic references to esoteric lyrics or inside jokes understood by perhaps only the most hardcore fans of the band? Who's to say? In the view of Wrecking Crew Studios' irrepressible Richie Goodtimes, a rock poster should be straightforward. "This ain't art school," he recently pointed out. "A poster should not require an explanation." On the other hand, in a time when rock was extremely young—approximately 2,500 years ago—the playwright Aristophanes offered the following advice: "Let each man exercise the art he knows." As long as the poster artist knows the band he's dealing with and creates a poster that is faithful to the music and vision of that band, maybe that's enough. The range of acceptable styles would then be virtually unlimited. If it made sense for that particular band, it would be appropriate.

Whether the poster captures the essence of the band and the feel of the music, therefore, may be the single most important consideration in designing a concert poster. Many would no doubt consider a poster for the band Lightning Bolt a horrible failure if it reflected the structure and precision of a classic Swiss-school poster. If the music borders on insanity, shouldn't that insanity be reflected in the design of the poster advertising that music? Just how serious poster artists are about the issue of "what fits the band" may be indicated by the more than 400 comments that poured into gigposters.com recently regarding the appropriateness of one particular black-and-white handbill posted there.

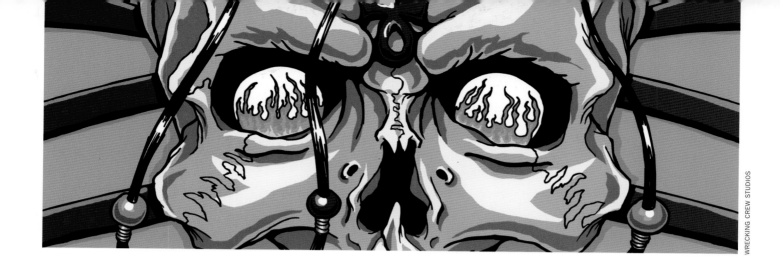

In light of the breadth of styles used by today's poster artists, the authors of this book have made room for a broad cross section of posters that represent a variety of printing techniques. You can decide which are most appropriate, which are most effective. Some posters, for instance, are exquisite examples of the capabilities of a fine screen printer—numerous colors, metallics, perfect registration, on archival stock. Others are printed on inexpensive paper, with few colors, and with more regard for spontaneity than precision. Some posters, such as those of accomplished painter and illustrator Joel Elrod (p. 42), are high-end offset prints made from beautiful paintings for legendary bands playing in legendary venues. Others are prints for local bands— hand pulled in dimly lit basements or garages by artists such as 22-year-old college student Ed Gossage (p. 57).

Each poster included in this book has a different story to tell. Each is a product of the individual artist's passion and imagination, yet each is beneficiary of the same evolving, decades-old rock-poster aesthetic. According to Milton Glaser, creator of the iconic rainbow-haired Dylan poster and one of the most influential graphic designers of the last half century, for a poster to serve its primary purpose, it isn't necessary that it be beautiful or decorative, or worth a lot of money after the fact, or that it broaden our understanding of the world, or reflect the artist's personal point of view. But, those things are essential to Glaser. Judging by posters like those in this book, we believe the artists who created them feel the same way.

The posters in this retrospective were selected from among thousands produced in and after the 1990s. They represent fundamentally dissimilar styles and points of view, but as different as they are from one another, each was crafted out of a genuine passion for the music. The artists who created the posters were fueled and inspired by the music. And, in the end, it's the music that provides the best context within which to appreciate and understand the artists' work.

There is something pure and potent in a concert poster. There is something about posters that satisfies a primordial need to touch the rough edges of our totems—to hold them in our hands and display them in places of honor. Objects such as these can't be replaced by digital representations of poster art—ghost posters that disappear when the power fails. Rather, it's precisely because they possess form and substance that tangible posters have the ability to anchor us physically to a specific concert in time and space. In this way the tactile magic of the humblest black-and-white handbill—the sensuous physicality of simple ink on paper— transcends the performance event itself. Long after the last notes have faded and the stage lights have gone dark, posters live on as physical connections to the bands, the performances, the audiences, and the fleeting alchemy that bound them all together for a time. And because the reproductions included in this book share that physical connection, we suggest you take your time as you thumb through the pages. Put on your favorite music and turn up the volume. These posters are meant to be seen, and touched, and *heard*.

We hope you enjoy them as much as we do,

NELS JACOBSON
DIRK FOWLER

Since the 2000 inception of his design company 33rpm, Seattle-based graphic designer Andrio Abero has cultivated a quiet presence as one of the city's most vital visual luminaries, one who has found a niche in the region's rich tradition of poster-art fetishism. Working in close connection with The Vera Project (Seattle's youth-focused nonprofit music and arts venue), Abero has fostered his meticulous aesthetic into a near stranglehold on the city's contemporary poster climate—a dominance reflected in his recent exhibition at the Seattle Art Museum's community art space, his contributions to the Transformer Gallery (Washington, D.C.), the Experience Music Project's Northwest poster retrospective "Paper Scissors ROCK", and the recently published *Art of Modern Rock: The Poster Explosion*. Abero has recently been honored with the Art Directors Club of New York's prestigious Young Guns award—an international competition for designers under thirty.

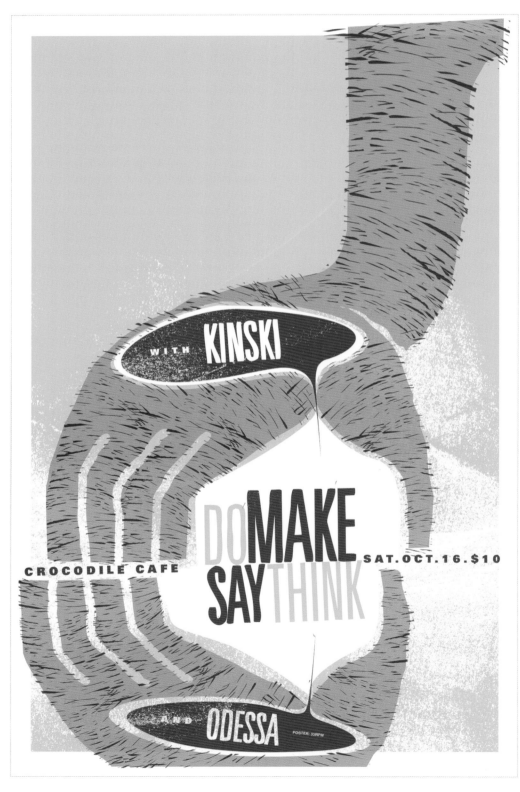

2004 3-COLOR SILKSCREEN 12 X 18 INCHES

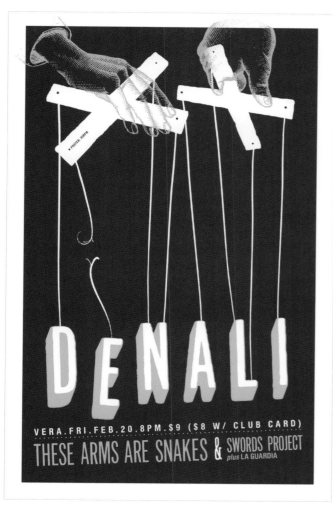

2004 2-COLOR SILKSCREEN 11 X 17 INCHES

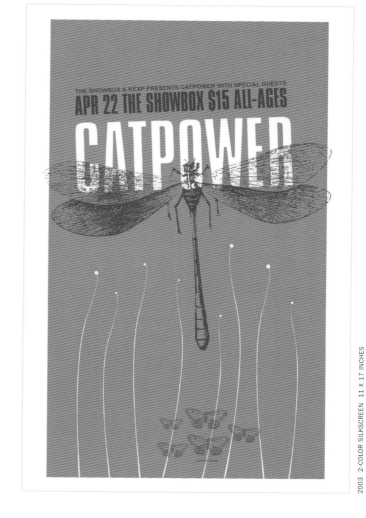

2003 2-COLOR SILKSCREEN 11 X 17 INCHES

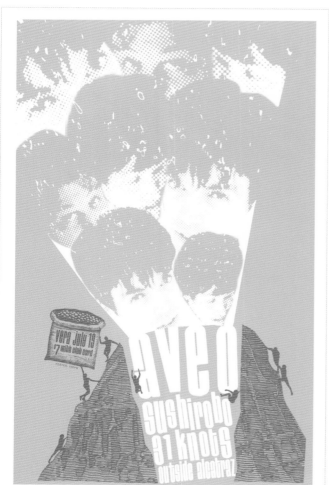

2003 2-COLOR SILKSCREEN 11 X 17 INCHES

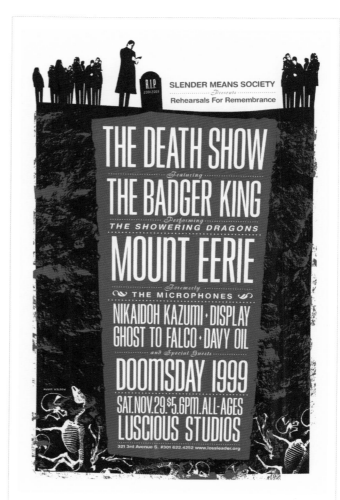

2004 2-COLOR SILKSCREEN 11 X 17 INCHES

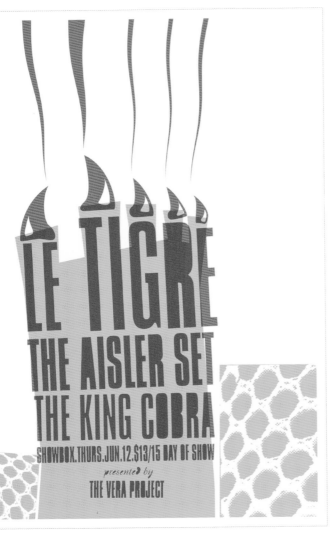

LE TIGRE
THE AISLER SET
THE KING COBRA
SHOWBOX.THURS.JUN.12.$13/15 DAY OF SHOW
presented by
THE VERA PROJECT

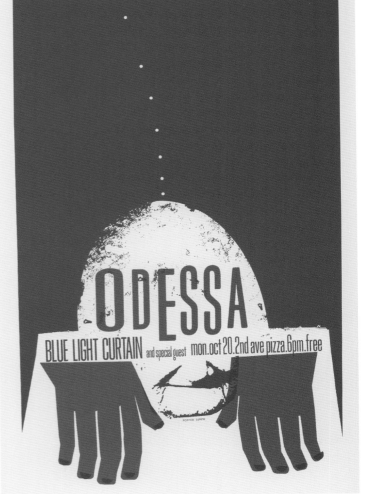

ODESSA
BLUE LIGHT CURTAIN *and special guest* mon.oct 20.2nd ave pizza.6pm.free

The Seattle International Film Festival presents
Exploding Cinema

ECS NORTH
Scientific American 2219 4th Ave. Seattle WA 98121 (206) 441-0464
DJ'S on trikes
Fri. June 4

THE HIDEAWAY
$8. Doors at 9pm.21 and up
Tickets only available on the night of show at the door.

Asterik Studio was founded in 2000, prompted by an equal passion for music and graphic design. Don Clark, Demetre Arges, and Ryan Clark joined forces after years of freelance work and grueling corporate-design positions to create a company where quality, creativity, and, most important, fun come first. Originally from Sacramento, California, the trio has discovered its true home in Seattle. Asterik is a full-time, fully-functional design firm that specializes in CD packaging, poster art, Web design, merchandise design, and everything in between. Their record-label clients include Atlantic, Capitol, Interscope, A&M, DreamWorks, RCA, Elektra, EMI, Warner Brothers, Geffen, Island, Vagrant, Drive-Thru, Tooth & Nail, Solid State, Victory, Equal Vision, Trustkill, and Ferret. Their work has appeared in such publications as *Communication Arts*, *print*, *HOW*, and *Computer Arts*, and the studio has been nominated for four Dove awards. Asterik Studio continues to keep it simple. They just do what they love and love what they do.

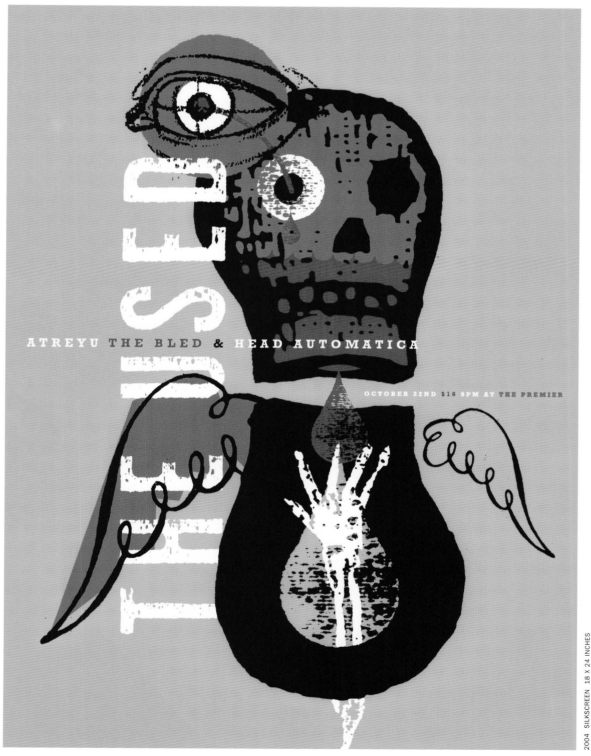

2004 SILKSCREEN 18 X 24 INCHES

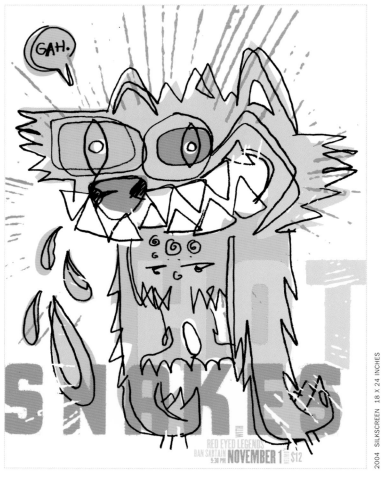

2004 SILKSCREEN 18 X 24 INCHES

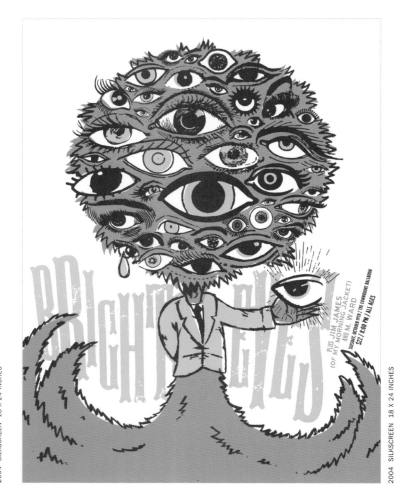

2004 SILKSCREEN 18 X 24 INCHES

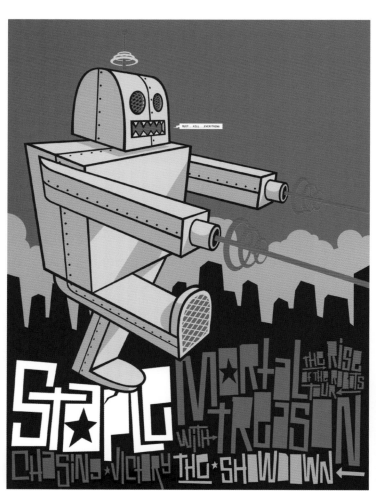

2004 SILKSCREEN 18 X 24 INCHES

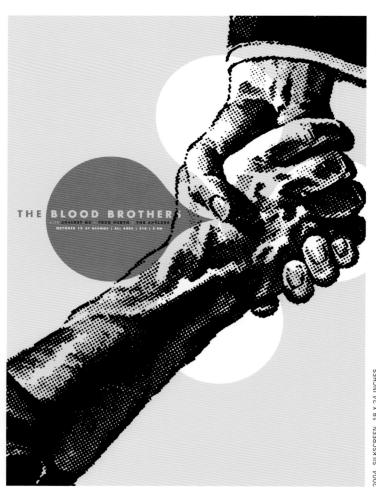

2004 SILKSCREEN 18 X 24 INCHES

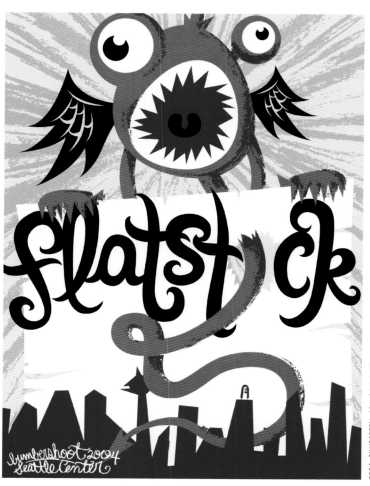

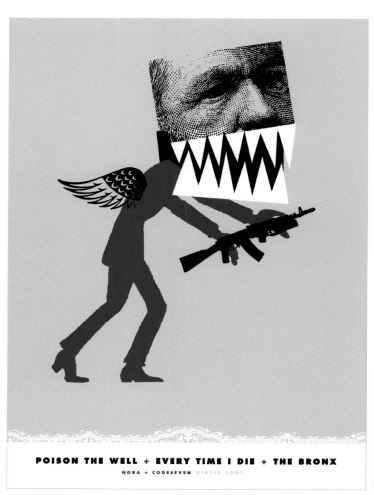

POISON THE WELL + EVERY TIME I DIE + THE BRONX

NORA + CODESEVEN WINTER 2003

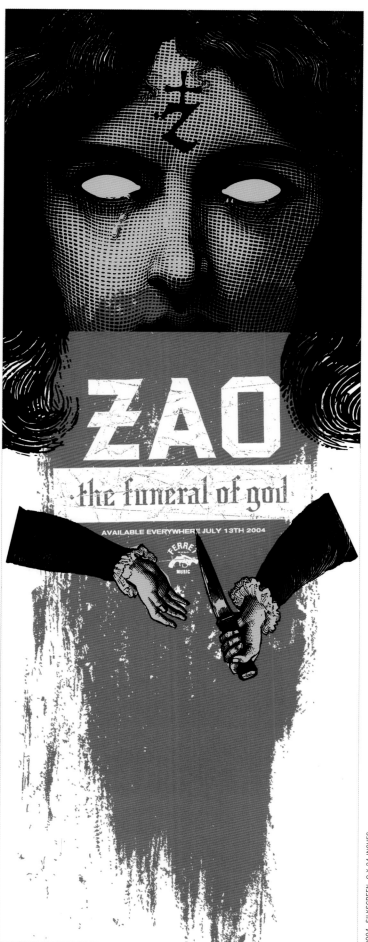

ZAO
the funeral of god

AVAILABLE EVERYWHERE JULY 13TH 2004

BruteFish Graphics is a collaboration between Ben Perez and Steve Sims that has consistently put out colorful and imaginative pieces for bands, promoters, and venues. Beginning in the early 1990s, both artists were individually producing posters for local musicians the old-school way—with a pen in one hand and a beer in the other. After a few years and quite a few hangovers, Ben and Steve realized that collaboration would make them more effective. A lot of brainstorming sessions and recovery meetings later, BruteFish Graphics was born. Having produced posters for a diverse list of acts since 2001, BruteFish Graphics is now branching out to design CD covers, T-shirts, logos, and marketing packages for a growing list of satisfied clients through commitment to their art.

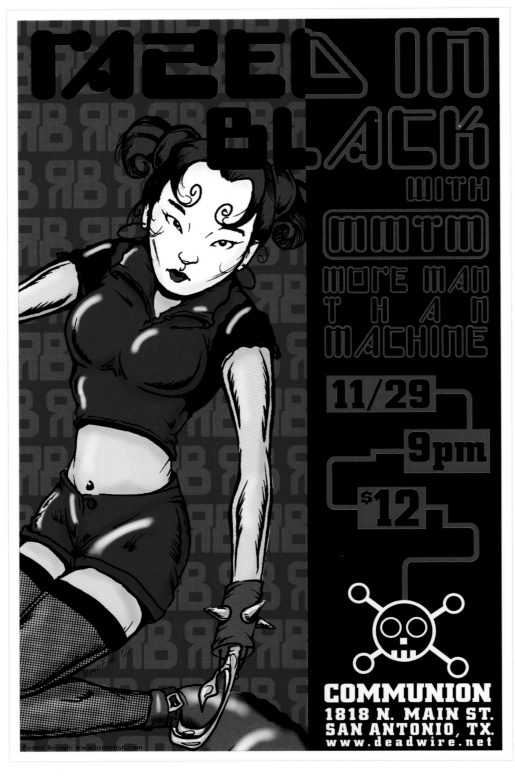

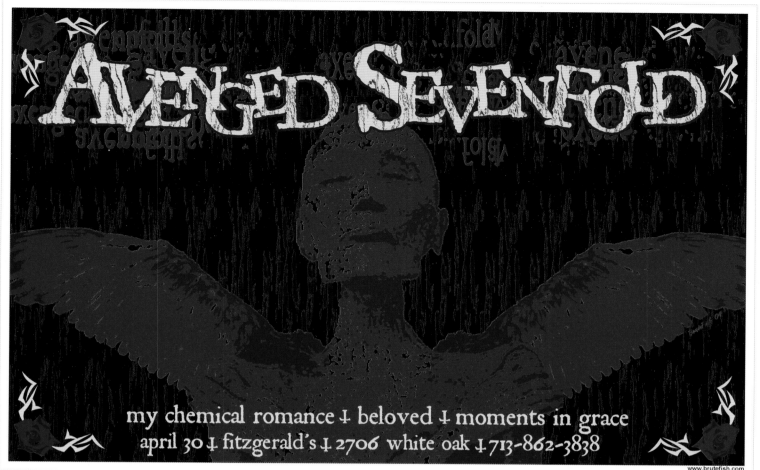

AVENGED SEVENFOLD

my chemical romance + beloved + moments in grace
april 30 + fitzgerald's + 2706 white oak + 713-862-3838

www.brutefish.com

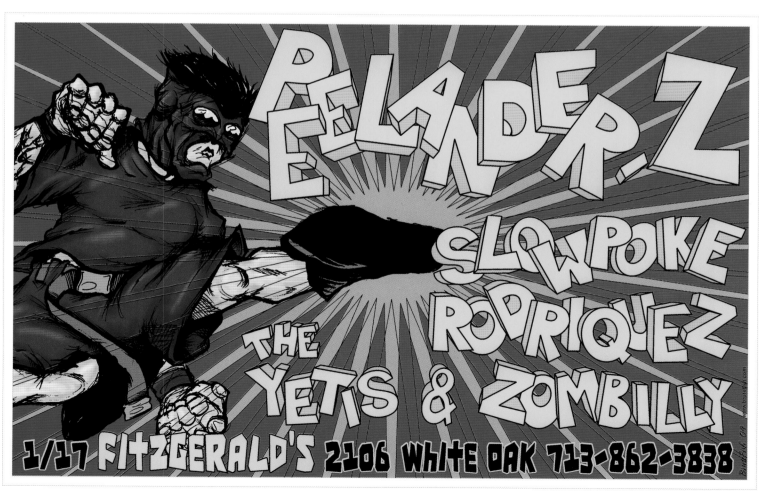

PEELANDER-Z
SLOWPOKE
RODRIQUEZ
THE YETIS & ZOMBILLY
1/17 FITZGERALD'S 2106 WHITE OAK 713-862-3838

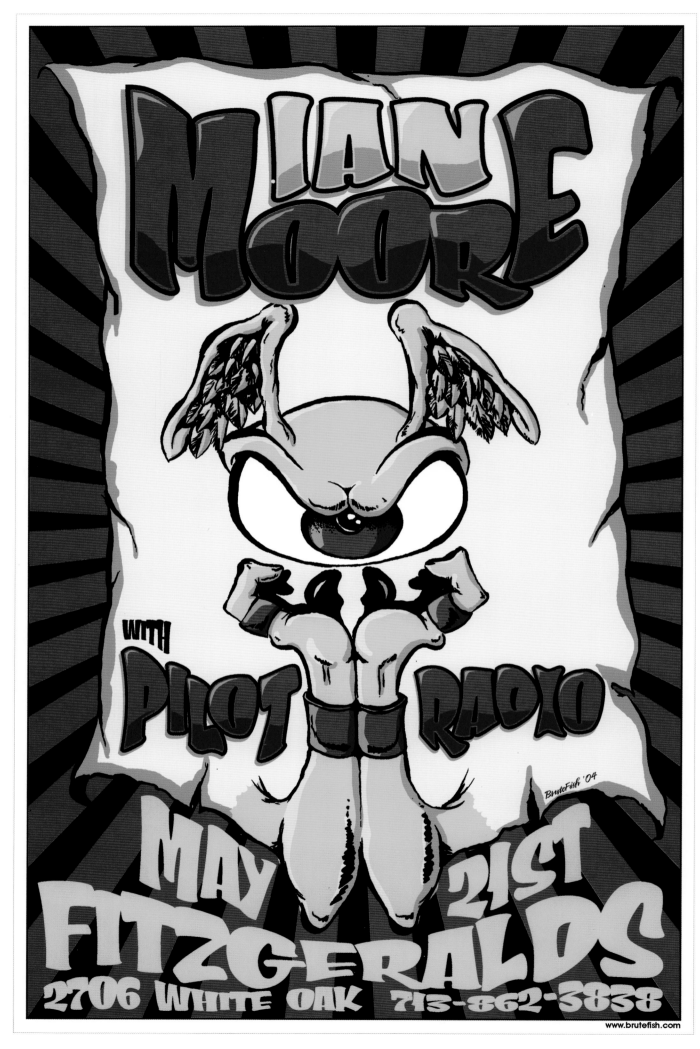

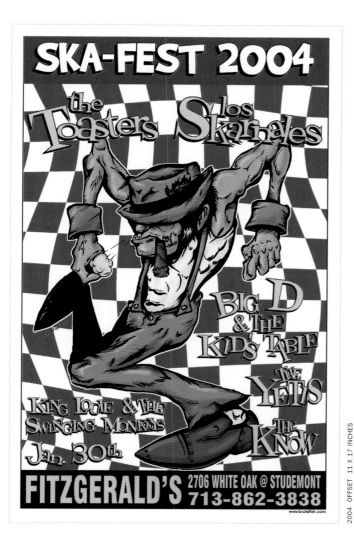

SKA-FEST 2004
the Toasters los Skarnales
BIG D & THE KIDS TABLE
THE YETIS
King Louie & The Swinging Monkeys
THE KNOW
Jan. 30th
FITZGERALD'S 2706 WHITE OAK @ STUDEMONT
713-862-3838
www.brutefish.com

2004 OFFSET 11 X 17 INCHES

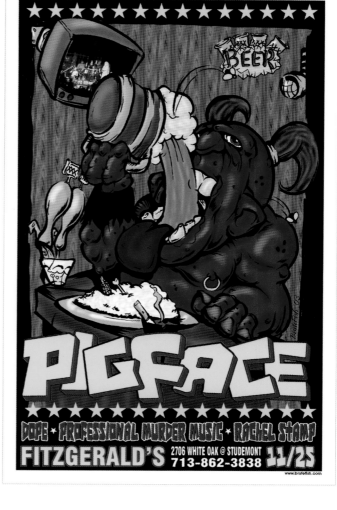

PIGFACE
DOPE • PROFESSIONAL MURDER MUSIC • RACHEL STAMP
FITZGERALD'S 2706 WHITE OAK @ STUDEMONT
713-862-3838 11/25
www.brutefish.com

2003 OFFSET 11 X 17 INCHES

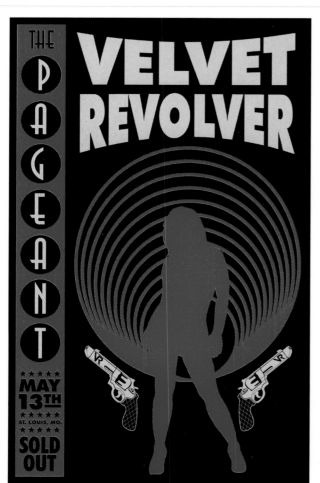

THE PAGEANT
VELVET REVOLVER
MAY 13TH
ST. LOUIS, MO.
SOLD OUT
ART DIRECTION: E. BLOCKIE
POSTER BY: WWW.BRUTEFISH.COM

2004 SILKSCREEN 11 X 17 INCHES

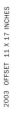

KMFDM
WWIII
NUMBERS 300 WESTHEIMER
SPECIAL GUESTS BILE
11/13

2003 SILKSCREEN 19 X 25 INCHES

Born and raised in St. Petersburg, Florida, Chad Cardoza has been creating posters for about three years. Working on a vintage 4 x 4 press out of the screen-print shop he shares with his brother Scooter, Chad hand-creates and screen-prints most of his posters. He thanks his wife Suzie for the garage-sale find of the 1-color 1-station press that got the whole thing started and his friend Jeff Sweat who introduced him to the world of rock-poster printing. Chad prints very small runs of posters for local promoters Jack Spatafora at Aestheticized and Tony Bullard at No Clubs. Influenced by local artists Chris Maher, Ryan Peel, and Kieran Walsh, Chad continues to keep his poster printing on the sly and only pops up now and then when an idea strikes or a favorite band hits town.

2003 SILKSCREEN ON PAPER 13 X 20 INCHES

2002 SILKSCREEN ON PAPER 12 X 19 INCHES

2001 SILKSCREEN ON PAPER 10 X 17 INCHES

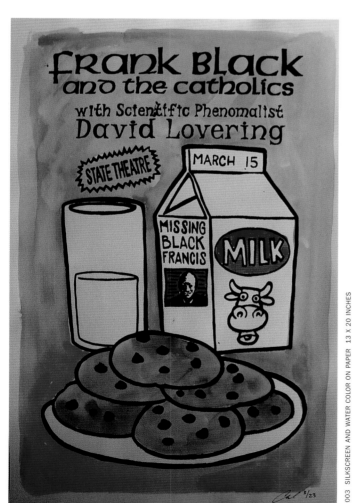

2003 SILKSCREEN AND WATER COLOR ON PAPER 13 X 20 INCHES

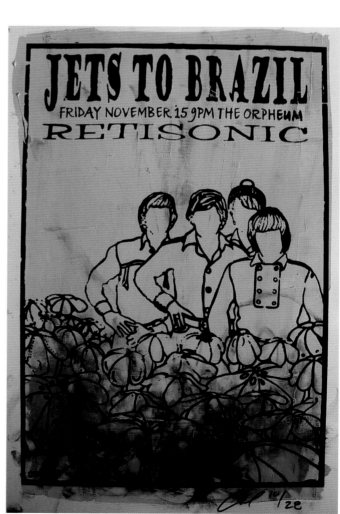

2002 SILKSCREEN ON PAPER 13 X 20 INCHES

A standout member of Texas's newest generation of rock-poster luminaries, Jared Connor creates posters with that irrepressible irreverence native to the Lone Star State. After years of late nights, "last calls" and paying his dues in the live-music clubs of Austin, he began producing his own posters in 2000. He founded his studio, Mexican Chocolate Design, shortly after that. With a graphic vision born in Texas and forged in the fires of the Gulf War, and a graphic vocabulary refined by his early schooling in commercial art and screen-printing, Jared refuses to make posters that are trite or trendy, self-indulgent tripe with no connection to a band's music and fan base. He creates honest posters. Today he counts among his clients Turbonegro, No Warning, Honky, Warner Brothers, Universal, Teepee, Arclight Records, and Capita Snowboards.

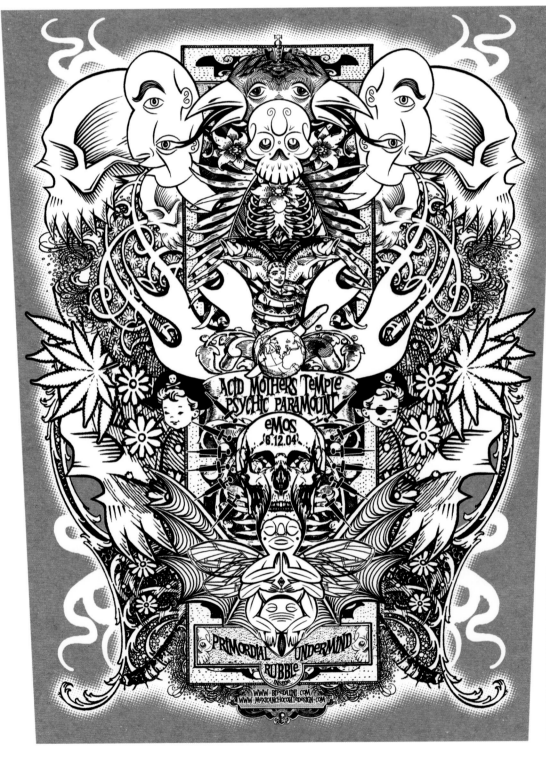

DESIGNED WITH THE COLLABORATION OF MARK PEDINI
2004 2-COLOR SCREENPRINT ON CHIPBOARD 16 X 24 INCHES

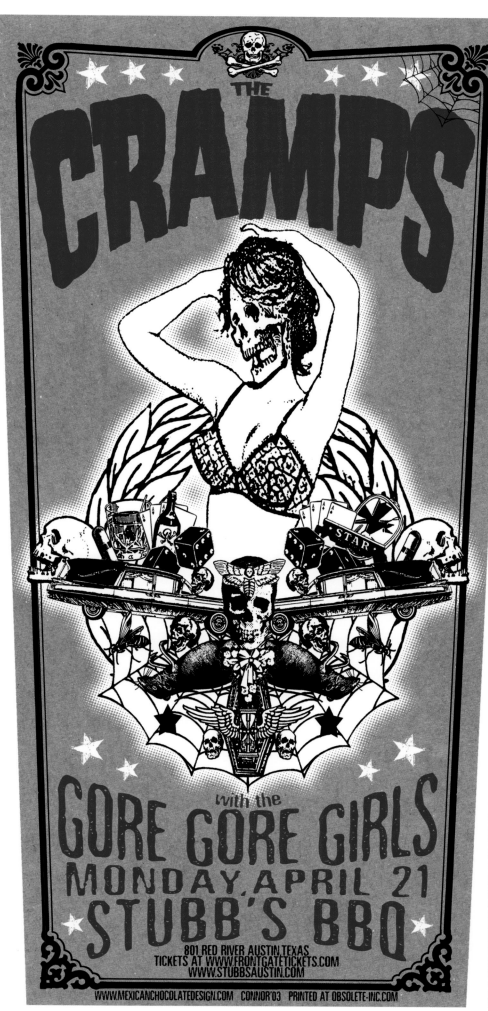

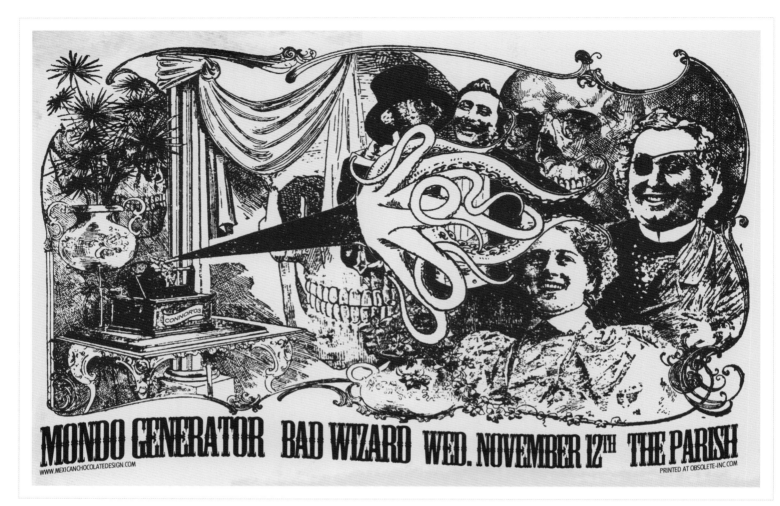

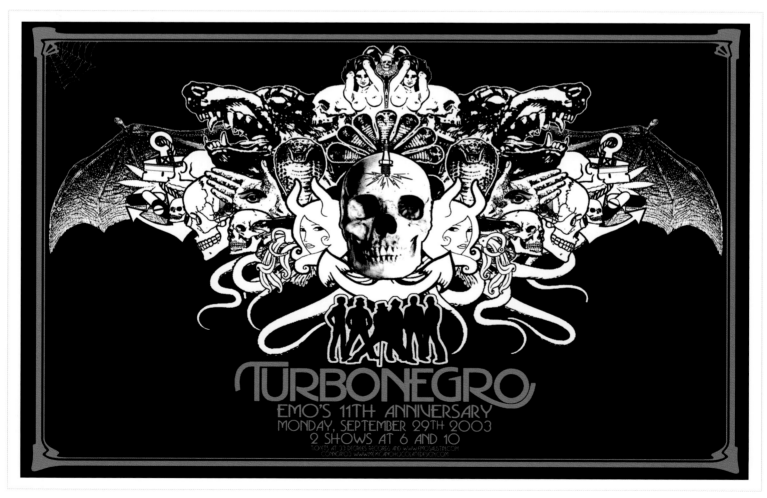

2003 SEPIA (DIAZO) PRINTS VARIOUS SIZES

2003 2-COLOR SCREENPRINT ON FRENCH BLACK SPECKLETONE 26 X 16 INCHES

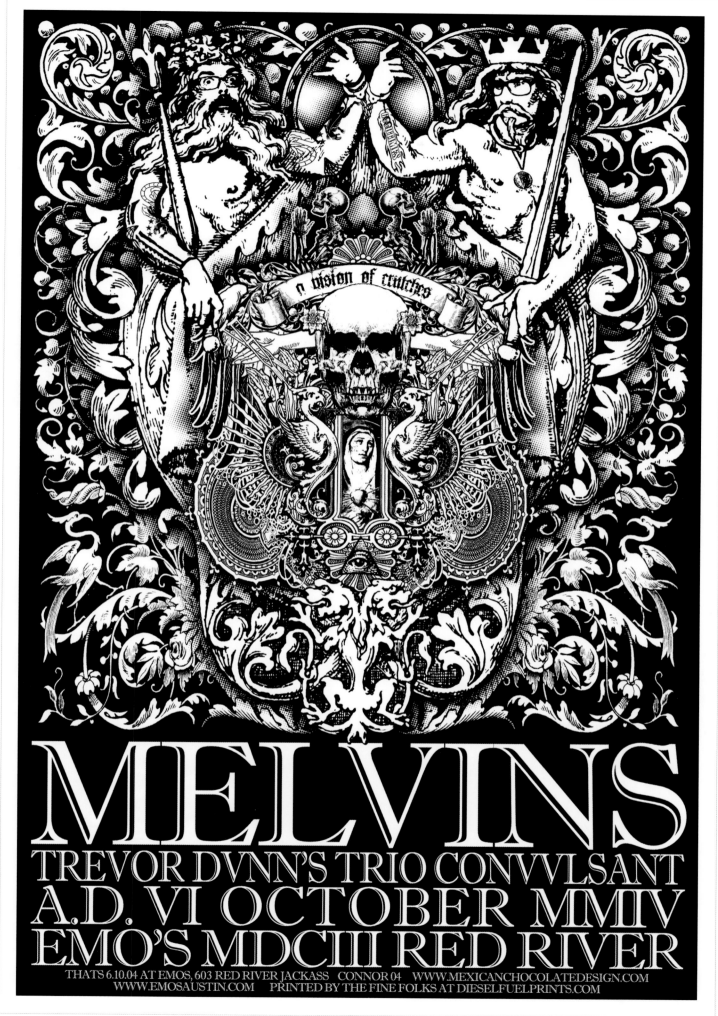

MELVINS

TREVOR DVNN'S TRIO CONVVLSANT
A.D. VI OCTOBER MMIV
EMO'S MDCIII RED RIVER

THATS 6.10.04 AT EMOS, 603 RED RIVER JACKASS CONNOR 04 WWW.MEXICANCHOCOLATEDESIGN.COM
WWW.EMOSAUSTIN.COM PRINTED BY THE FINE FOLKS AT DIESELFUELPRINTS.COM

2004 1-COLOR SCREENPRINT ON FRENCH BLACK SPECKLETONE GLOW-IN-THE-DARK INK 24 X 35 INCHES

Born in the southern Bible Belt, Jason Cooper was raised on a steady diet of KISS, movie monsters, punk rock, skateboarding, and heavy metal music. No surprise then that this contradiction led him into the unorthodox world of blotter acid art, silkscreen rock posters, tattoo art, and other underground forms of self-expression. Combining a lowbrow style and cynical humor with religious iconography and erotica, Cooper forges his own path in a world of safe art to create emotionally challenging works that can be found in galleries from San Francisco to Manchester, United Kingdom, as well as in Hard Rock Cafes around the world. He also participates regularly in solo and group exhibitions, and has been featured in many art-related publications.

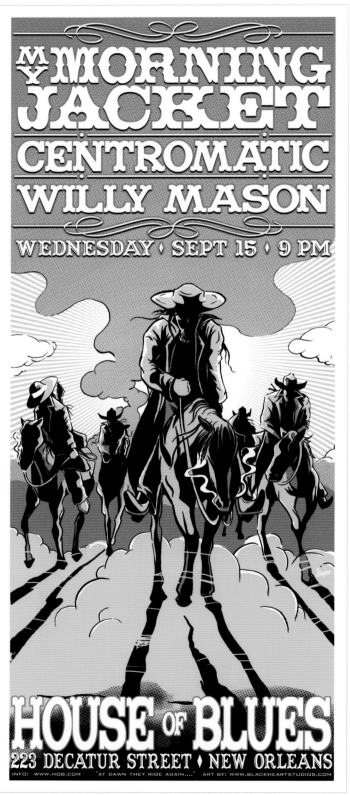

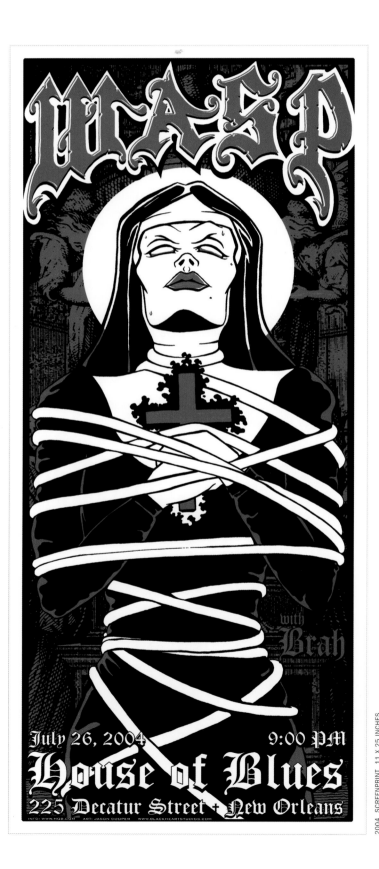

2004 SCREENPRINT 11 X 25 INCHES

2004 SCREENPRINT 11 X 25 INCHES

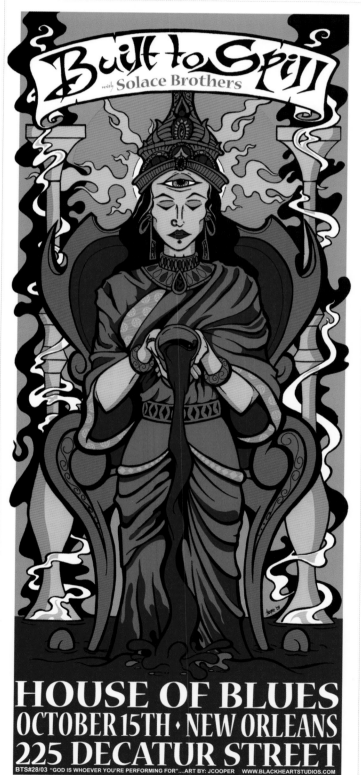

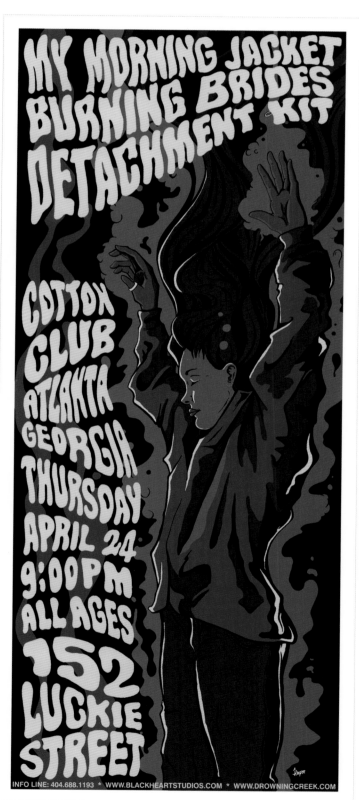

"I started collecting concert posters in the early 1980s, finding them at garage sales and flea markets and yanking them off telephone poles. Then I got into doing them myself. By 1996, I was selling overruns at record shows and flea markets. Then I began receiving commissions for posters from other venues around the country. It's really great when I get a poster signed by the band and they compliment my work. But the ultimate compliment is when I'm out hanging posters and someone stops and pulls one off the pole the way I used to do." Based in Tulsa, Oklahoma, David Dean began producing posters for the legendary Cain's Ballroom in 1995. Self-taught, with no formal training, Dean designs his posters with both band fans and collectors in mind. He has produced posters for varied artists such as Velvet Revolver, Eric Clapton, Butthole Surfers, Gov't Mule, ZZ Top, and Bob Dylan. In 1999, he created the Electric Factory Numbered Series in Philadelphia and produced the first eight posters in the series. Today Dean is one of the few active midwest poster artists, and he concentrates on venues in this region.

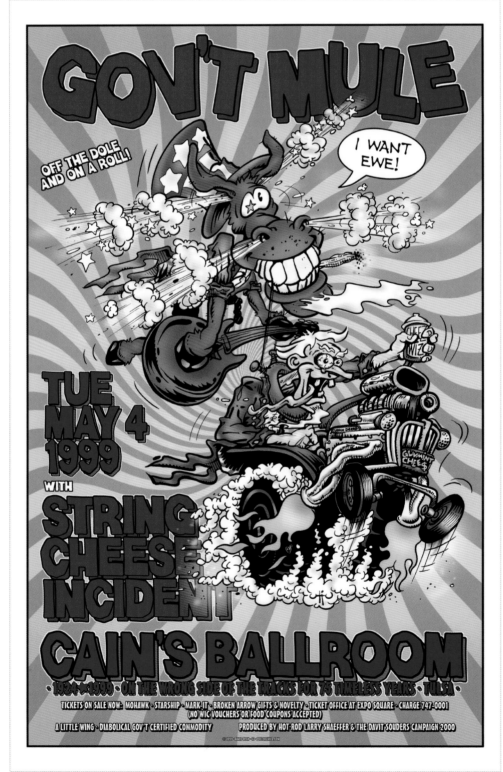

1999 OFFSET 13 X 20-1/2 INCHES

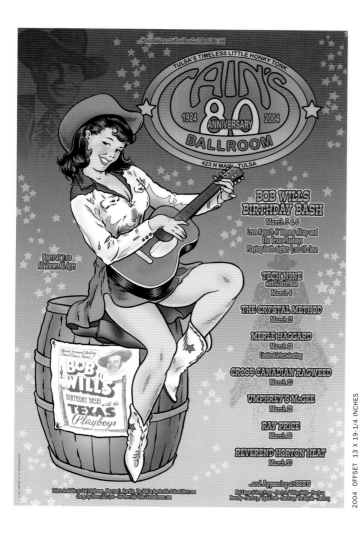

2004 OFFSET 13 X 19-1/4 INCHES

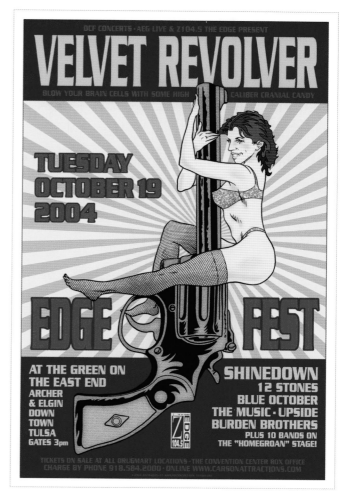

2004 OFFSET 12-1/4 X 18-3/4 INCHES

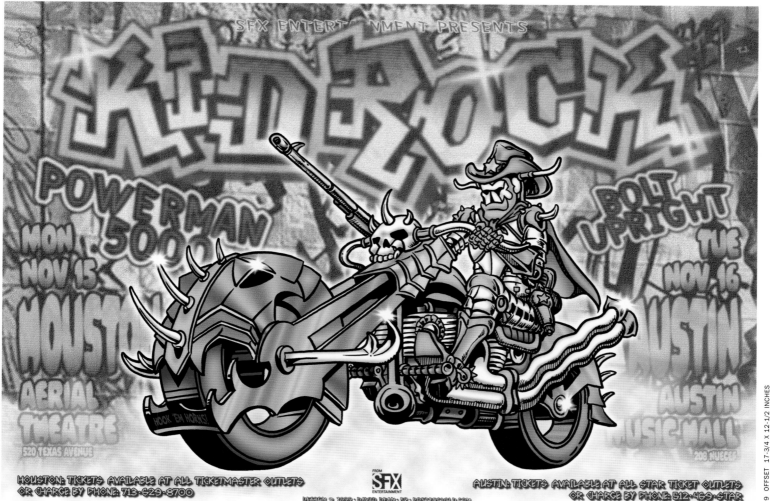

1999 OFFSET 17-3/4 X 12-1/2 INCHES

The Decoder Ring Design Concern believes that design should be three things: simple, smart, and pretty. Anything less is ineffective and anything more diffuses clarity and dilutes impact. The approach seems to work. Founded in 2004 after the demise of the seminal design powerhouse, Factor27, The Decoder Ring Design Concern is manned by Paul Fucik, Geoff Peveto, and "the new guy" Christian Helms, who showed up on the doorstep one day by way of Art Chantry. Before then Paul and Geoff had been cranking out designs for clients that ranged from Sonic Youth to Levi's to Willie Nelson to SXSW, and gaining accolades from the likes of *Swag: Rock Posters of the '90s, Art of Modern Rock: The Poster Explosion, Taschen's 1,000 Favorite Websites, Dynamic Graphics*, and *print*. Since Helms came on board in 2004, The Decoder Ring Design Concern hasn't missed a step, continuing to work with clients like SXSW, Modest Mouse, James Victore/AIGA, Ruta Maya, Beulah, and Azul.

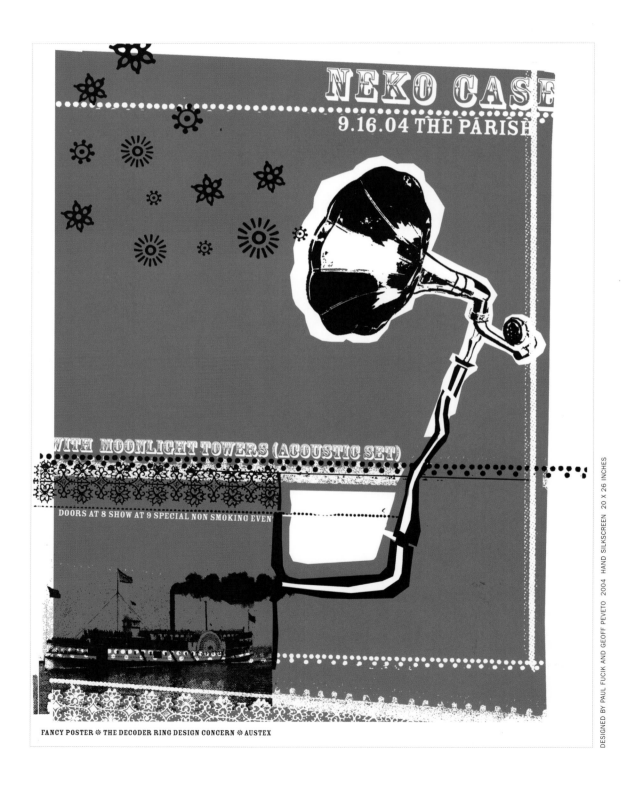

FANCY POSTER ❋ THE DECODER RING DESIGN CONCERN ❋ AUSTEX

DESIGNED BY PAUL FUCIK AND GEOFF PEVETO 2004 HAND SILKSCREEN 20 X 26 INCHES

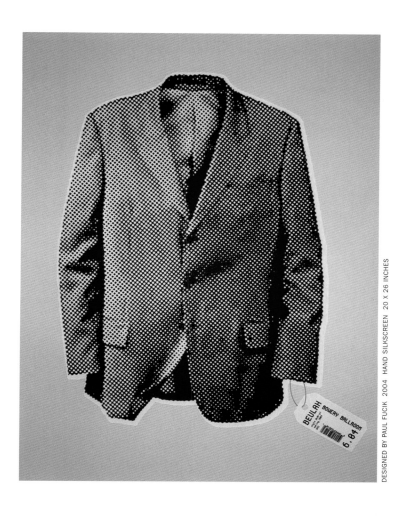

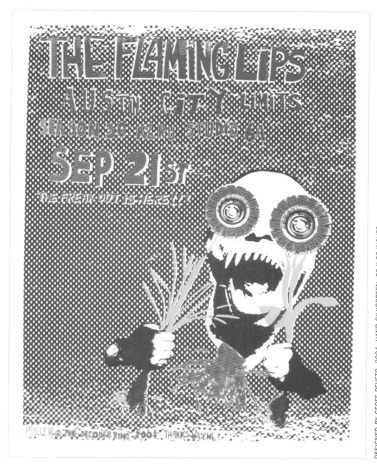

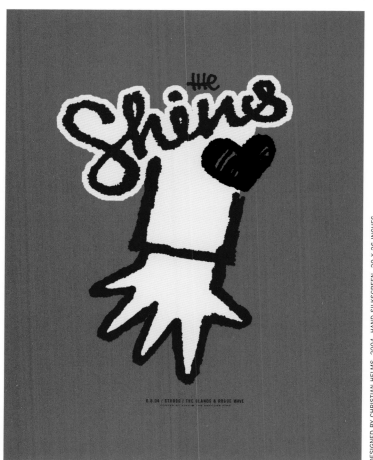

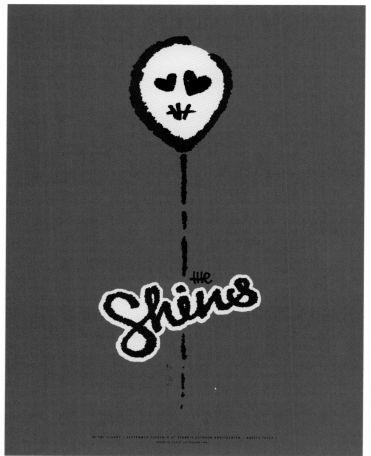

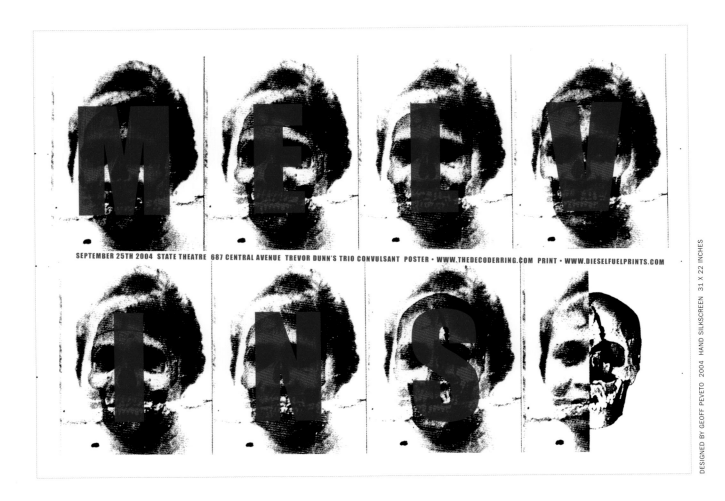

DESIGNED BY GEOFF PEVETO 2004 HAND SILKSCREEN 31 X 22 INCHES

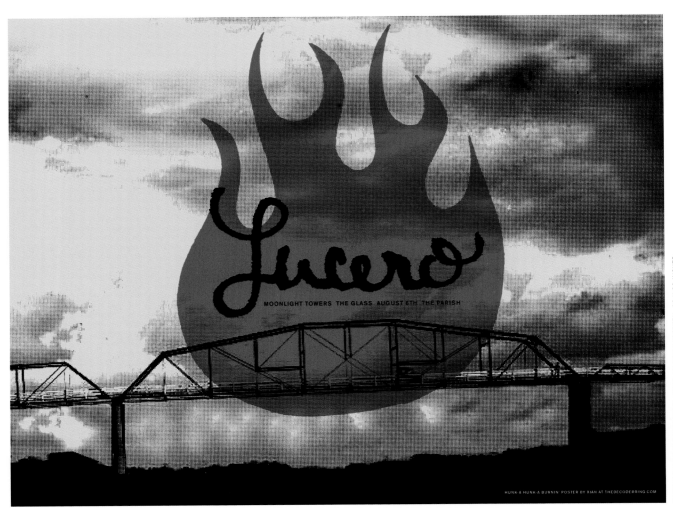

DESIGNED BY CHRISTIAN HELMS 2004 HAND SILKSCREEN 26 X 20 INCHES

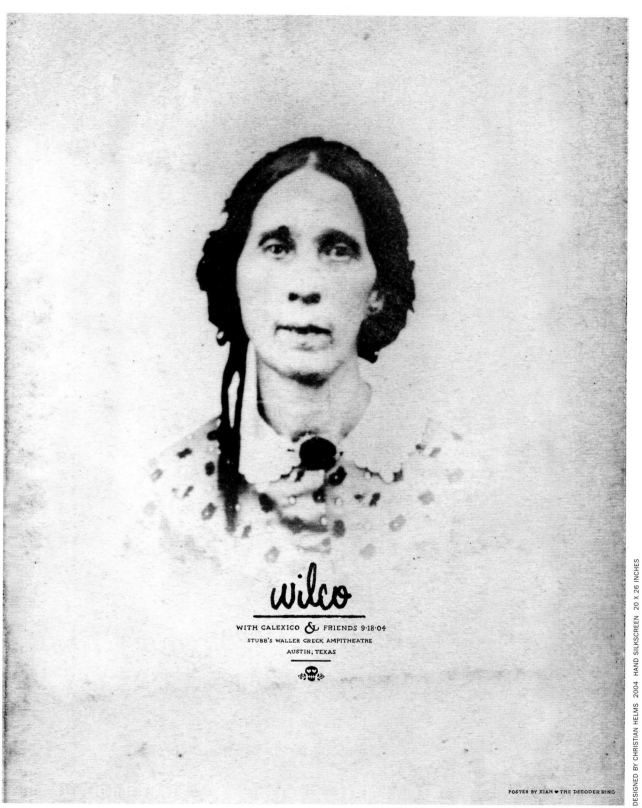

After moving to San Francisco in 1995, Joel Elrod began creating concert posters for Bill Graham Presents. His portfolio includes posters for Train, Bob Dylan, Phish, Creed, Tricky, The Waterboys, Widespread Panic, the Horde Festival, Sonvolt, Elvis Costello, Jack Johnson, "X", and Herbie Hancock. Many are on permanent display at the legendary Fillmore Auditorium in San Francisco. Elrod's BGP posters for Korn, Wheezer, Jane's Addiction, Willie Nelson, David Byrne, and Ryan Adams have been featured in *print*'s regional design annuals, and four appeared in the *American Illustration* annuals. He does editorial illustration for such publications as *Rolling Stone, Newsweek, Boston, Texas Monthly, Men's Journal, Smart Money*, the *Dallas Morning News, The San Francisco Bay Guardian*, the *Fort Worth Star-Telegram*, and *Bike*. Elrod has been painting since age two and in 1993 received his bachelor of fine arts degree with an emphasis in illustration from Northern Arizona University. As a rock-poster artist, he enjoys a freedom of expression that other commercial art does not allow.

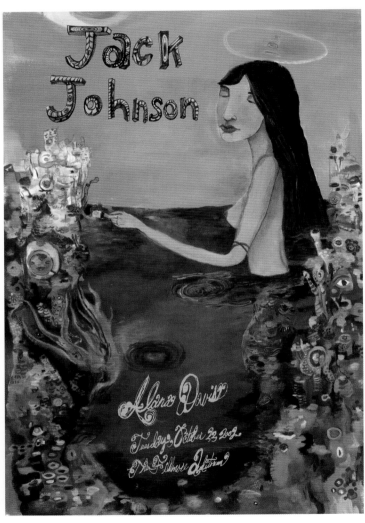

2002 OFFSET 13 X 19 INCHES

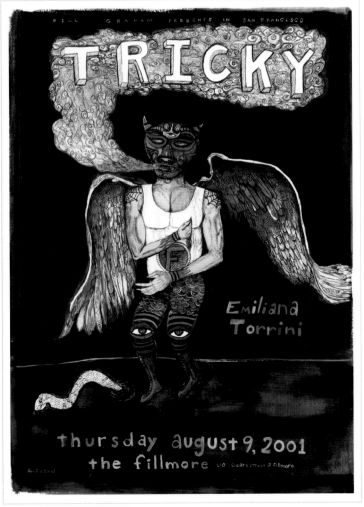

2001 OFFSET 13 X 19 INCHES

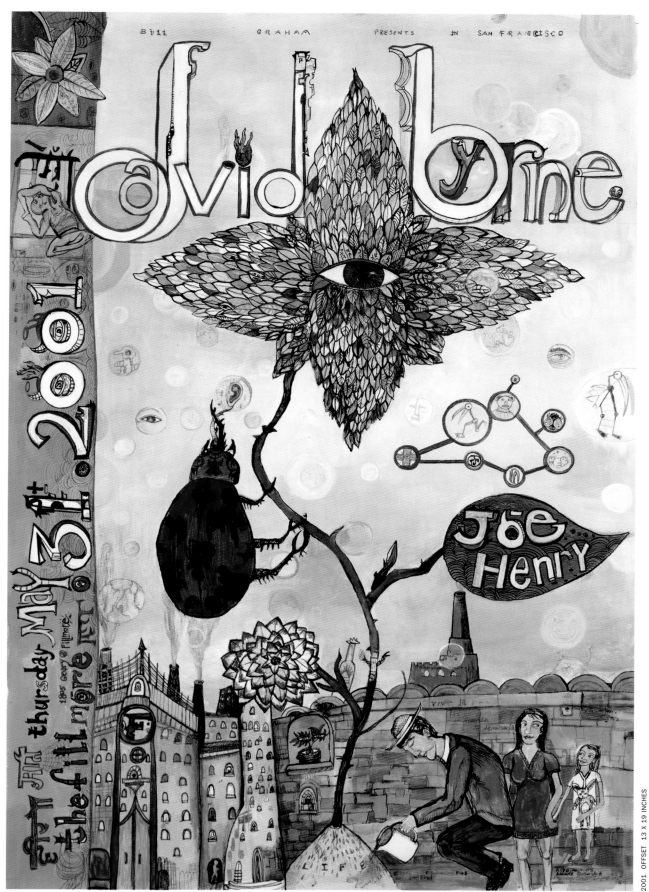

2001 OFFSET 13 X 19 INCHES

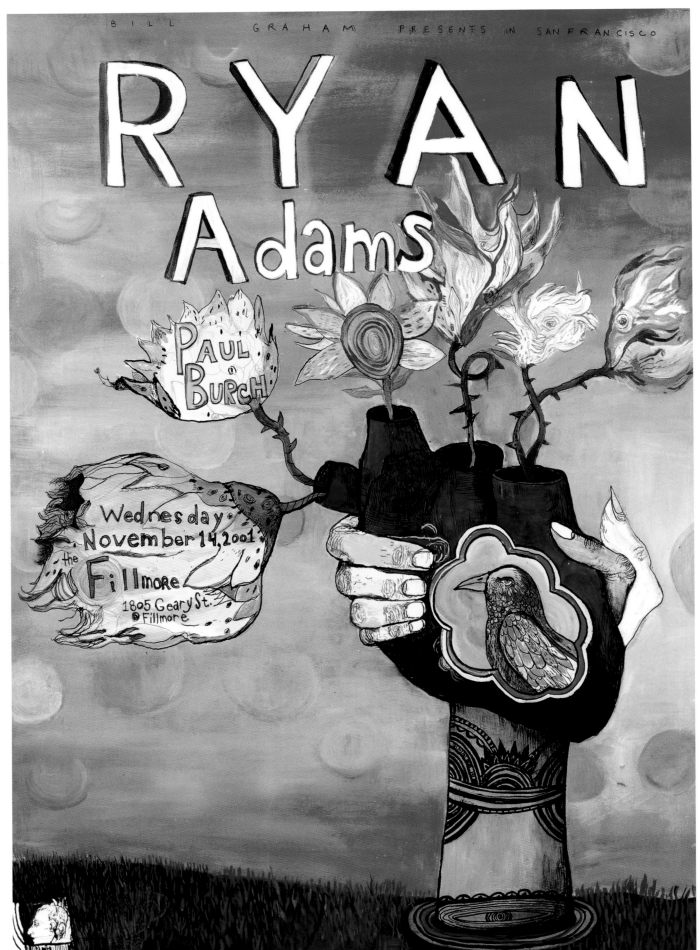

Formed in fall 2001 after the demise of LowBrowInk, a collaborative with Jeff Wood, Jonny Thief, and Mike Martin, EngineHouse13 is the husband and wife team of Mike and Cari Martin. The duo are dedicated music lovers who crank out some of today's best and most recognizable design and limited edition posters in the world. Heavily influenced by the hot-rod and kustom-kulture scene in America, Mike has been designing rock posters and fliers since 1986. Cari is the team's photographer and the glue that keeps the business all together! Most of EngineHouse13's posters are manually screen-printed by the artist, are of the highest quality attainable, and are signed and numbered to ensure the collectability of the prints. EngineHouse13 has worked for Bob Marley Music, and Jimi Hendrix Ltd., among other recognized bands, promoters, and sportswear companies.

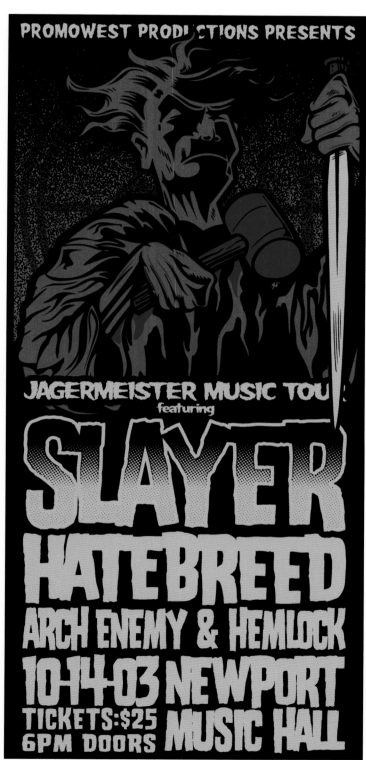

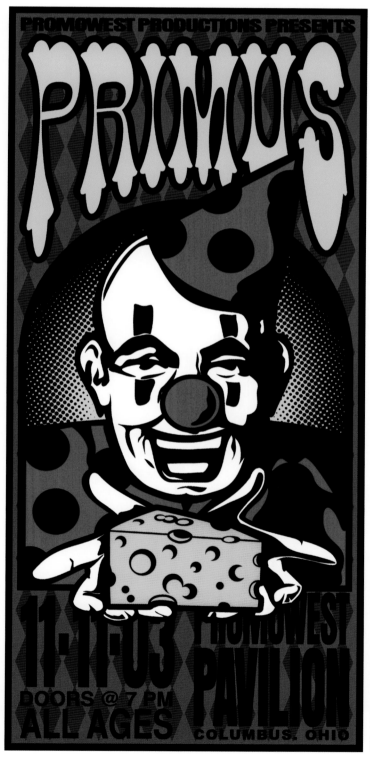

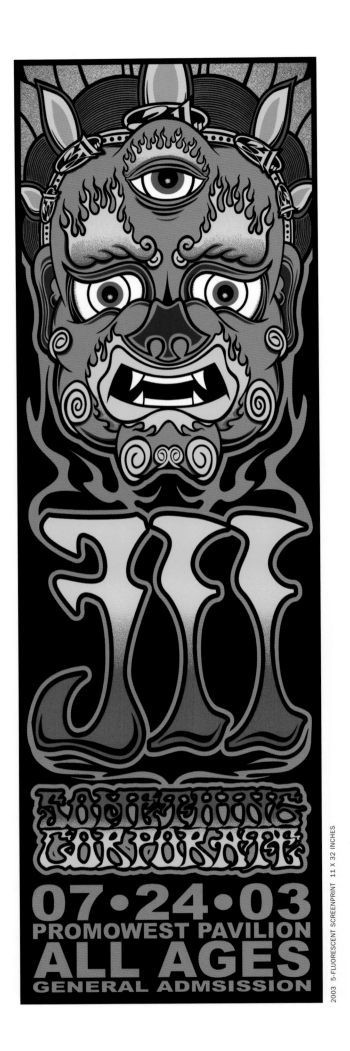

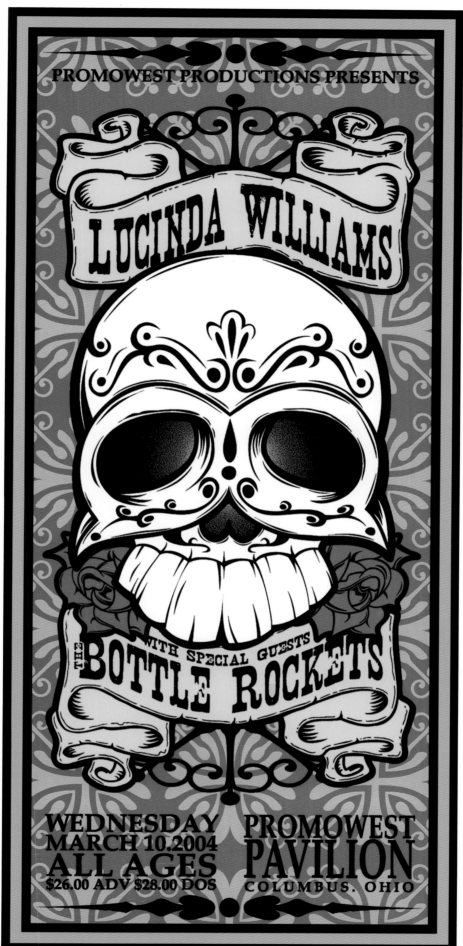

2004 3-FLUORESCENT SCREENPRINT 13 X 26 INCHES

Based in the true birthplace of rock and roll, Buddy Holly's hometown of Lubbock, Texas, Dirk Fowler and his wife Carol operate a small full-service design studio called f2design. After almost ten years as an art director in advertising, Dirk combined his love for making art and his love of all things old in his approach to poster art. He prints his posters on a Vandercook No. 1 proof press built in the 1930s, he uses vintage wood and metal type and hand-cut and hand-carved images, and he hand-inks every impression. His posters are sometimes sloppy. You can feel the ink. He likes it that way. Dirk is an assistant professor of graphic design at Texas Tech University. His work has been recognized by major graphic design publications like *print*, *STEP Inside Design*, the Society of Publication Directors, and the New York Type Director's Club, and it's been exhibited in galleries across the country.

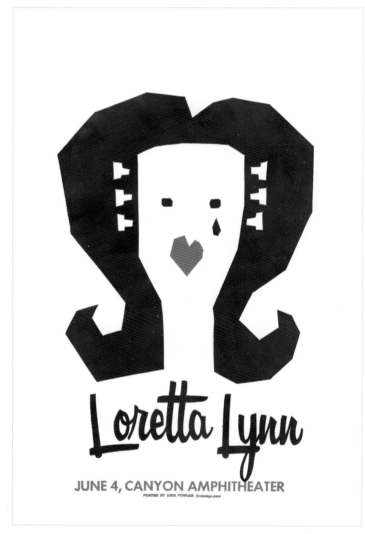

2004 LETTERPRESS 13 X 20 INCHES

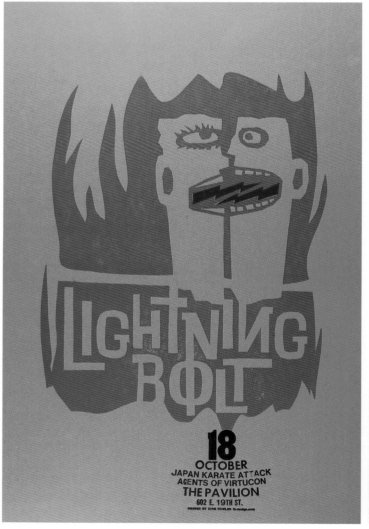

2003 LETTERPRESS 15-1/2 X 23 INCHES

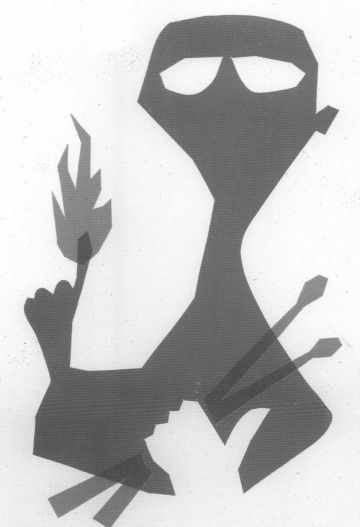

VANDERMARK FIVE ATOMIC

JUNE 22

THE WOODRUFF BUILDING, 5TH FLOOR
424 S. GAY ST., KNOXVILLE

POSTER BY DIRK FOWLER 12-design.com

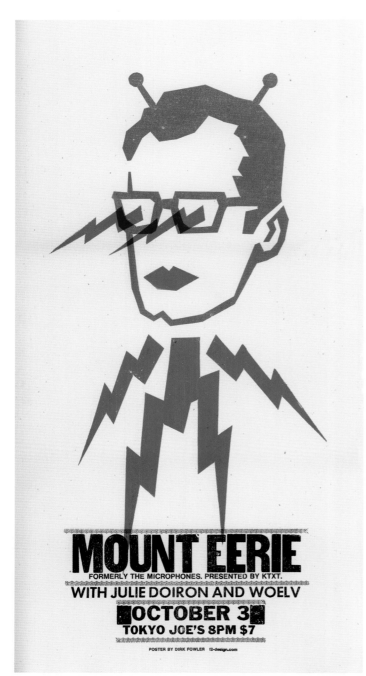

MOUNT EERIE
FORMERLY THE MICROPHONES. PRESENTED BY KTXT.
WITH JULIE DOIRON AND WOELV
OCTOBER 3
TOKYO JOE'S 8PM $7
POSTER BY DIRK FOWLER f2-design.com

2004 LETTERPRESS 13 X 23 INCHES

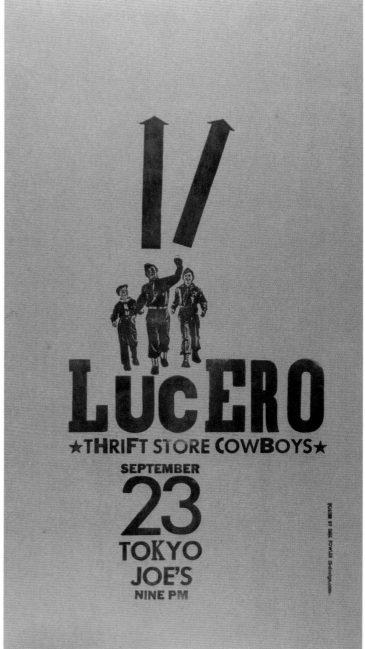

LUCERO
★THRIFT STORE COWBOYS★
SEPTEMBER 23
TOKYO JOE'S
NINE PM

POSTER BY DIRK FOWLER f2-design.com

2003 LETTERPRESS 12 X 22-1/2 INCHES

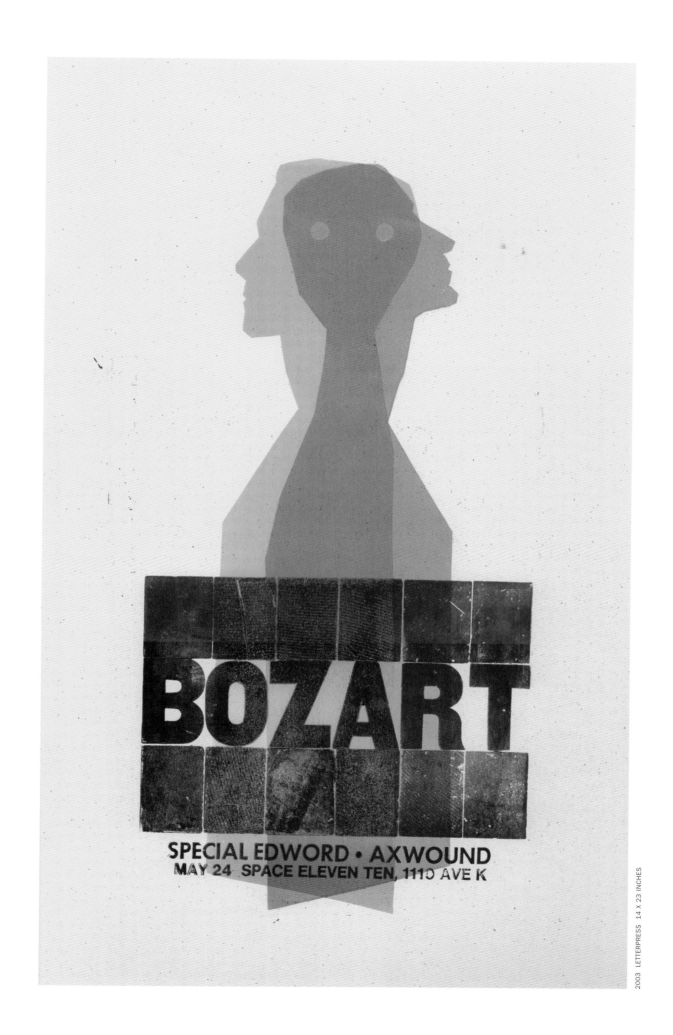

Jeff Gaither is a native Kentuckian, born in 1960 in Louisville. He's a self-taught artist, having worked in many mediums, including acrylic, ink, mixed media, and clay. Gaither uses his experimentation with all of these art forms to fuel his graphic design, which in the last twenty years has appeared in more than 1,000 magazines and on 200 CD covers. His work uses an old-school approach with humor and a little darkness thrown in to create hard-featured and malevolent illustrations. In the past he worked with legendary Ed "Big Daddy" Roth doing comics, T-shirts, and stickers. Gaither is known for taking the ideas and needs of the client and fusing them with his dynamic vision to create one-of-a-kind pieces of insane art, many of which can be seen on his website, "Art for the Criminally Insane."

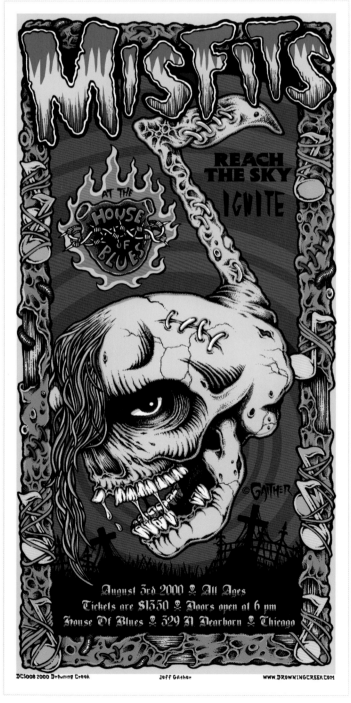

2001 SILKSCREEN 10 X 21 INCHES

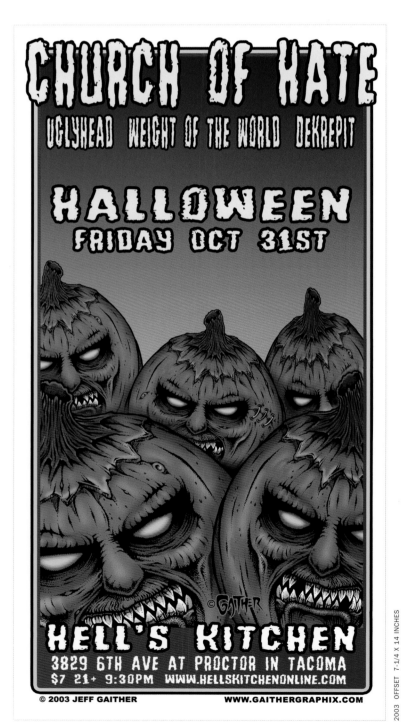

2003 OFFSET 7-1/4 X 14 INCHES

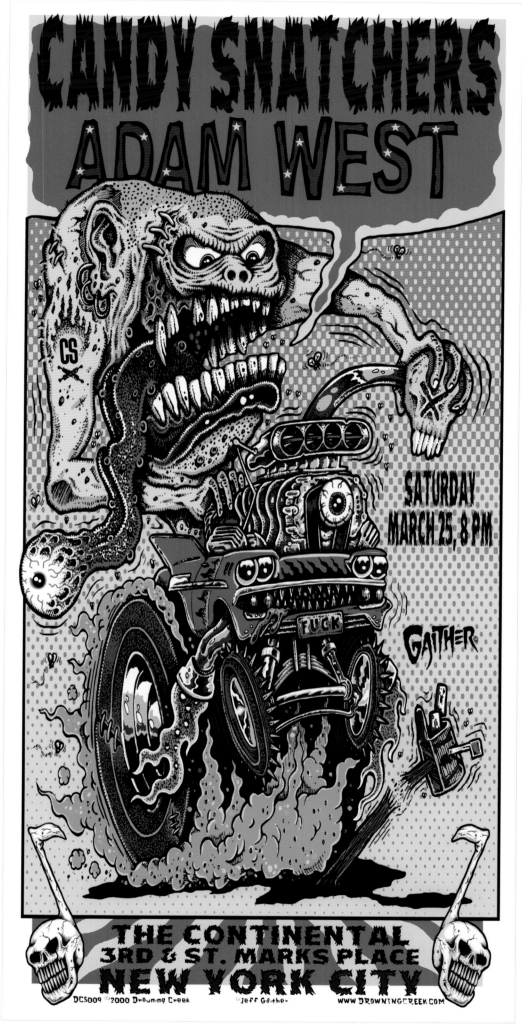

2001 SILKSCREEN 10 X 21 INCHES

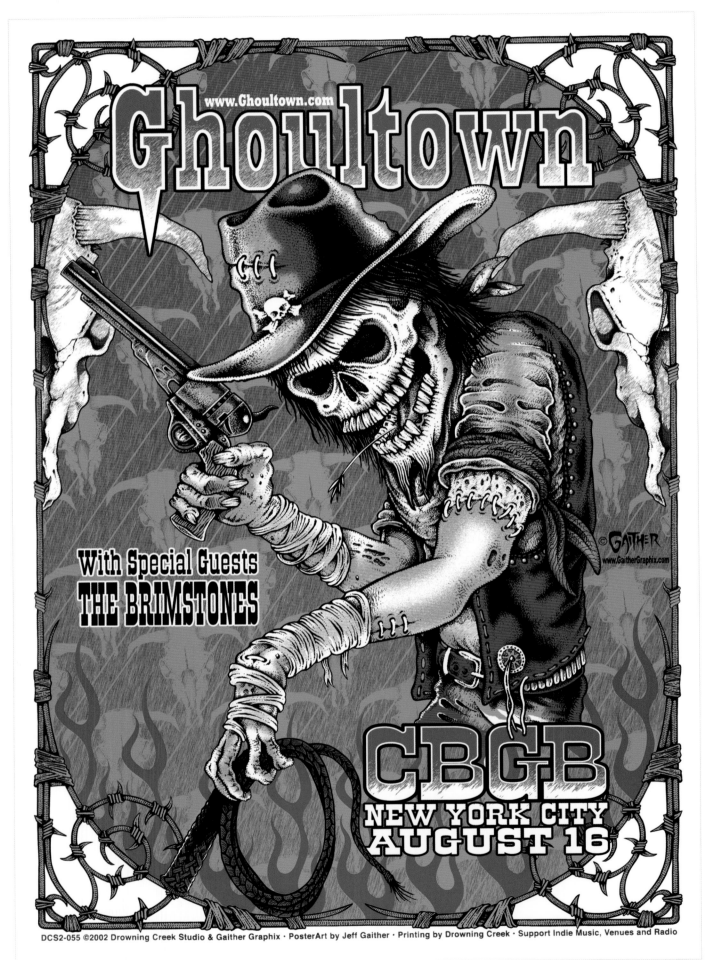

2002 SILKSCREEN 14 X 20 INCHES

2003 OFFSET 11 X 17 INCHES

Born in Dodge City, Kansas, in 1945, Danny Garrett served in Vietnam and came to Austin, Texas in 1971. There he did his first music art, a performance poster for John Sebastian at the newly opened Armadillo World Headquarters. He's done posters for many other Austin venues, including The Texas Opry House, The Austin Opry House, Castle Creek, Soap Creek Saloon, and the one he's most identified with, Antone's, Austin's Home of the Blues. He's done portraits of the many blues greats who have played Antone's—Muddy Waters, Ray Charles, B. B. King, Albert King, Buddy Guy, Bobby Blue Bland, Albert Collins, The Fabulous Thunderbirds, Stevie Ray Vaughan, Jerry Lee Lewis, George Jones, Ray Price, and Clifton Chenier. He started doing digital graphic art in 1991 while working for a computer game company.

1996 OFFSET 11 X 17 INCHES

Fueled by a passion for art and music, Ed Gossage founded Attledo Design Company, a full-service design studio and print shop on the outskirts of Lubbock, Texas. Gossage studied graphic design at Texas Tech University, where fellow poster artist and professor Dirk Fowler introduced him to the rock poster scene and greatly influenced the style currently associated with Attledo (pronounced at-tel-do for "that will do" in Texan). Since 2003, Attledo has moved on from producing cheap photocopied flyers for local shows to creating some of the hottest screen-printed posters for venues and bands across the nation. Located in a garage where all posters are printed by hand with love and care, Attledo currently works for clients such as Capitol Records, Pipeline Productions, and Brand New.

2004 2-COLOR SILKSCREEN 13 X 20 INCHES

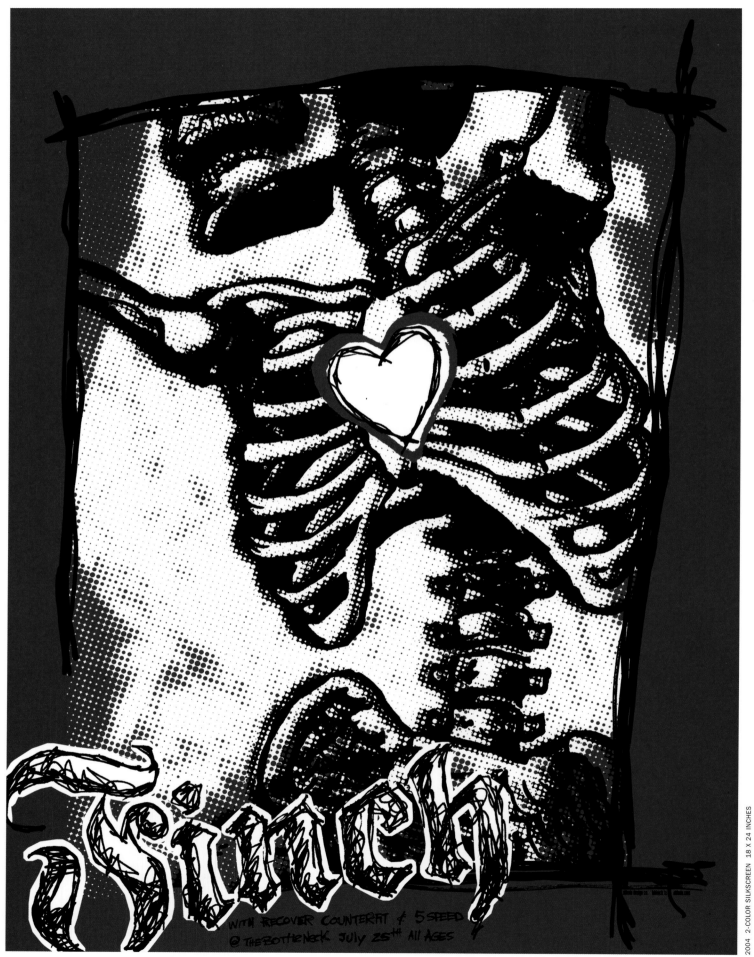

WITH RECOVER COUNTERFIT & 5 SPEED
@ THE BOTTLENECK JULY 25TH ALL AGES

2004 2-COLOR SILKSCREEN 18 X 24 INCHES

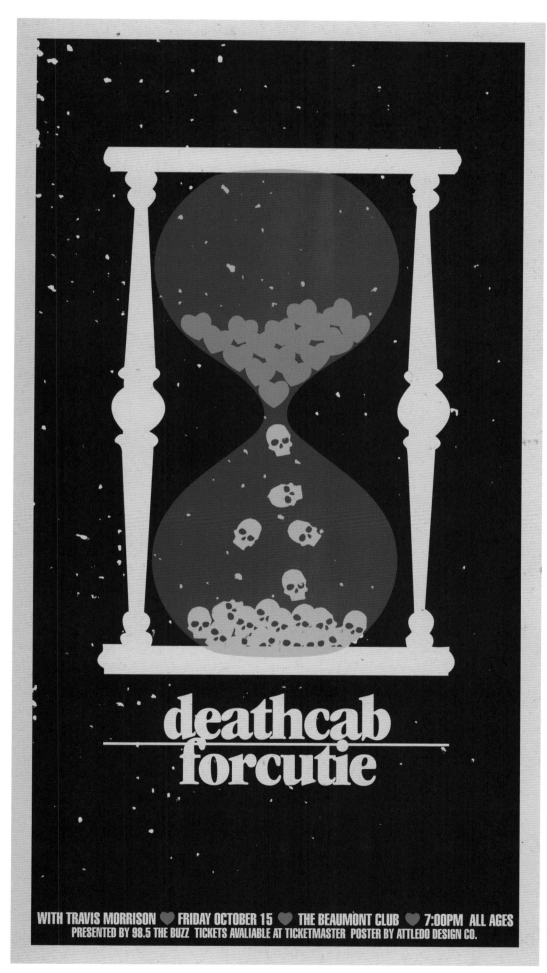

deathcab
forcutie

WITH TRAVIS MORRISON ♥ FRIDAY OCTOBER 15 ♥ THE BEAUMONT CLUB ♥ 7:00PM ALL AGES
PRESENTED BY 98.5 THE BUZZ TICKETS AVALIABLE AT TICKETMASTER POSTER BY ATTLEDO DESIGN CO.

2004 3-COLOR SILKSCREEN 13 X 24 INCHES

After moving from Chicago to San Diego in 1996, Michael Buchmiller started *Hand Carved Magazine*, a publication that focuses on independent music. Shortly thereafter came Hand Carved Radio and Hand Carved Graphics, whose first concert poster promoted Pretty Girls Make Graves. Within two months, Buchmiller was doing all the concert posters for Chain Reaction, an all-ages venue in Anaheim, California. Hand Carved Graphics is now a partnership with Mark Kearns, and the firm handles everything from website production to apparel design. Their work has been displayed in art shows across the country and in the *Art of Modern Rock: The Poster Explosion, Panda Meat,* and *Electric Frankenstein!: High-Energy Rock & Roll Poster Art.*

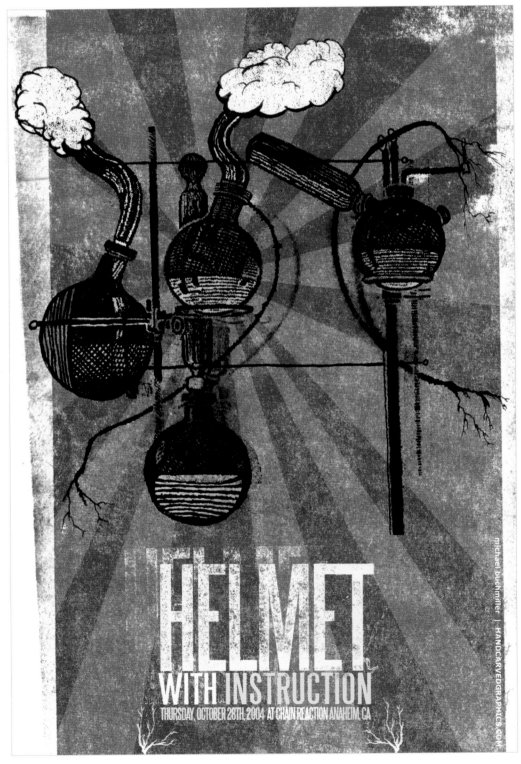

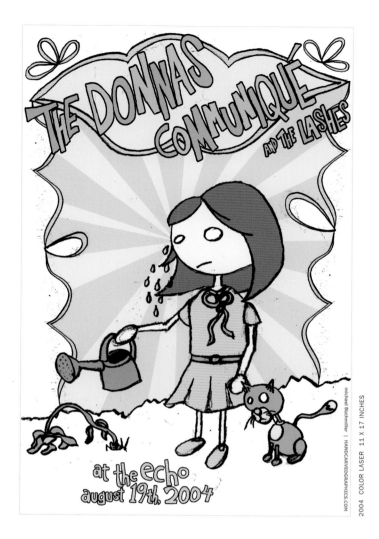

michael buchmiller | HANDCARVEDGRAPHICS.COM

2004 COLOR LASER 11 X 17 INCHES

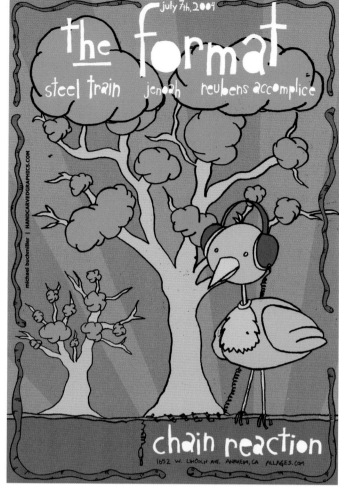

michael buchmiller | HANDCARVEDGRAPHICS.COM

2004 COLOR LASER 11 X 17 INCHES

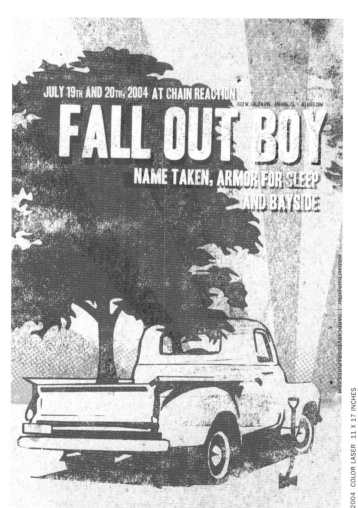

michael buchmiller | HANDCARVEDGRAPHICS.COM

2004 COLOR LASER 11 X 17 INCHES

michael buchmiller | HANDCARVEDGRAPHICS.COM

2004 COLOR LASER 11 X 17 INCHES

Aiming to integrate the music and art scene in a collusion of sound and image, Jeff Holland, the man behind Cryptographics, has designed more than 500 posters and flyers for concerts in the Boulder/Denver area since 1993. The posters have been seen on kiosks and in hip record stores like Barts, Albums On the Hill, Wax Trax, and Twist & Shout. Some are framed at The Fillmore in Denver. Holland is also host to Radio 1190's Route 78 West, a program that features old 78s, and he plays in the electronic band Multicast. Recorded the night of the events, selected live performances from Holland's archive were played at the opening of his most recent poster show to demonstrate the connection between posters and performances.

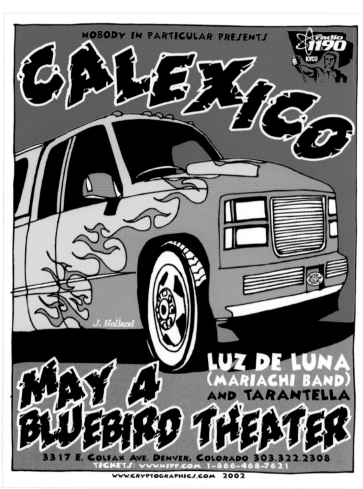

2002 SILKSCREEN 18 X 23 INCHES

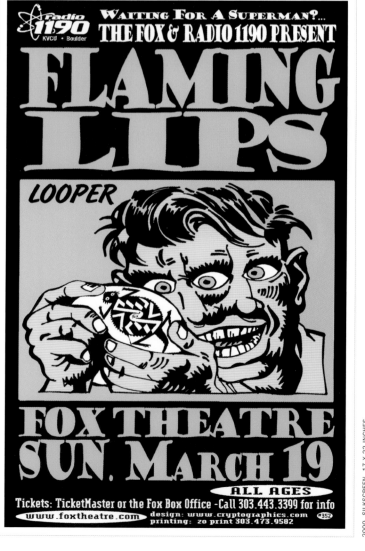

2000 SILKSCREEN 17 X 22 INCHES

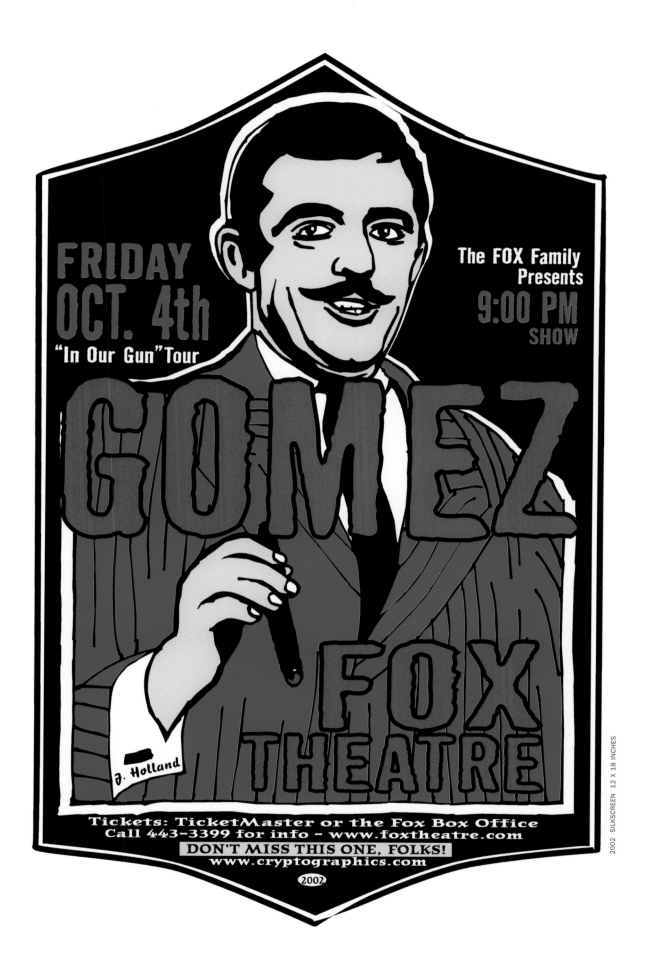

Born in 1973 and raised in New Orleans, Allen Jaeger was influenced early on by the horror genre of the late 1970s and 1980s. At the age of 16, he started working for a record label meeting many people he admired in the music scene. Over the years his work has evolved from rock posters to tour shirts and CD covers for bands like the Misfits and Skinny Puppy, to name a few. Jaeger believes his job is to deliver what he sees as a fan of the music to the paper, all with the help of a hand-operated two-clamp press built from scratch on an old coffee table. Jaeger works for the band, the fans, and himself. His ultimate goal and reward: artwork that promotes the band in a proper representation and makes a connection between the fan and the music.

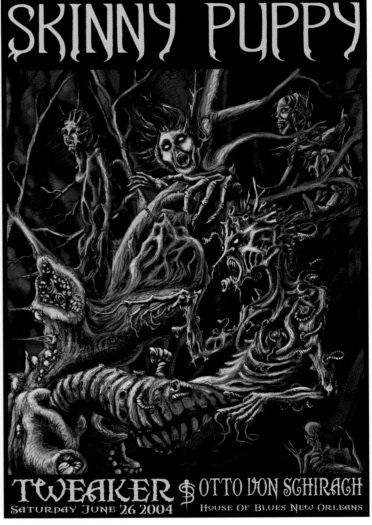

2004 26-LAYER SILKSCREEN 18 X 26 INCHES EACH

MINISTRY

MY LIFE WITH THE THRILL KILL KULT

HANZEL UND GRETYL, MONDAY, SEPTEMBER 13
HOUSE OF BLUES 225 DECATUR ST. NEW ORLEANS, LA

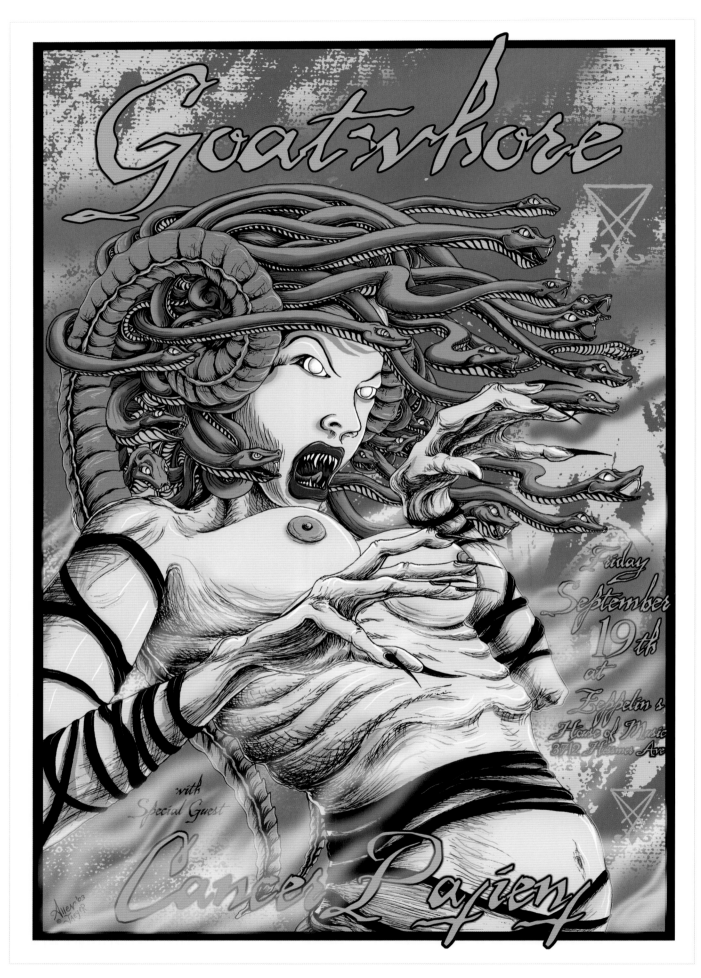

2002 13-LAYER SILKSCREEN 18 X 26 INCHES

Chicago-born Nels Jacobson, aka Jagmo, has been creating distinctive hand-drawn and hand-cut poster designs for twenty-five years. Lured to Texas in the late 1970s by Austin's active music scene and the absence of sub-zero temperatures, Jagmo drew inspiration from Austin poster pioneers Franklin, Priest, Juke, Garrett, Narum, Yeates, and Awn, and he worked predominantly with Bee-Bop Screen-Printing and offset printer Terry "Speleo" Raines. Because his print runs were small and most posters were distributed in advance of the shows, many sought-after pieces are now difficult to find. In addition to working with countless bands, clubs, and promoters, Nels helped organize the Texas-U.S.S.R. Musicians' Exchange in 1987 and served for many years as art director for the annual SXSW Music Conference. After retreating to the comparative serenity of law school in 1992, he now lives in San Francisco where he remains active in the poster community, hobnobs with other poster artists, and creates the occasional poster.

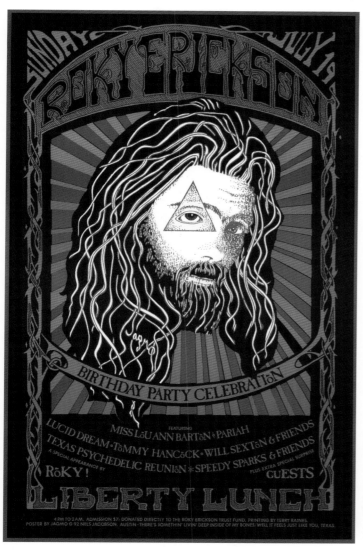

1992 OFFSET 11 X 17 INCHES

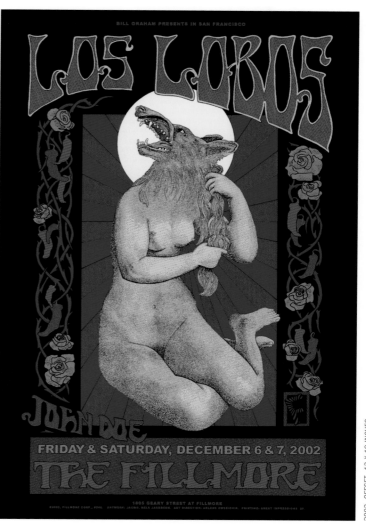

2002 OFFSET 13 X 19 INCHES

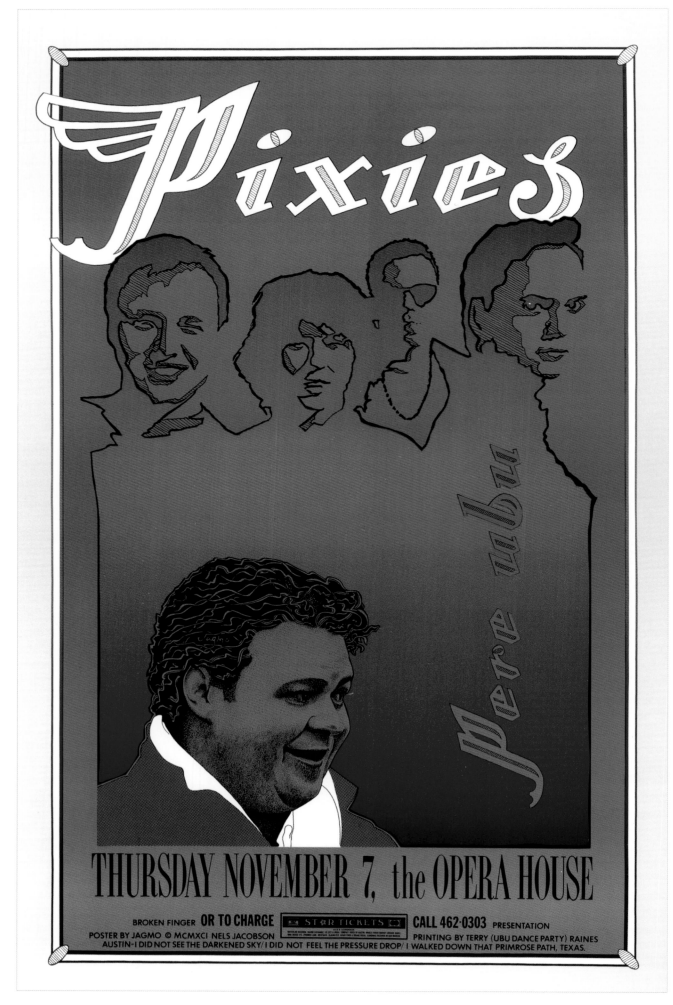

1991 OFFSET 11 X 17 INCHES

The founder of Stereotype Design in New York City, Mike Joyce was formerly art director at MTV Networks and creative director at Platinum Design. He has designed many projects in the music and entertainment fields, including the J Records logo and Iggy Pop's new album, *Skull Ring*. His work has been featured in *Communication Arts'* Fresh section, *print*'s 20 Under 30 issue, AIGA's Soundblast exhibitions, the One Club's One Show, the Art Directors Club's first Young Guns show, and the Permanent Collection of the Library of Congress. In 2004 Joyce was named co-chair of the Art Directors Club's Young Guns 4. He teaches typography and design at the School of Visual Arts in Manhattan.

2004 SILKSCREEN 18 X 24 INCHES

2003 SILKSCREEN 18 X 24 INCHES

FALL
OUT
BOY

AUGUST 2ND 2003
WICKER PARK FEST
CHICAGO ILLINOIS

2003 SILKSCREEN 18 X 24 INCHES

2003 SILKSCREEN 18 X 24 INCHES

Guy Juke was born in San Angelo, Texas, in 1951 and, encouraged in art studies by his architect father, moved to Austin in 1972. There he hung around the local music scene, the Armadillo World Headquarters especially, and gained exposure to the music poster community. It wasn't long before he was producing concert posters for the likes of Frank Zappa, Ricky Lee Jones, Talking Heads, and too many more to mention, plus illustrations for local magazines and album covers. Juke has won many awards for his designs, including one from AIGA. His classic series of silk-screened posters for local events such as Carnaval and the Austin Chronicle Music Awards are coveted collector's items that hang proudly in hipsters' homes all over the world.

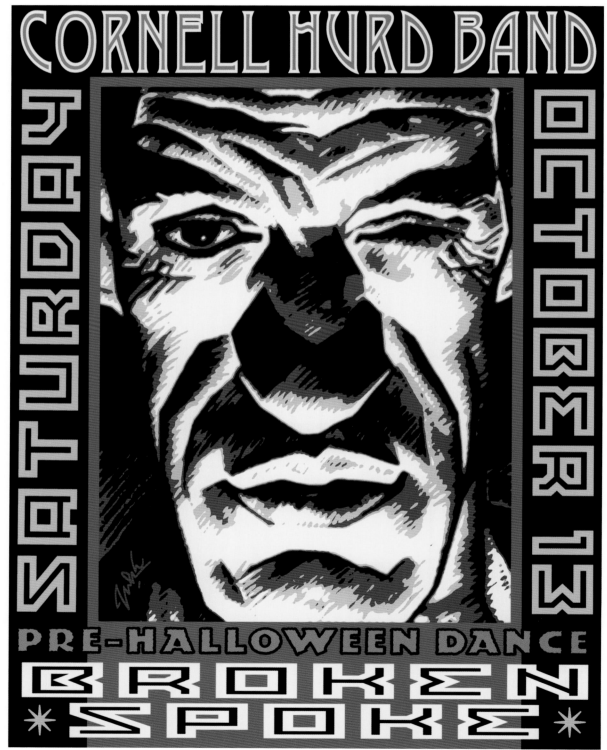

2002 OFFSET 13 X 19 INCHES

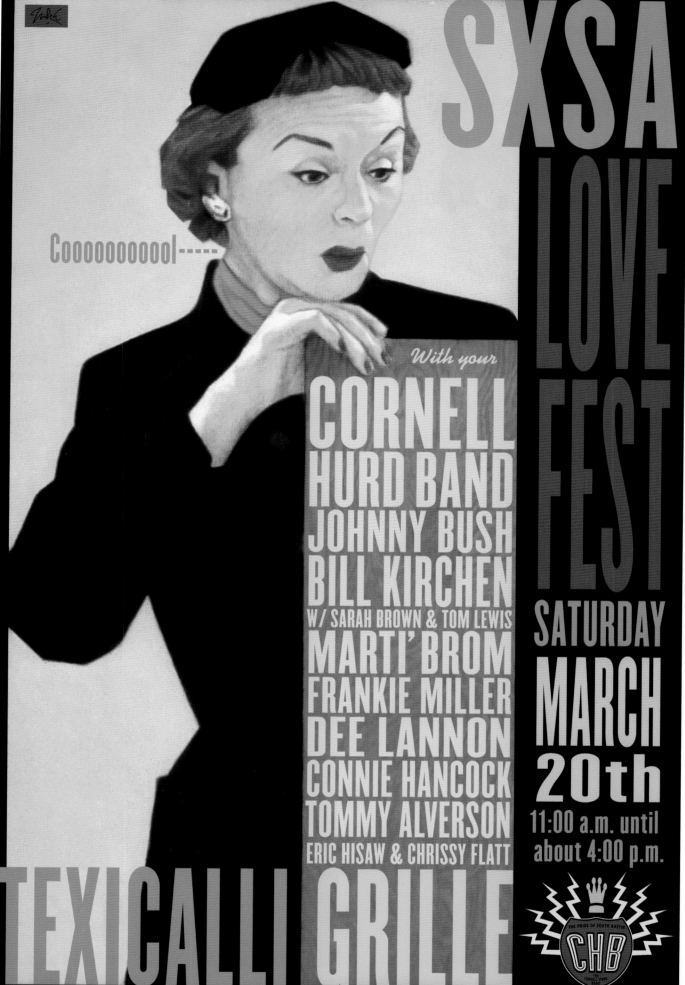

Coooooooooool-----

SXSA LOVE FEST

With your
CORNELL HURD BAND
JOHNNY BUSH
BILL KIRCHEN
W/ SARAH BROWN & TOM LEWIS
MARTI' BROM
FRANKIE MILLER
DEE LANNON
CONNIE HANCOCK
TOMMY ALVERSON
ERIC HISAW & CHRISSY FLATT

TEXICALLI GRILLE

SATURDAY MARCH 20th
11:00 a.m. until about 4:00 p.m.

THE PRIDE OF SOUTH AUSTIN
CHB
THE CORNELL HURD BAND

Born in 1977 in Valencia, Spain, Leviathan grew up in a family of artists, always surrounded by pencils and paint. Wild rock and roll, American comics, femmes fatales, and pop-art graphics, all inspire Leviathan's graphic art. His work invokes the United States in the 1950s and 1960s: the glamour of stars of the cinematographic firmament, and the allure of riding a Harley while listening to rock and roll. Designs by this underground icon appear on posters and album covers, and since 1997, on signed T-shirts. Nowadays, his clothing designs have a cult following with rock and film stars alike. He combines his passion for creating and drawing posters and covers with his work at an advertising agency.

2004 SILKSCREEN 26 X 37-1/2 INCHES

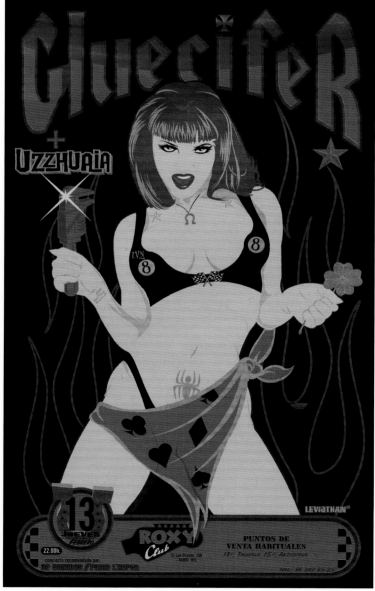

2003 SILKSCREEN 15-3/4 X 24-3/4 INCHES

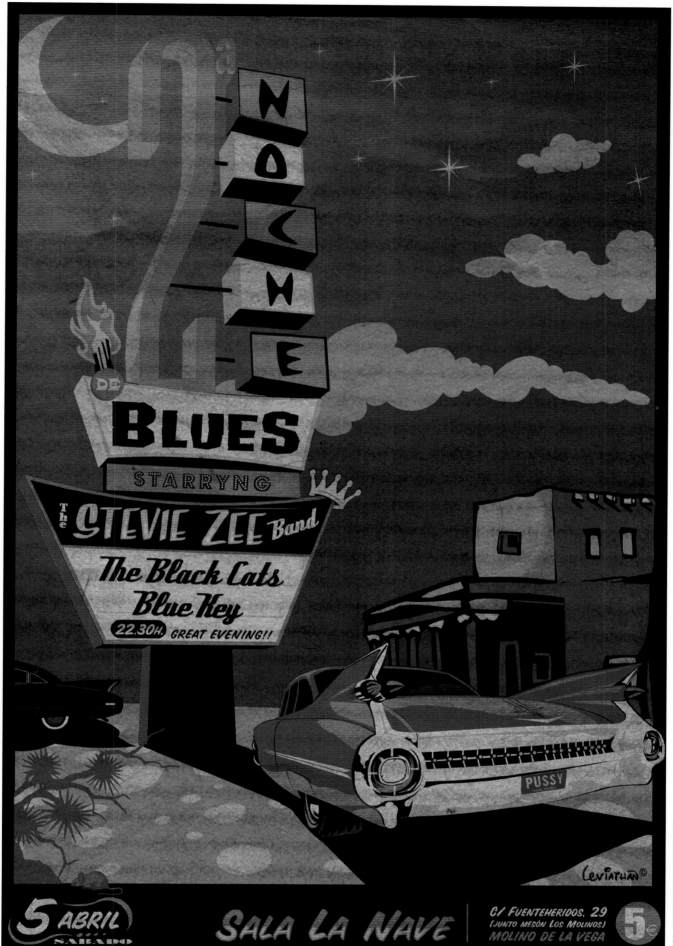

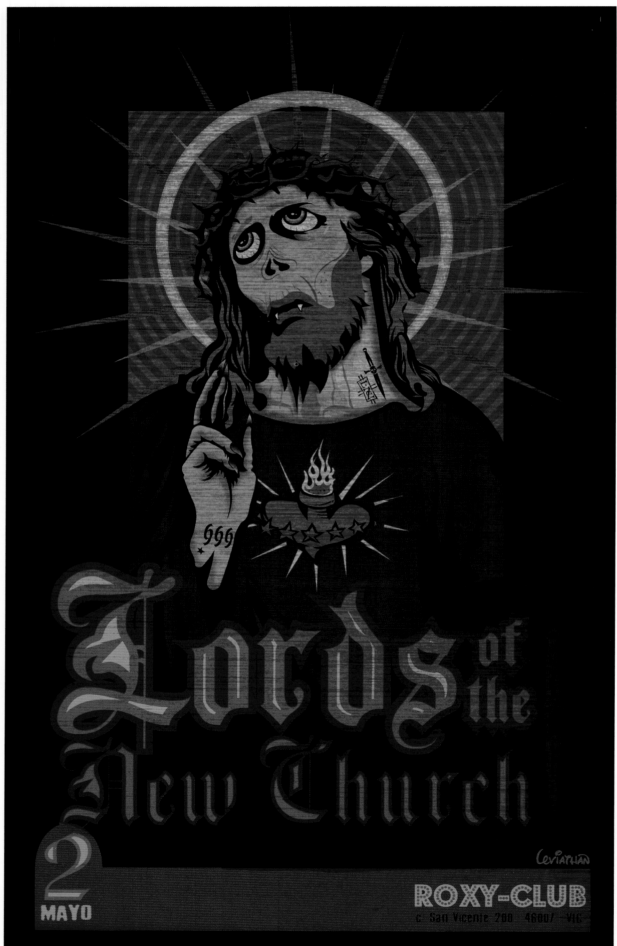

2003 SILKSCREEN 15-3/4 X 24-3/4 INCHES

Born and raised in New Jersey in 1967, Ron Liberti was fired from his first job when he blew off work to see The Ramones. His future foretold, Liberti studied art and film at Montclair State in New Jersey and went on to study printmaking in Brighton, England. In 1991, he moved to Chapel Hill, North Carolina.

There a thriving gush of local music and art inspired him to form the band Pipe and begin making posters. Liberti has designed posters for hundreds of shows, printed thousands by hand, and is proud of the tactile quality of his work and the stylistic integrity that links the homemade music he loves with the posters'

bold intuitive images. His work has been shown worldwide. Now based in Carrboro, North Carolina, as a freelance designer/poster maker, Liberti is a co-founder of Hypno-Vista Records and a member of the bands The Ghost of Rock, Bringerer, and Poncho Holly's Bullfight Party.

2003 PHOTOCOPY AND RED SHARPIE ON BACK 11 X 17 INCHES

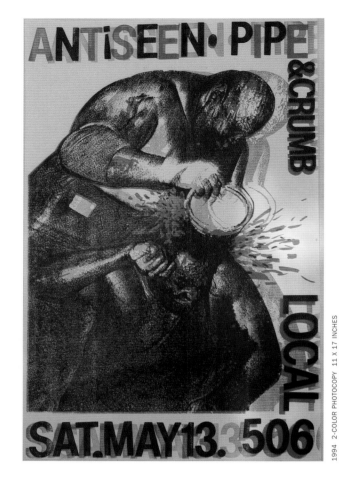

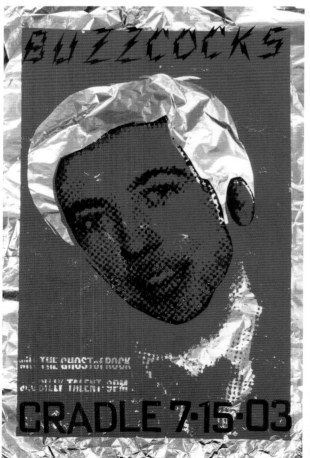

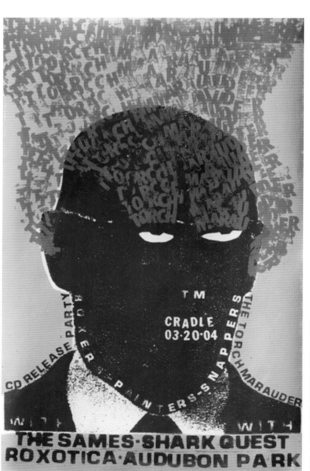

In July 2002, Lil Tuffy commenced designing and hand-screening posters to combat his self-diagnosed Attention Deficit Disorder and to satisfy his hunger for sharing his artistic vision with the world. Later that year, he was taken under the wing of living rock-art legends Chuck Sperry and Ron Donovan and their infamous Firehouse. There he explored the rock and roll psyche, posing young ladies in gossamer garments with semiautomatic firearms in posh lofts, beside fog-kissed windows, along sordid city streets. The juxtaposition of delicate natural beauty with steadfast matter is a key element of Lil Tuffy's unique style and popular appeal. From simple typography to stark photography, his work contrasts an ethereal vulnerability that one wants to protect with an inherent strength that one wants to master. In this way, he feels, he captures the essence of the poster mystique.

2004 SCREENPRINT 19 X 25 INCHES

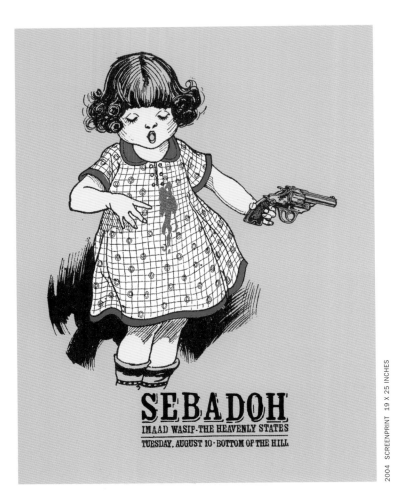

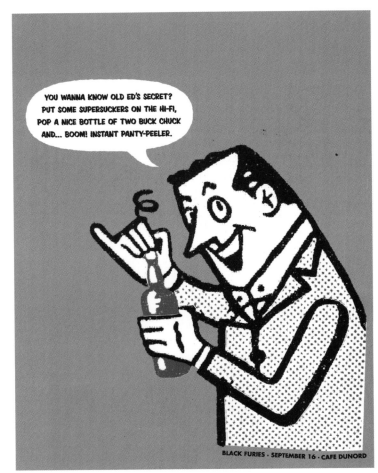

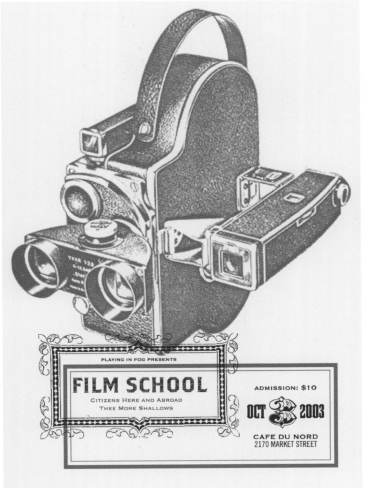

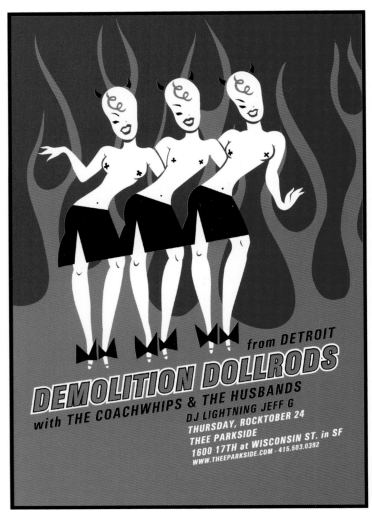

BRAID RECOVER · MONEEN · EMANUEL
7·15 BOTTOM OF THE HILL

2004 SCREENPRINT 19 X 25 INCHES

Lonny Unitus began making posters in the mid-1990s to promote the small local scene in Fargo, North Dakota. Most of that work, small black and white photocopied flyers, was for local bands. After moving to Mississippi, Lonny Unitus created posters and other promotional material for big acts like Willie Nelson, ZZ Top, and Merle Haggard. Still searching for a creative outlet, he went back to his contacts in Fargo and began designing gigposters screen-printed by his friend Justin Seng. The amazing networking of gigposters.com has subsequently led Lonny Unitus to design posters for shows across the United States and in Europe. Now based in Minneapolis, he still works with Seng in Fargo, and has begun doing his own screen-printing with a collective of other Minneapolis poster artists.

2003 OFFSET 11 X 17 INCHES

2003 2-COLOR SCREENPRINT 11 X 21 INCHES

2004 OFFSET 11 X 17 INCHES

TRACY AND THE PLASTiCS WiTH THE QUiLS Qail BaRR and GUiTaN MAGEDDON THUrSAPRIL22 PLAiNSART MUSEUM $7ALLAGES!! 7:30 PM • 8:00 PM SHOW BAR FOR 21+ PRESENTED BY DM COOPERATIVE

7:30 PM • 8:00 PM SHOW BAR FOR 21+ PRESENTED BY DM COOPERATIVE

2004 2-COLOR SCREENPRINT 8-1/4 X 20 INCHES

A professional art lab devoted to rock music, Malleus extends its tentacles through a variety of artistic fields. Initially illustrators inspired by 1970s style, the Malleus wizards have moved on to design CD, LP, and magazine covers; videoclips, animations, paintings, T-shirts, and other merchandising items; and DVD projects, video projections, and websites. Today Malleus is the only Italian design firm whose handmade silk-screened rock posters have been exhibited worldwide, in Italy, Philadelphia, Rio de Janeiro, London, Los Angeles, San Francisco, Belgium, Germany, and Holland. Malleus has realized posters for Auf Der Maur, Bongzilla, Brant Bjork, The Cure, The Donnas, Mastodon, Earthlings?, Flaming Lips, Fu Manchu, Iggy Pop, Korn, Melvins, Monster Magnet, Motorpsycho, Muse, Nashville Pussy, Nina Nastasia, Sigur Ros, Spiritual Beggars, Tomahawk, Turbonegro, and Ufomammut.

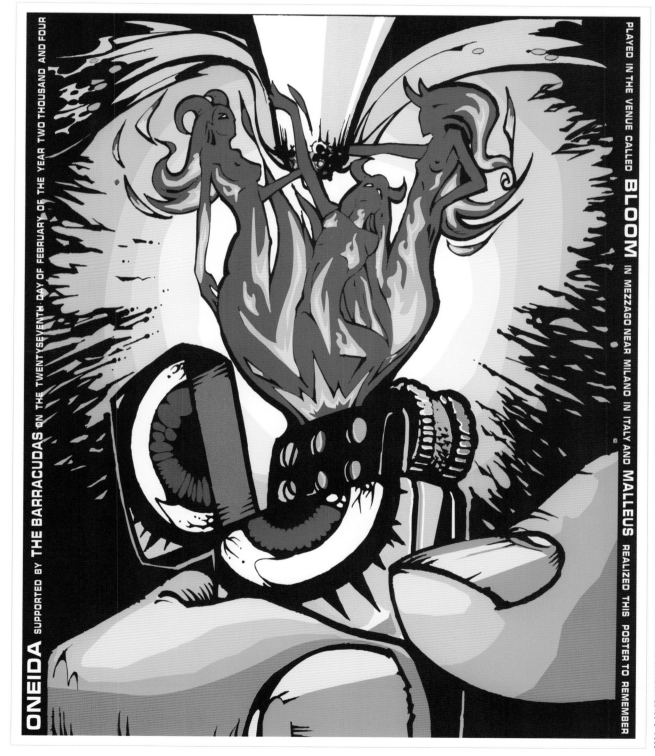

2004 3-COLOR HANDMADE SILKSCREEN 15-3/4 X 19-1/2 INCHES

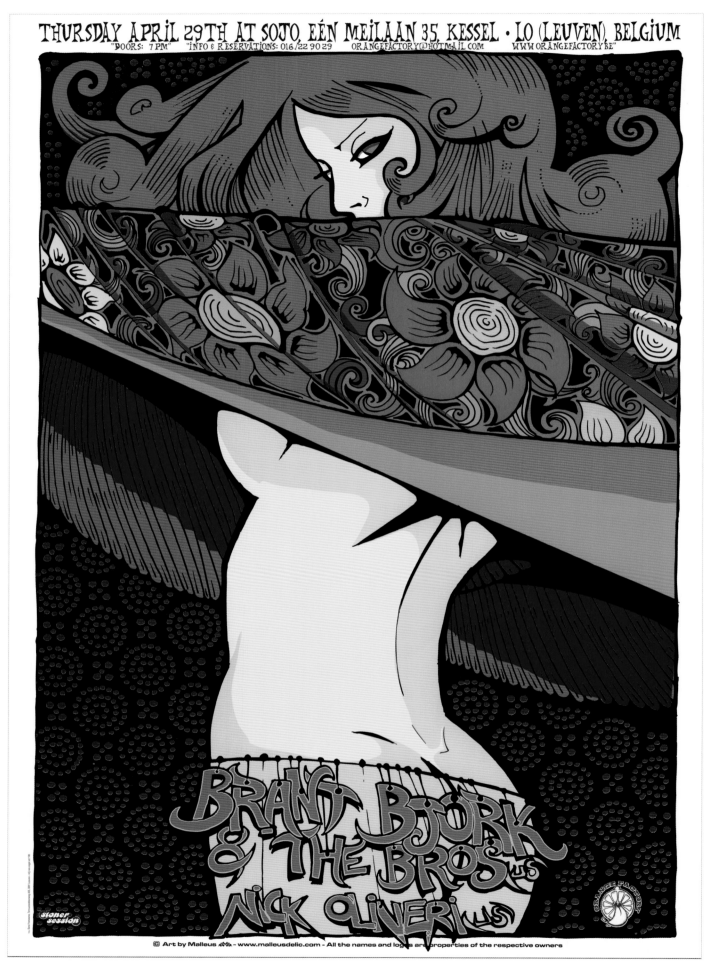

2004 OFFSET 19-1/2 X 27-1/2 INCHES

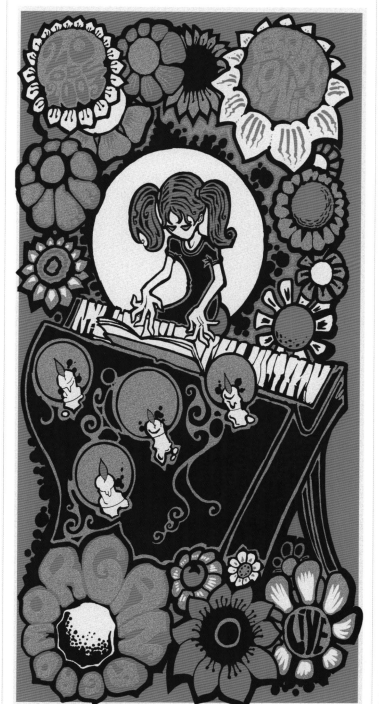

Dan McCarthy was born in 1976 on Cape Cod, Massachusetts. A big part of his life has always been making art and playing music. In the 1990s, he started playing in bands and making flyers to promote shows at local venues. At the age of eighteen, he moved to Boston to study at The School of The Museum of Fine Arts, where he began screen-printing and designing posters as well as painting and drawing. McCarthy's work explores the relationship between nature and technology and the cyclical nature of life and death. Since graduation, he has exhibited his work at local galleries, worked on community art projects, and designed numerous posters, CD covers, and T-shirts. Presently, he works as an artist and designer in his Jamaica Plain apartment and plays drums in the band Helms.

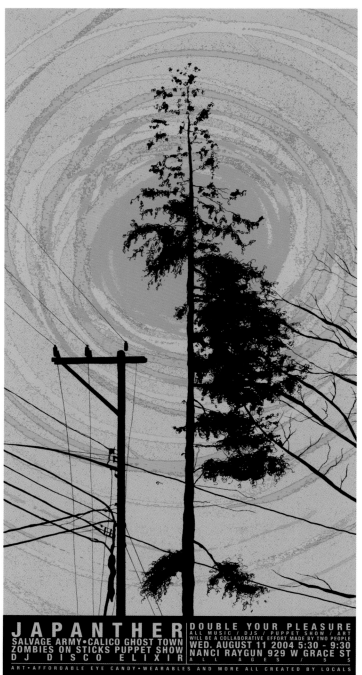

2004 3-COLOR SCREENPRINT 11 X 22 INCHES

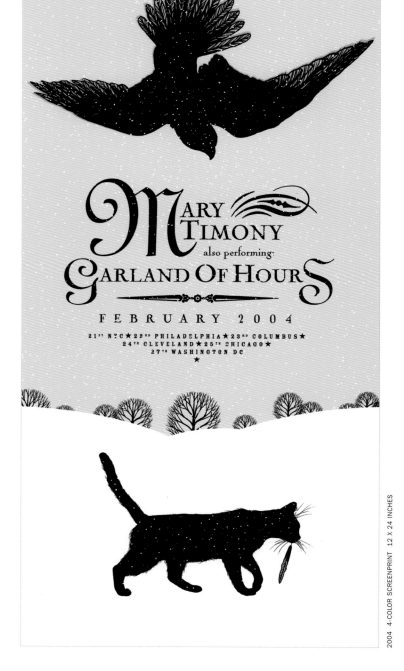

2004 4-COLOR SCREENPRINT 12 X 24 INCHES

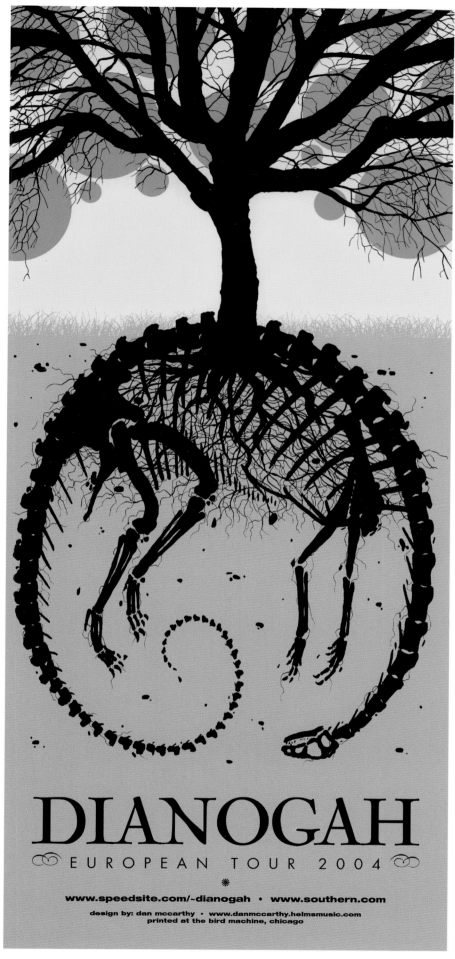

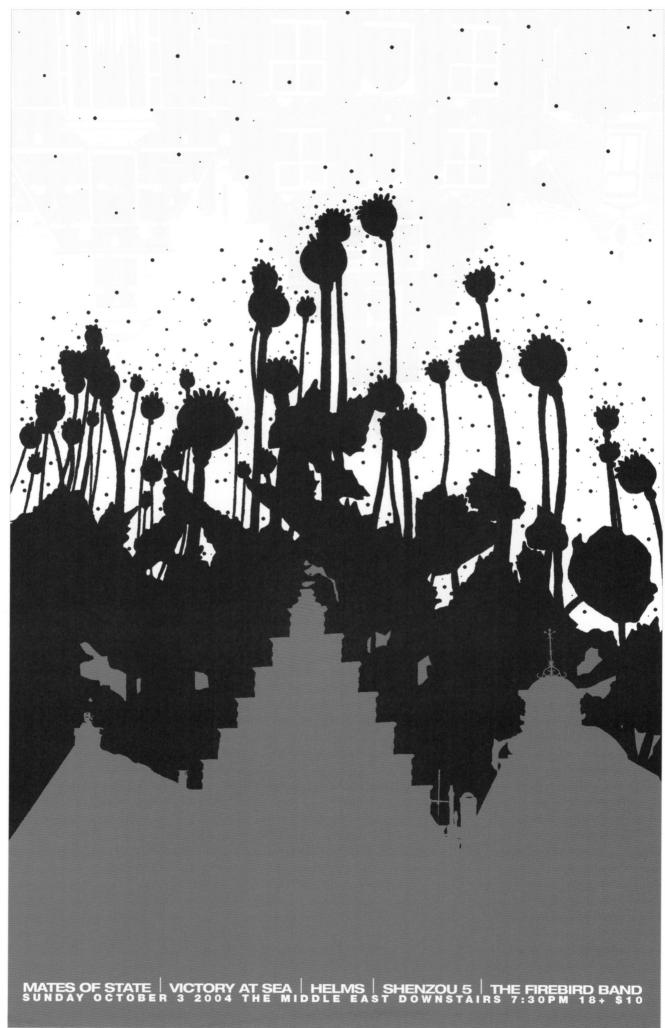

MATES OF STATE | VICTORY AT SEA | HELMS | SHENZOU 5 | THE FIREBIRD BAND
SUNDAY OCTOBER 3 2004 THE MIDDLE EAST DOWNSTAIRS 7:30PM 18+ $10

2004 3-COLOR SCREENPRINT 16 X 24 INCHES

After a brief stint operating a cotton candy machine, Tara McPherson made the transition to producing eye candy for the entertainment industry—which proved a much more exciting atmosphere. She has been creating rock posters for bands such as Beck, PJ Harvey, The Strokes, and Interpol for three years now. "The posters encompass two things I love most in life—art and music. I get a lot of creative freedom to create an image that works on different levels. It promotes the show for the band and, I hope, provokes an intellectual response from the viewers. There's a lot I want to say about human emotion, and posters are one medium that emotion works amazingly well with."

McPherson also paints comic-book covers for DC Vertigo Comics, and she's worked on major ad campaigns for companies like Fanta soda. She's shown her fine art paintings in such galleries as La Luz de Jesus, Tin Man Alley, and M Modern. Keep a lookout for McPherson toys and books in the near future!

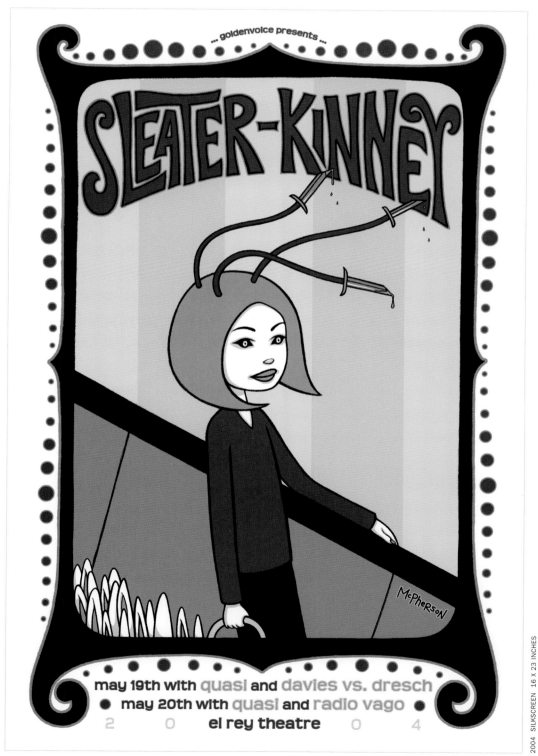

2004 SILKSCREEN 16 X 23 INCHES

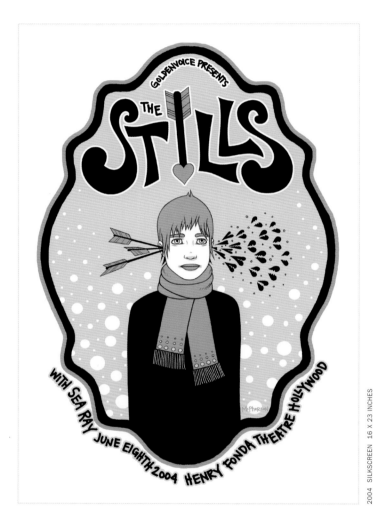

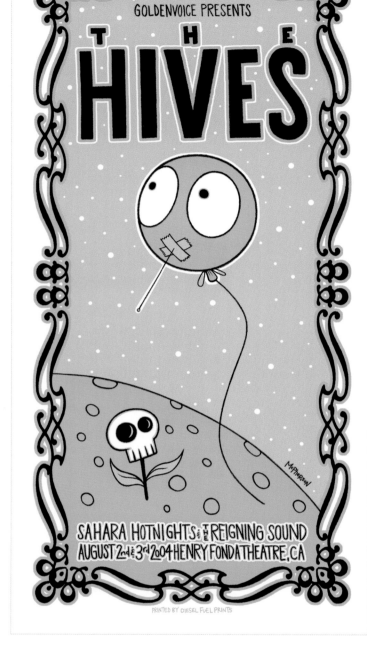

2004 SILKSCREEN 16 X 23 INCHES

2004 SILKSCREEN 12 X 23 INCHES

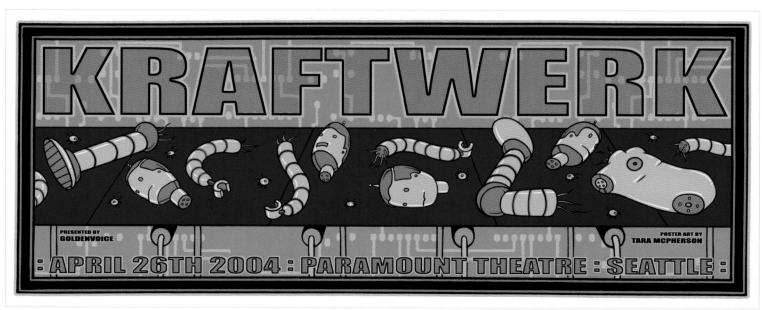

2004 SILKSCREEN 25 X 11 INCHES

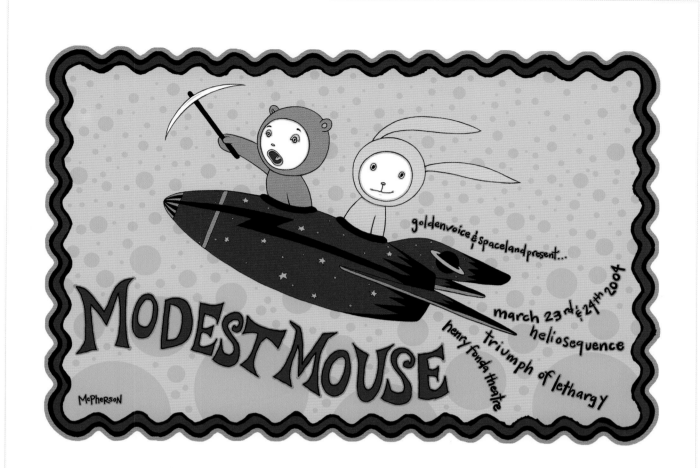

2004 SILKSCREEN 23 X 16 INCHES

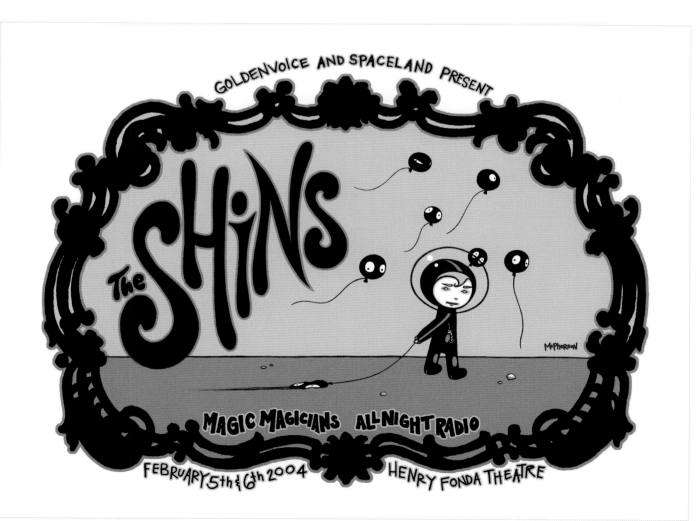

2004 SILKSCREEN 23 X 16 INCHES

From the deep corners of his basement studio, Kevin Mercer makes rock posters. Lots of them. He started Largemammal Print in 2002 with posters for Philadelphia area bands, promoters, and friends on a small scale. As he and his brother Brian, also a poster artist, continued to build the studio's resources, Mercer made the jump to larger print sizes through a chance meeting with The Heads of State, who were in desperate need of a printer. After doing full-sized posters for that studio, as well as other local and national artists, Largemammal Print blossomed as both a design studio and print shop. Mercer now focuses on designing and printing his own work, and he enjoys creating posters that are as interesting and challenging as the bands they promote.

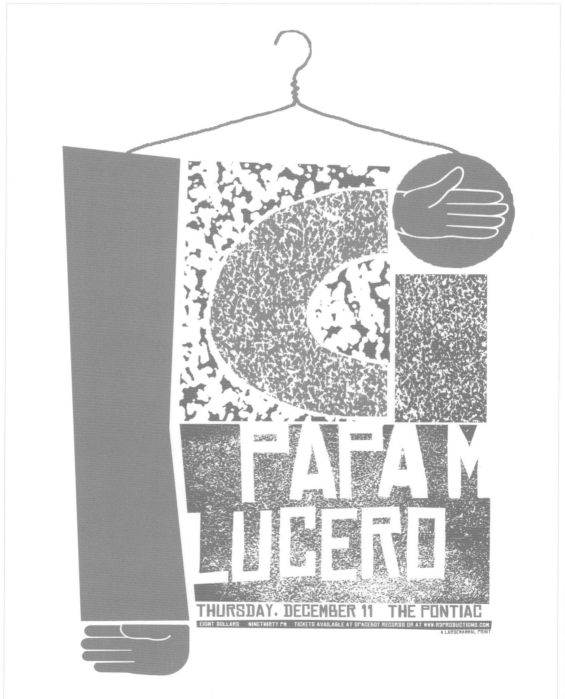

2003 SCREENPRINT 19 X 25 INCHES

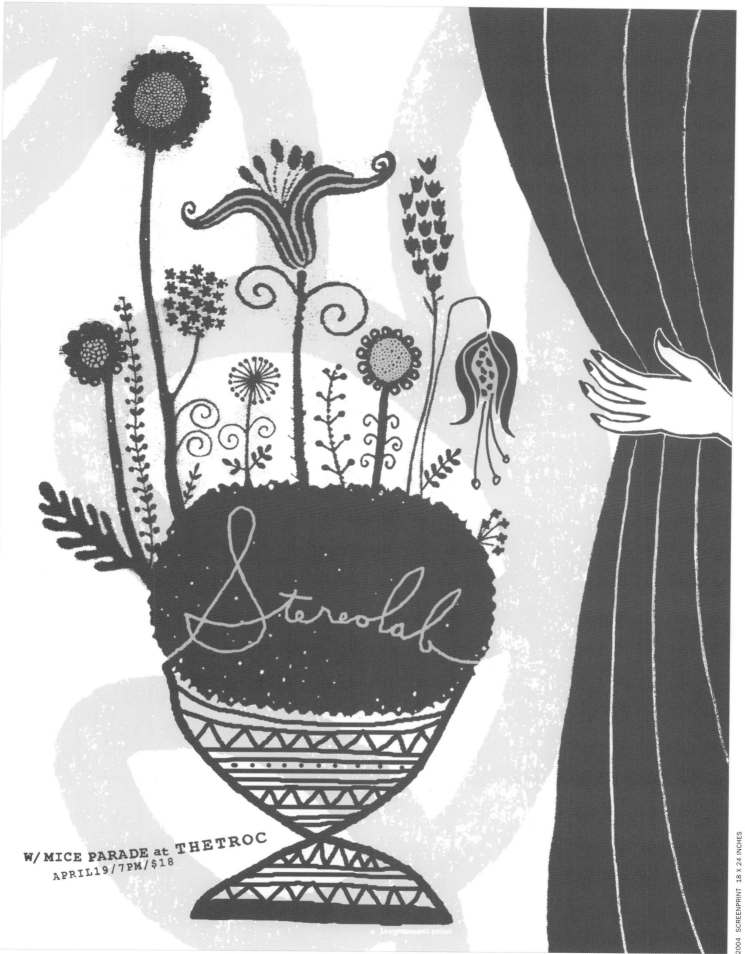

Stereolab

W/ MICE PARADE at THETROC
APRIL19/7PM/$18

a largemammal print

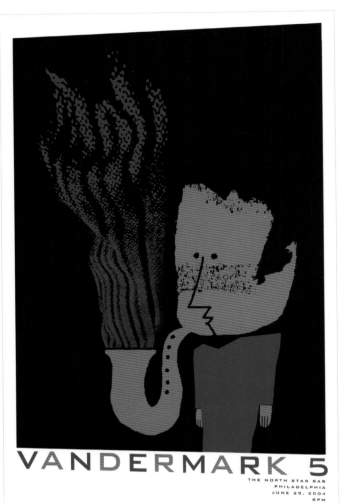

VANDERMARK 5

THE NORTH STAR BAR
PHILADELPHIA
JUNE 29, 2004
8PM

2004 SCREENPRINT 13 X 20 INCHES

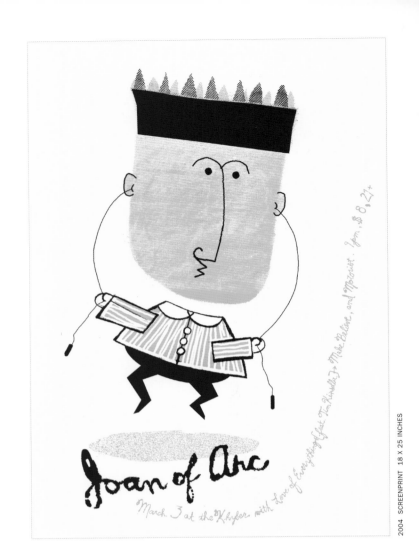

Joan of Arc

March 3 at the Khyfer with Love of Everything (feat Jim Kinsella)+ Mike Kinsella, and Motorist, 9pm, $8, 21+

2004 SCREENPRINT 18 X 25 INCHES

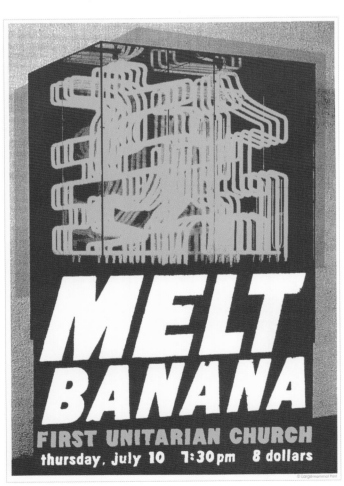

MELT
BANANA

FIRST UNITARIAN CHURCH

thursday, july 10 7:30pm 8 dollars

2003 SCREENPRINT 17-1/2 X 25 INCHES

WATCH THAT MAN.
I THINK HE'S BEEN EXPOSED TO...

HOT
SNAKES

with Mr Airplane Man & Two Tears
OCTOBER 7 AT THE NORTH STAR
7PM ALL AGES $10

WWW.LARGEMAMMALPRINT.COM

2004 SCREENPRINT 18 X 24 INCHES

Located in Atlanta, Georgia, Methane Studios was founded in 1998 by Mark McDevitt and Robert Lee for his band King Lear Jet. An obsession was born from those initial experiments and they soon began their quest into the world of limited-edition silkscreen prints after meeting Janet Ridgeway, owner of the hip club, The Echo Lounge, in East Atlanta. After silk-screening posters in a garage as an artistic outlet, the duo developed a reputation for unique, diverse styles, and worldwide poster sales ensued. Over the last few years they've been expanding the design projects they handle, and they hope their growing client list will put a little more methane in *your* life.

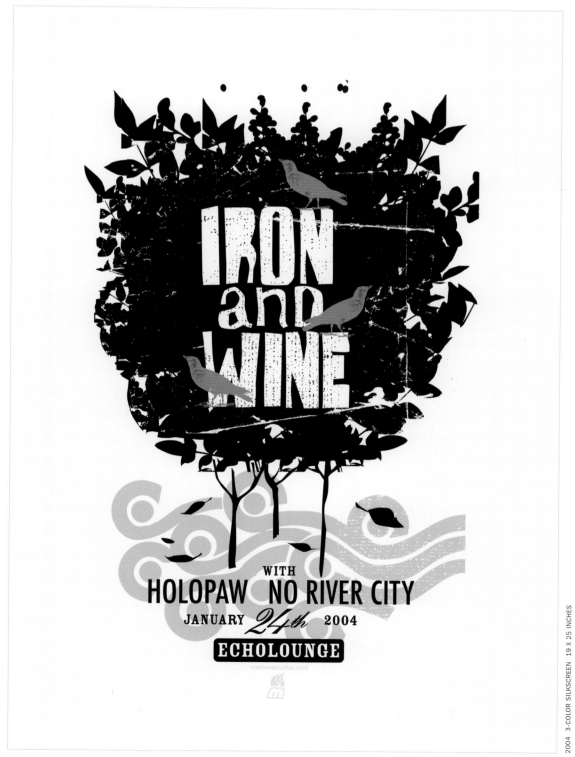

2004 3-COLOR SILKSCREEN 19 X 25 INCHES

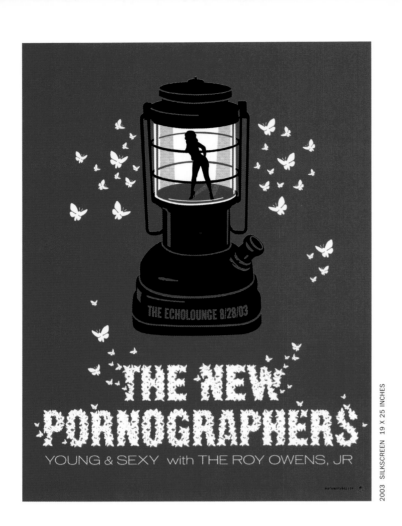

THE NEW PORNOGRAPHERS

YOUNG & SEXY with THE ROY OWENS, JR

2003 SILKSCREEN 19 X 25 INCHES

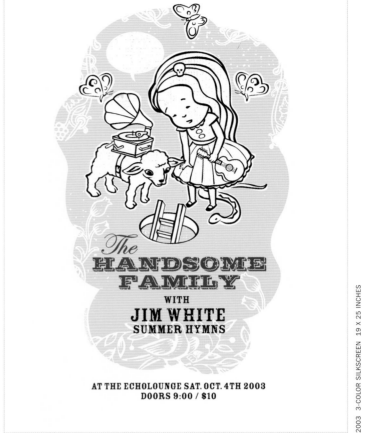

The HANDSOME FAMILY

WITH

JIM WHITE
SUMMER HYMNS

AT THE ECHOLOUNGE SAT. OCT. 4TH 2003
DOORS 9:00 / $10

2003 3-COLOR SILKSCREEN 19 X 25 INCHES

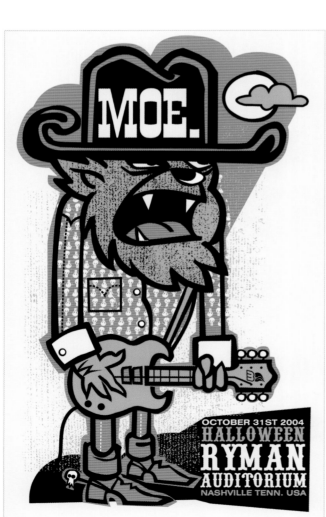

MOE.

OCTOBER 31ST 2004
HALLOWEEN
RYMAN
AUDITORIUM
NASHVILLE TENN, USA

2004 3-COLOR SILKSCREEN 16 X 25 INCHES

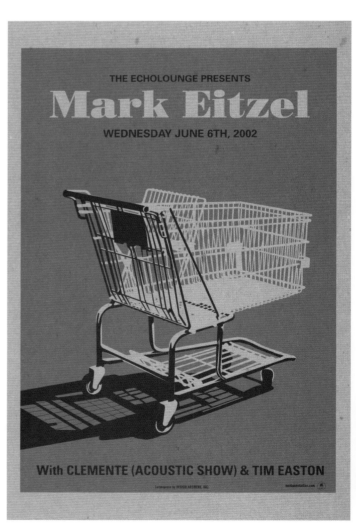

THE ECHOLOUNGE PRESENTS

Mark Eitzel
WEDNESDAY JUNE 6TH, 2002

With CLEMENTE (ACOUSTIC SHOW) & TIM EASTON

2002 SILKSCREEN 12 X 19 INCHES

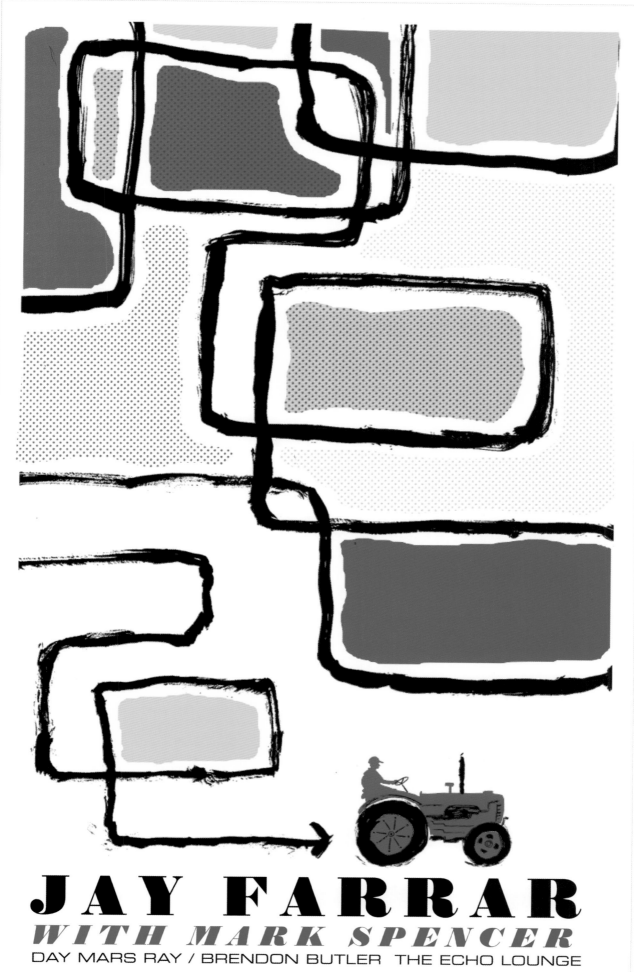

JAY FARRAR
WITH MARK SPENCER
DAY MARS RAY / BRENDON BUTLER THE ECHO LOUNGE

8/6/04

methanestudios.com

2004 SILKSCREEN 12 X 19 INCHES

Born in New Mexico, Michael Michael Motorcycle lives and works in Pasadena, California, where he continues to develop seeds of artistry planted by his grandmother, an accomplished painter who gave him his first brushes and colors when he was nine. Throughout the 1980s and 1990s he drew flyers for his own bands and those of his friends. Then he was bitten by the poster-making bug after seeing some of Coop's posters in local record shops. His early posters were digital offset prints, many of which incorporated his paintings. Not satisfied with the tactile qualities of offset printing, Michael Michael Motorcycle learned the craft of screen-printing posters from expert John Miner at his local college. He works from a cramped but efficient shop in his garage and basement, and for the last two years has been making posters for the Los Angeles production company Goldenvoice.

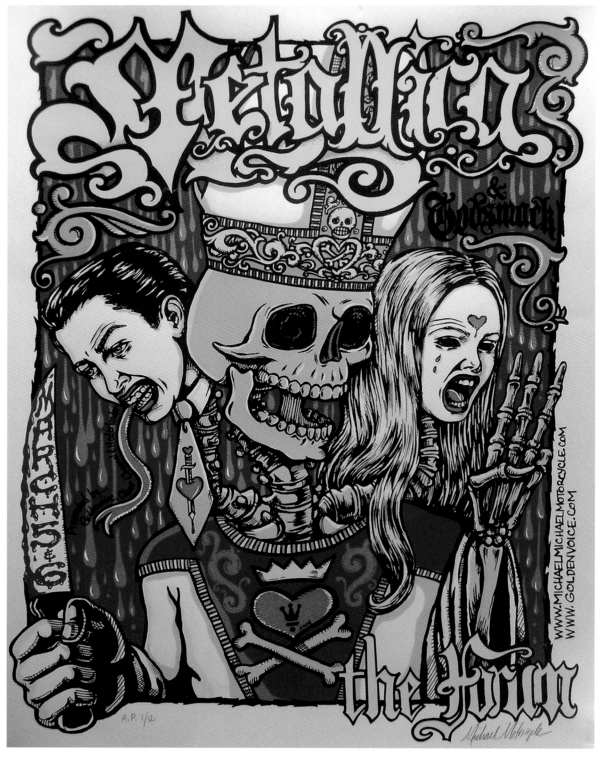

WWW.MICHAELMICHAELMOTORCYCLE.COM
WWW.GOLDENVOICE.COM

2004 5-COLOR SCREENPRINT 20 X 26 INCHES

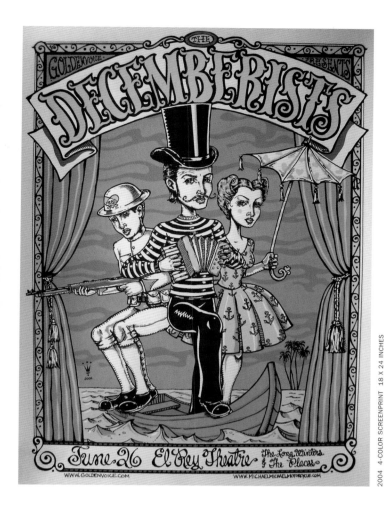

2004 4-COLOR SCREENPRINT 18 X 24 INCHES

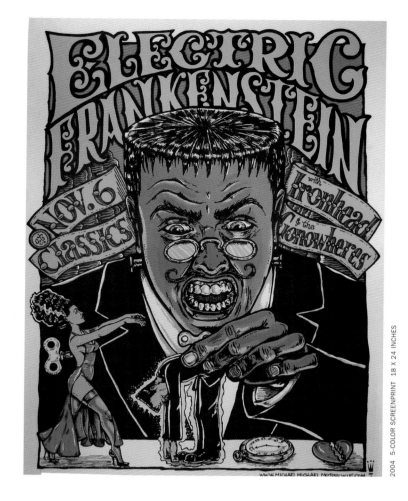

2004 5-COLOR SCREENPRINT 18 X 24 INCHES

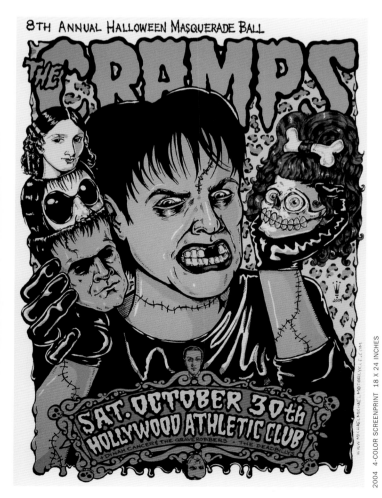

2004 4-COLOR SCREENPRINT 18 X 24 INCHES

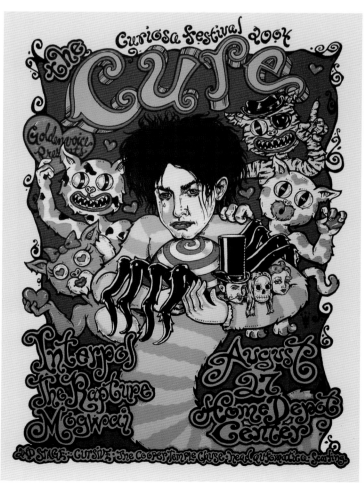

2004 5-COLOR SCREENPRINT 18 X 24 INCHES

Mixing styles and effects, Jeff Miller effortlessly melds his love for music and art to create poster, logo, and merchandise graphics for various bands and organizations. Based in Austin, Texas, he began by doing favors, and attracted attention from bands and fans alike; next came commissions to produce art for top names like Widespread Panic, Bob Dylan, and Willie Nelson. Other clients include 10,000 Lakes Festival, Oak Mountain Amphitheatre, Bill Bass Concerts, and Railroad Earth. Miller's designs are often sold by the bands and provide collectable mementos from Austin and far beyond. His work promotes bands and events in national magazines and alternative newspapers, and it was recently featured in the DVD *JamCam Chronicles*.

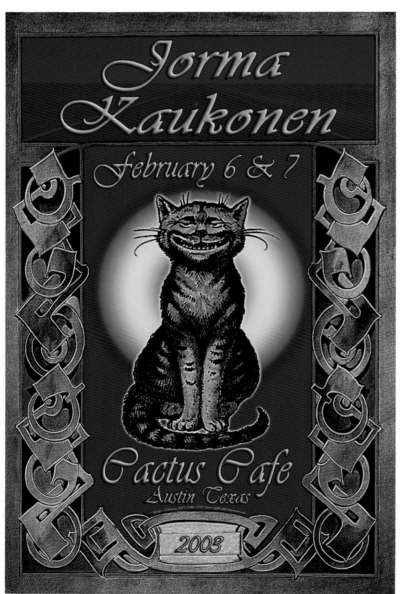

2003 OFFSET 11 X 17 INCHES

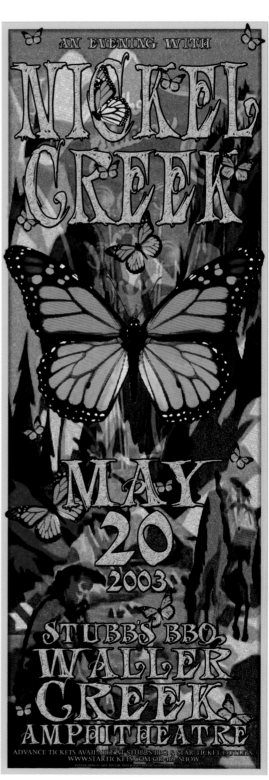

2003 OFFSET 6 X 17-1/2 INCHES

Mister Reusch is no good at screen-printing, but he loves painting, so the posters he's been creating for bands since late 1996 are all hand-painted acrylic, ink, and gouache on Bristol board. They're scanned into Photoshop to get the colors right, then digitally printed. Clients for this award-winning freelance illustrator include Burton Snowboards, Bauer-Nike, Llewellyn, *The Boston Globe*, Something Weird Video, and the World Famous Pontani Sisters, and he's created more than 500 illustrations for the Phoenix Media Group alone. His work has been exhibited across America and has appeared in several books. Mister Reusch makes masks, costumes, props, and glow-in-the-dark merchandise for two venues: Black Cat Burlesque, the troupe he and his tassel-twirling partner Miss Firecracker founded in 2003 to revive classic spook shows, and Miss Firecracker's masked female wrestling league, La Gata Negra. Their Boston terrier's name is Frankenstein.

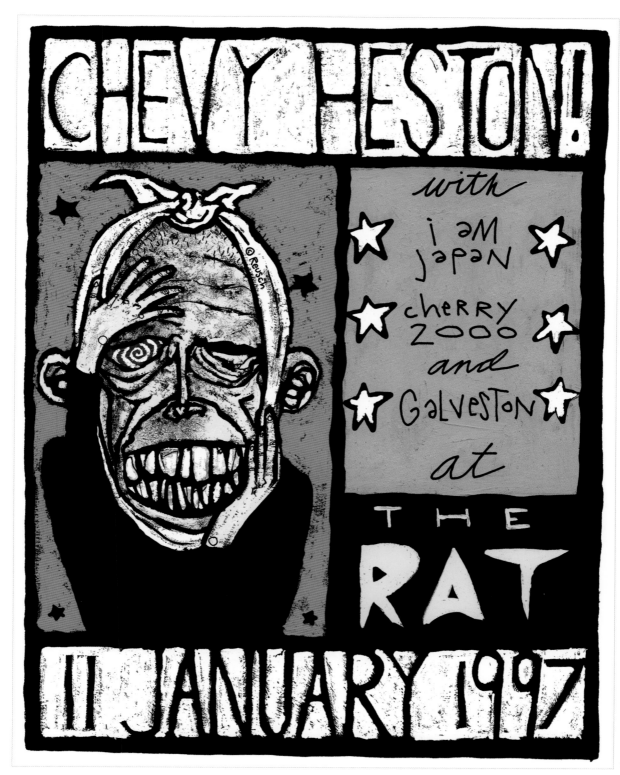

1997 DIGITAL PRINT FROM GOUACHE PAINTING 8-1/2 X 11 INCHES

103

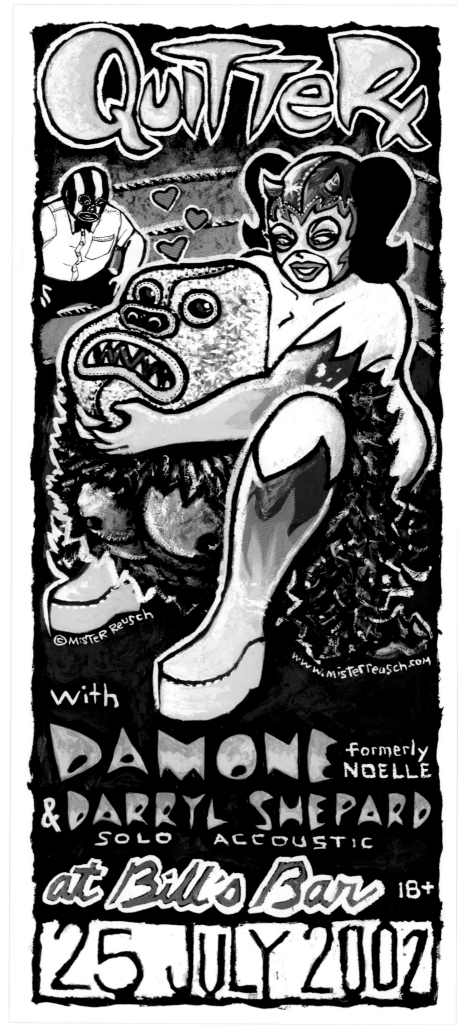

2002 DIGITAL PRINT FROM ACRYLIC PAINTING 5-1/2 X 17 INCHES

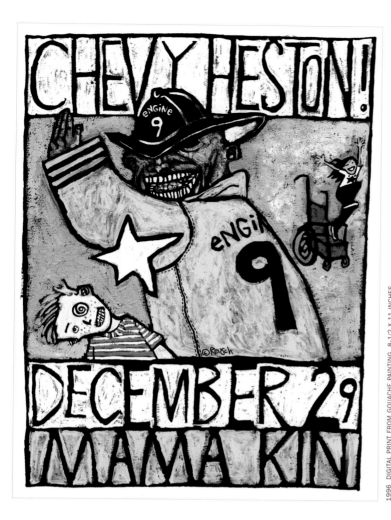

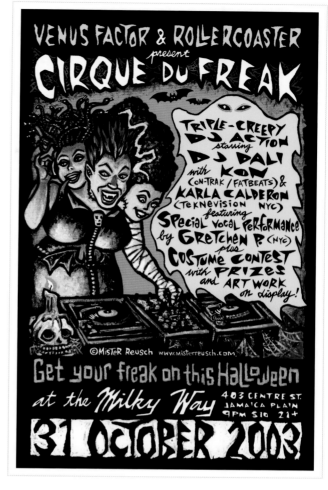

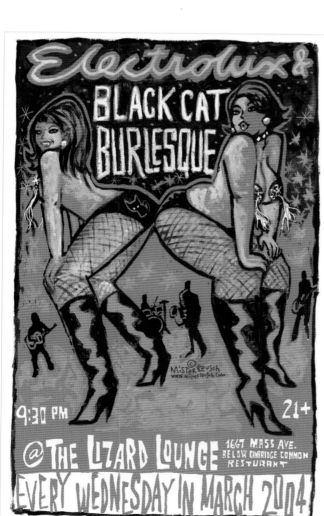

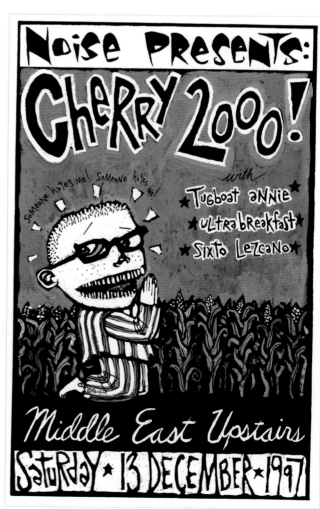

Currently vice-president of creative for Virgin Records America in New York City, Sean Mosher-Smith co-owns Slow Hearth Studio with his wife Katie. Operating out of Brooklyn since 1992, the studio boasts an extensive portfolio of work in graphic design, photography, photo illustration, and typography, and the intriguing ways the disciplines merge in the digital age. The studio has created everything from websites and CD packaging to book covers and editorial photography for clients such as *Time* magazine, the *Village Voice*, RCA Records, Viacom, Avon Books, MTV, Universal Records, and Warner Bros. Slow Hearth's design and photography have been displayed in *Communication Arts*, The Art Directors Club of New York's Young Guns 1 exhibit, *IDEA* magazine, *Photo District News, Cool Type 2, Visible Music, FOUNDation*, and *IdN*. The studio has won *Communication Arts* photography awards, *PDN* photography awards, and most recently an Alex award for packaging.

2002 4-COLOR OFFSET 24 X 36 INCHES EACH

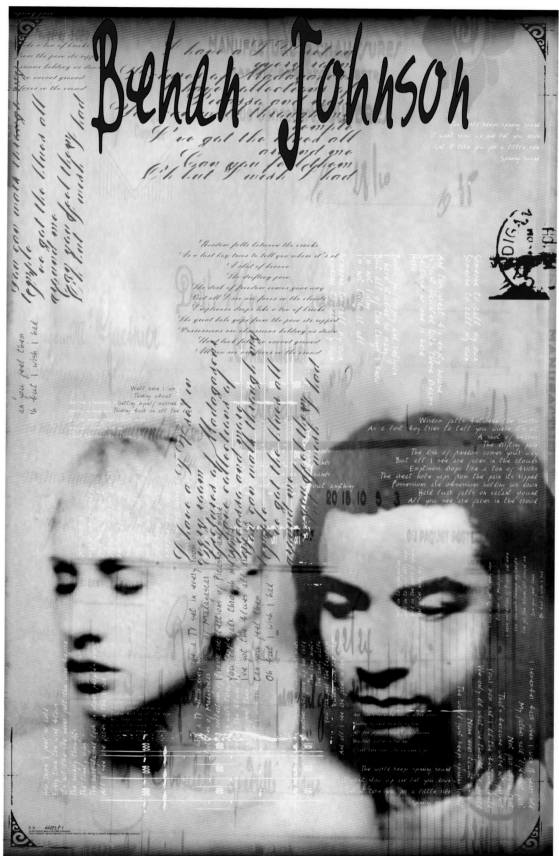

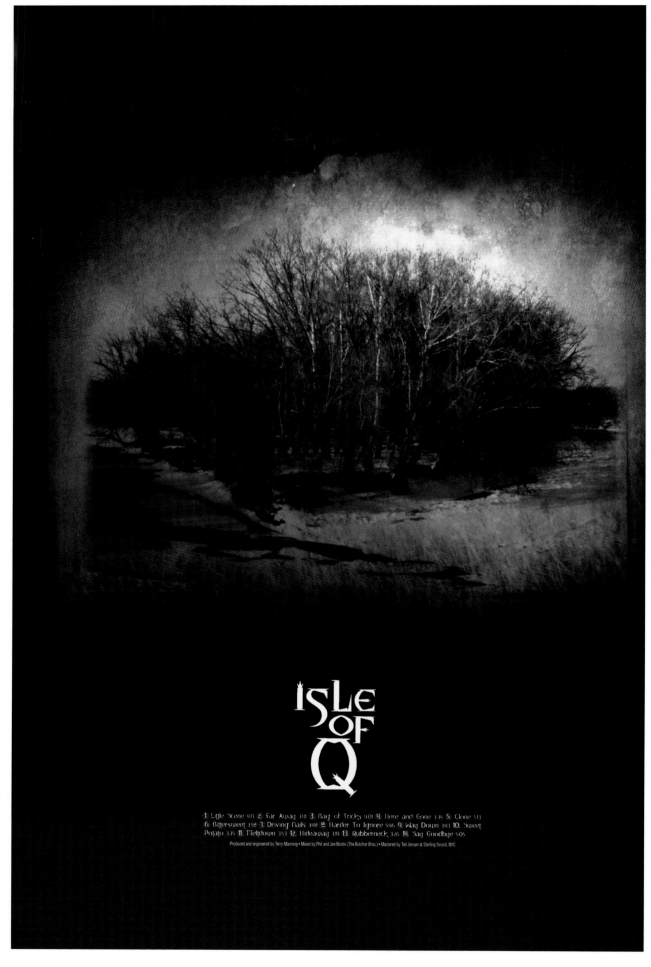

ISLE OF Q

1. Little Scene 4:11 2. Far Away 3:41 3. Bag of Tricks 4:01 4. Here and Gone 3:41 5. Clone 5:11
6. Bittersweet 3:52 7. Driving Nails 3:42 8. Harder To Ignore 5:16 9. Way Down 3:41 10. Sweet
Potato 3:35 11. Meltdown 3:53 12. Hideaway 3:11 13. Rubberneck 3:26 14. Say Goodbye 5:05

Produced and engineered by Terry Manning • Mixed by Phil and Joe Nicolo (The Butcher Bros.) • Mastered by Ted Jensen at Sterling Sound, NYC

2001 4-COLOR OFFSET 18 X 24 INCHES

If you grow up in Wisconsin and own eleven Ramones tapes in seventh grade, you can bet the story of your life is going to be interesting. Meet Jason Munn. In high school he was that kid—you know the one: he didn't say a word and, at the lunch table, fit snugly between the seven-foot rocker and the guy in the raccoon-skin hat. Ten years later, it's no surprise that Munn turns out products for bands who resemble those lunch-table kids. After making his first poster only two years ago, in an Oakland, California, warehouse, Munn now runs The Small Stakes, a studio that has established him as a respected designer who provides products for bands and commercial work for such non-music companies as Random House publishing and the local pizzeria.

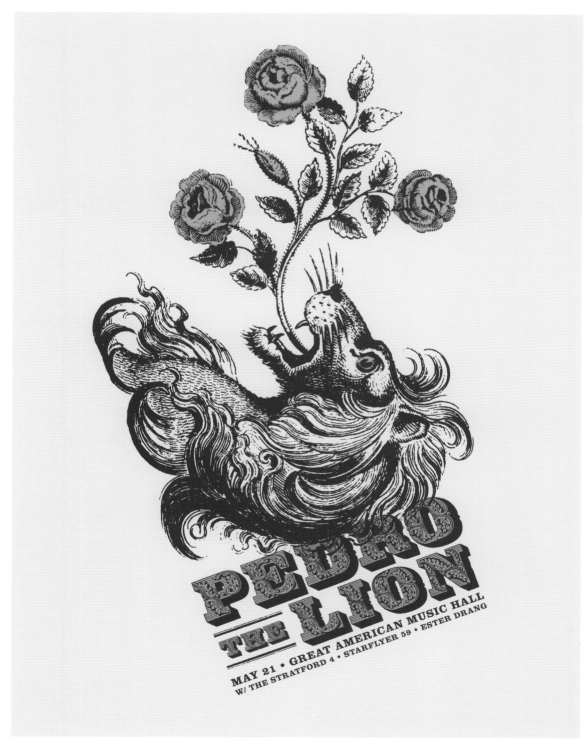

2003 SILKSCREEN 19 X 25 INCHES

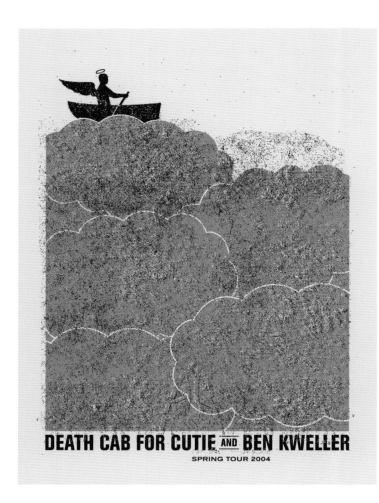

DEATH CAB FOR CUTIE AND BEN KWELLER
SPRING TOUR 2004

2004 SILKSCREEN 19 X 25 INCHES

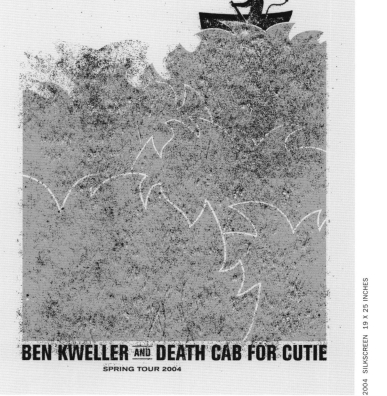

BEN KWELLER AND DEATH CAB FOR CUTIE
SPRING TOUR 2004

2004 SILKSCREEN 19 X 25 INCHES

THE DISMEMBERMENT PLAN
WITH ENON AND BEAUTY PILL – SATURDAY, JUNE 7 – SLIM'S

2003 SILKSCREEN 19 X 25 INCHES

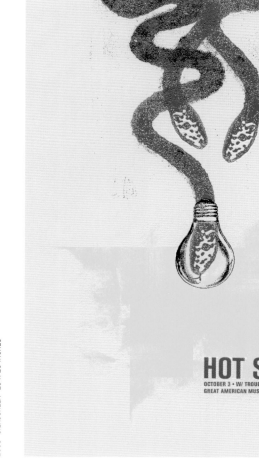

HOT SNAKES
OCTOBER 3 • W/ TROUBLE EVERYDAY & THE HUSBANDS
GREAT AMERICAN MUSIC HALL • 8PM • $14 • ALL AGES

2004 SILKSCREEN 19 X 25 INCHES

Born in Austin, Texas, in 1947, Bill Narum moved to Houston where he began his professional career in graphic design and illustration in the late 1960s with underground cartoons and illustrations for *Space City!*, Houston's alternative newspaper, and concert posters for Liberty Hall, Love Street Light Circus, Of Our Own, Anderson Fair, and many other Houston music venues. Narum's work gained national and international acclaim through album covers and concert promotions for ZZ Top. He also designed the band's staging, which at one point included live cacti, a longhorn steer, and a buffalo, and he produced the painted tour-truck convoy, a mural of Texas spanning 160 feet, for the band's World Wide Texas Tour. Since returning to Austin in the early 1970s, Narum has done illustrations for *The Texas Observer* and *The Austin Sun*, and concert posters for such Austin performance halls as Armadillo World Headquarters, The Continental Club, La Zona Rosa, and many other venues. He continues to contribute to the development of the Texas music industry with music packaging, posters, and album covers for Amazing Records, Antone's Records, Armadillo Records, and many private labels.

2004 OFFSET 11 X 17 INCHES

2003 OFFSET 11 X 17 INCHES

111

In 2000, Sub Pop art directors Jeff Kleinsmith and Jesse LeDoux formed Patent Pending Industries, a small, two-person firm specializing in music-related design such as limited-edition screen-printed show posters and CD packaging. Patent Pending Industries quickly grew to include their own printing studio with the addition of printing genius Brian Taylor and with the help of Jacob McMurray. Patent Pending's work has appeared in numerous magazines and books as well as in various gallery shows, including Roq la Rue, Basil Hallward Gallery, and Easy Street. They have work in permanent collections of the Experience Music Project and The Rock and Roll Hall of Fame.

DESIGN BY JEFF KLEINSMITH (PATENT PENDING). PRINTED BY PATENT PENDING PRESS.

DESIGNED BY JEFF KLEINSMITH 2004 SILKSCREEN 15 X 24 INCHES

DESIGNED BY JEFF KLEINSMITH 2000 SILKSCREEN 15 X 21 INCHES

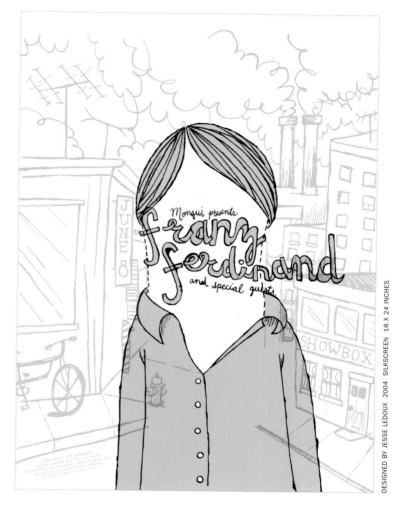

DESIGNED BY JESSE LEDOUX 2004 SILKSCREEN 18 X 24 INCHES

DESIGNED BY JESSE LEDOUX 2004 SILKSCREEN 18 X 24 INCHES

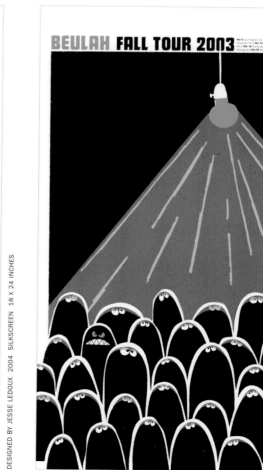

DESIGNED BY JESSE LEDOUX 2003 SILKSCREEN 18 X 24 INCHES

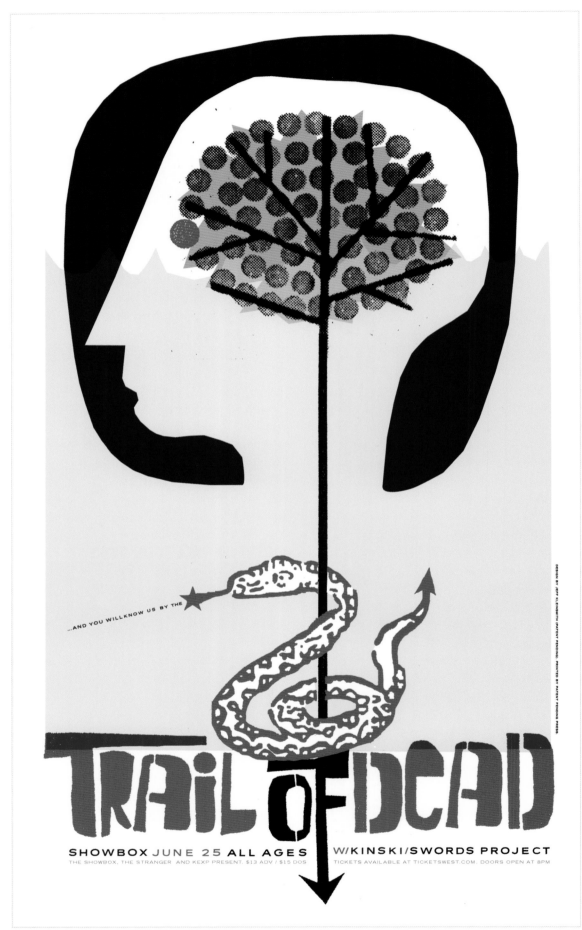

...AND YOU WILL KNOW US BY THE

TRAIL OF DEAD

SHOWBOX JUNE 25 ALL AGES W/KINSKI/SWORDS PROJECT

THE SHOWBOX, THE STRANGER AND KEXP PRESENT. $13 ADV / $15 DOS TICKETS AVAILABLE AT TICKETSWEST.COM. DOORS OPEN AT 8PM

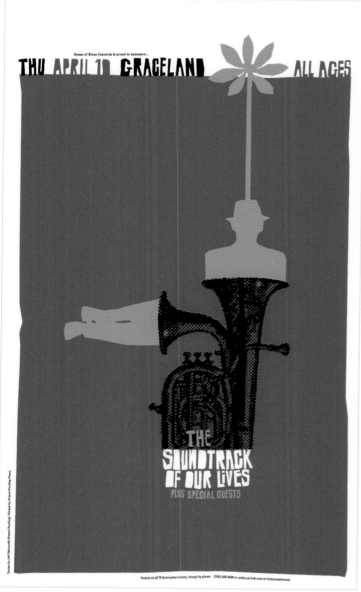

DESIGNED BY JEFF KLEINSMITH 2002 SILKSCREEN 15 X 24-1/2 INCHES

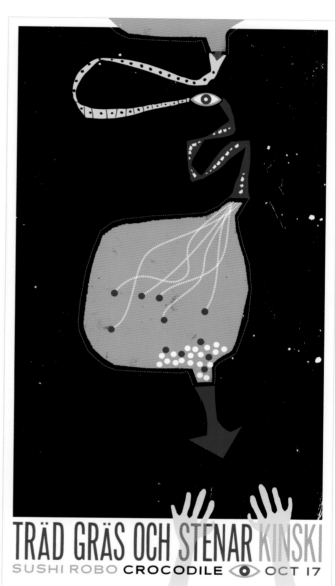

DESIGNED BY JEFF KLEINSMITH 2003 SILKSCREEN 13 X 24-1/2 INCHES

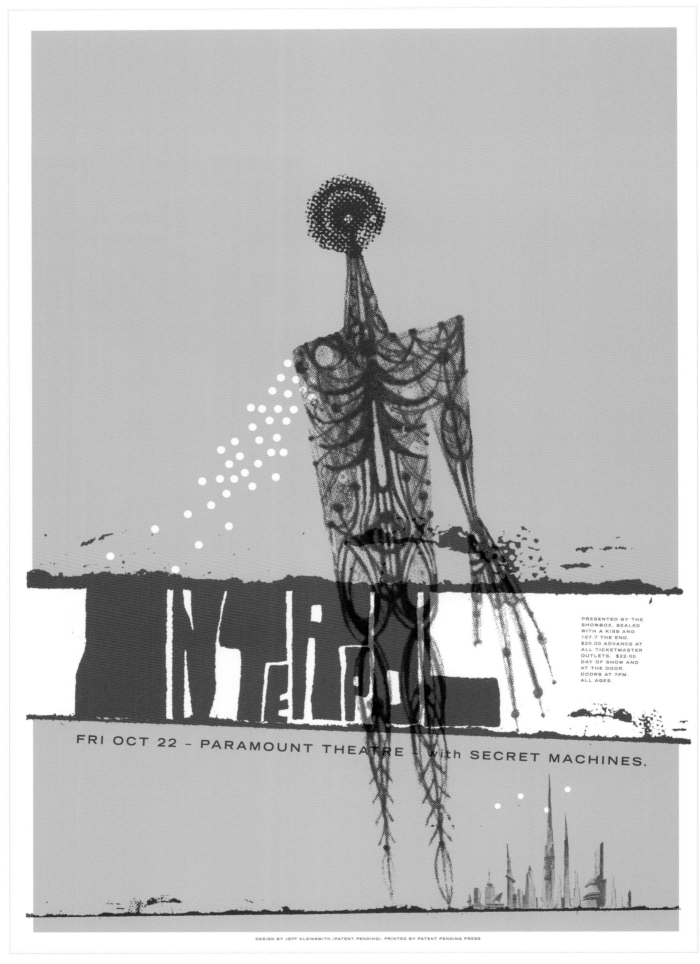

FRI OCT 22 – PARAMOUNT THEATRE with SECRET MACHINES.

PRESENTED BY THE
SHOWBOX, SEALED
WITH A KISS AND
107.7 THE END.
$20.00 ADVANCE AT
ALL TICKETMASTER
OUTLETS. $22.00
DAY OF SHOW AND
AT THE DOOR.
DOORS AT 7PM.
ALL AGES.

DESIGN BY JEFF KLEINSMITH (PATENT PENDING). PRINTED BY PATENT PENDING PRESS

DESIGNED BY JEFF KLEINSMITH 2004 SILKSCREEN 17 X 24 INCHES

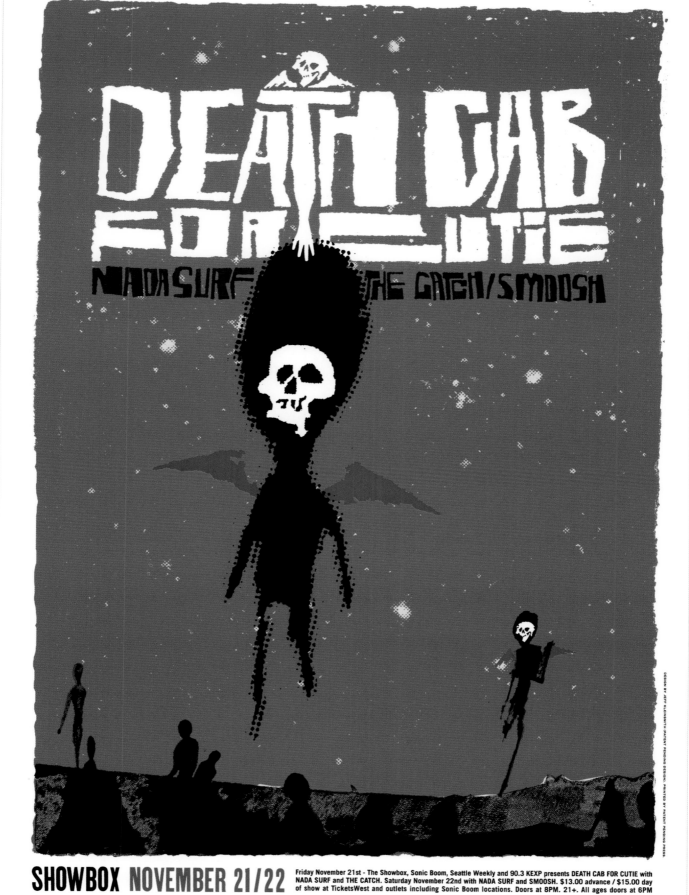

SHOWBOX NOVEMBER 21/22 Friday November 21st - The Showbox, Sonic Boom, Seattle Weekly and 90.3 KEXP presents DEATH CAB FOR CUTIE with NADA SURF and THE CATCH. Saturday November 22nd with NADA SURF and SMOOSH. $13.00 advance / $15.00 day of show at TicketsWest and outlets including Sonic Boom locations. Doors at 8PM. 21+. All ages doors at 6PM

Texas native Billy Perkins grew up just north of Austin, Texas, where he has lived and worked since his 1987 graduation from Southern Texas State University with a BFA in commercial art. He designed his first poster in 1990 while serving as art director for Austin's largest print shop. Perkins's freelance studio Penhead

Design was born in 1992, along with its slogan "Good Ideas thru Bad Living." His posters are characterized by a variety of styles—mostly illustration, but he also uses photos. An illustrator all his life, Perkins was greatly influenced early on by Silver Age comics artists, such as Buscema, Kirby, and Colan. He is a three-time Best Concert Poster

award-winner at the annual Austin Music Awards, and he's now branching out from his very active poster work into CD packaging and art prints. His work appears in several recent books and magazines, including *Art of Modern Rock: The Poster Explosion* and *Gasoline* magazine in Canada.

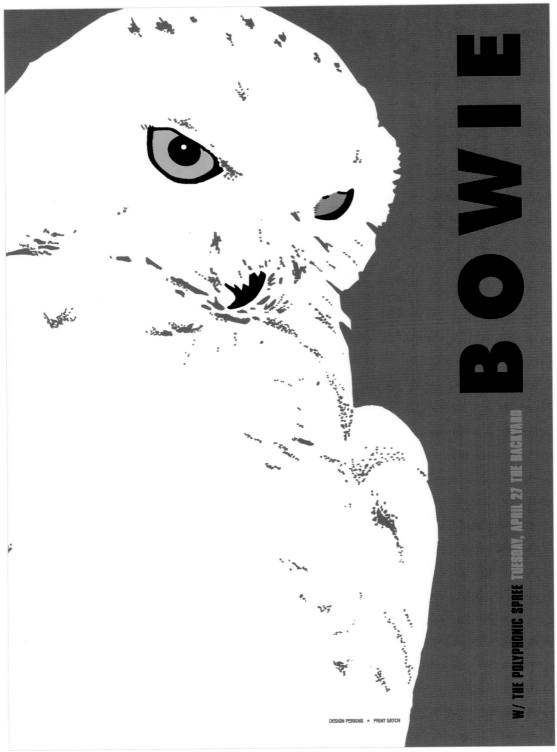

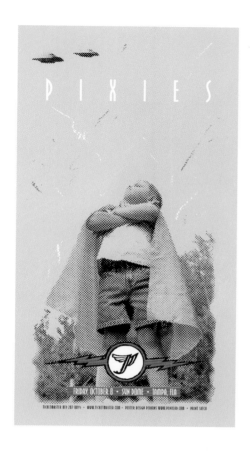

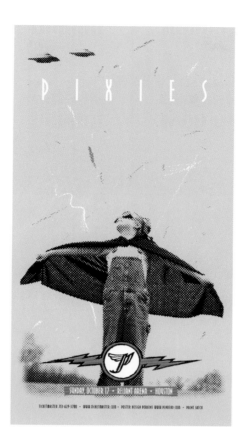

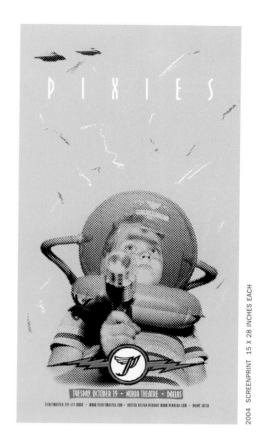

2004 SCREENPRINT 15 X 28 INCHES EACH

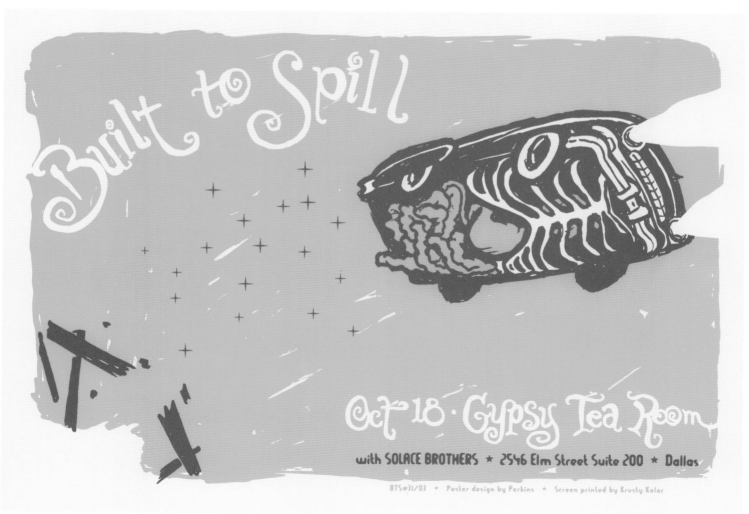

2003 SCREENPRINT 20 X 14 INCHES

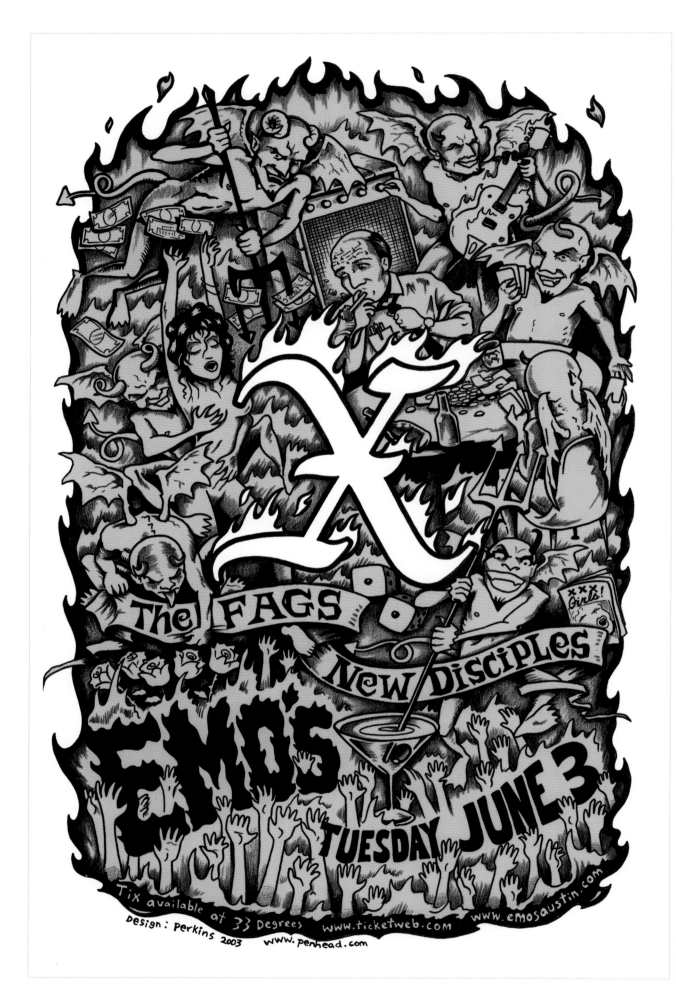

2003 SILKSCREEN 15 X 25 INCHES

Jim Phillips is best known for rock posters and surf and skateboard art. He's created more than 100 rock posters since starting out in 1967 at the Crosstown Bus in Boston. He did a poster for the Doors's first east coast appearance, at which he worked the light shows with a lady named Dolly who later became his wife and lifelong partner. Born in 1944, Phillips has lived mostly in Santa Cruz, California. One early job was applying art to surfboards. His first published work appeared in *Surfer* with many surfing publications since. From the mid-1970s to 1990, Phillips was art director for Santa Cruz Skateboards, creating hundreds of skateboard designs. He's done posters for BGP and other venues, and he became art director of FD/Maritime Hall in 1995. A book of his work, *The Surf, Skate & Rock Art of Jim Phillips* was published in 2003.

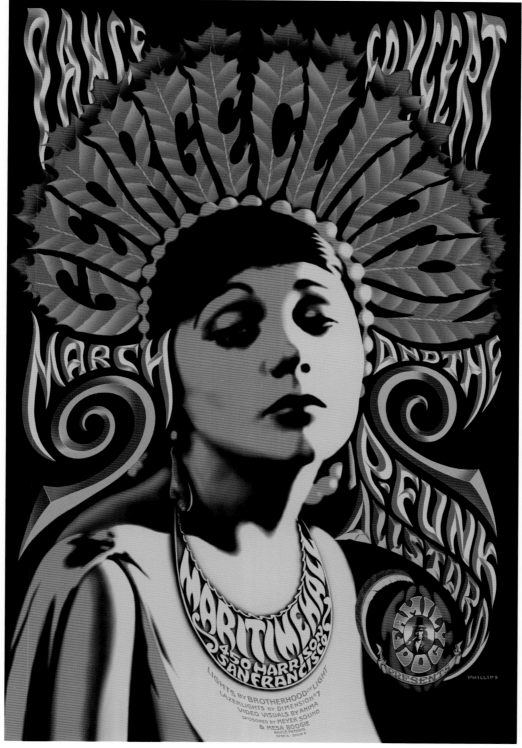

1996 OFFSET 13 X 19-1/2 INCHES

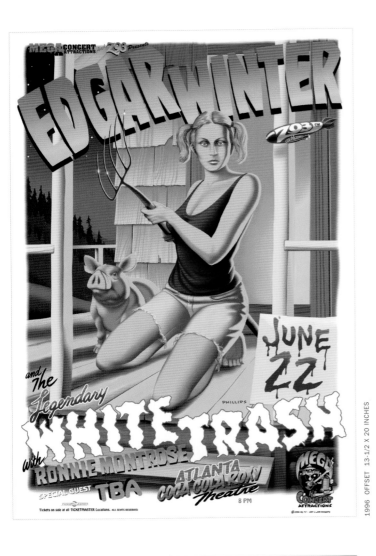

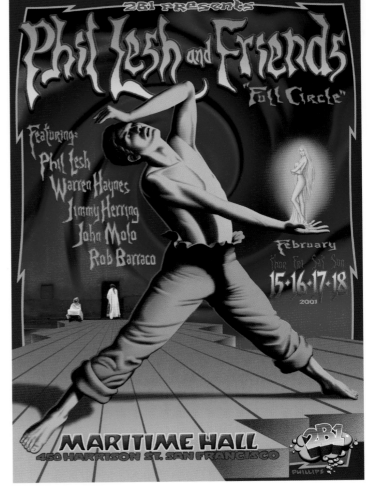

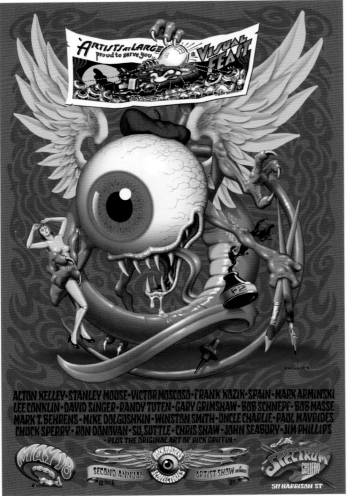

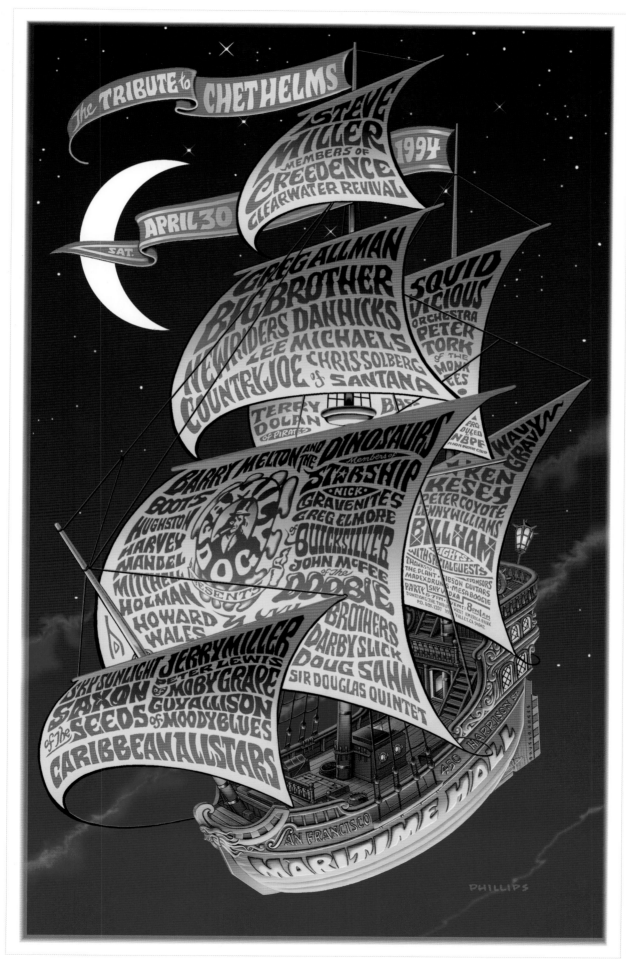

Founded in 1991, Plazm publishes an eclectic design and culture magazine, *Plazm*, with worldwide distribution. The firm also operates an innovative type foundry that employs custom typography to build identities and advertising, interactive, and retail experiences. Recent Plazm projects include the book *XXX: The Power of Sex in Contemporary Design*, customized global type identity for Nike, and a forty-two color silkscreen print of *The Last Supper*. In 1997 *i-D* magazine ranked Plazm one of the world's forty most influential design firms and it's been featured in the 100 show, AIGA national show, the Art Directors Club, *Eye, Communication Arts, Graphis*, and *IDEA*. Plazm received the creative resistance award from *Adbusters* in 2001 and its complete catalogue is included in the permanent collection of the San Francisco Museum of Modern Art. Plazm Partners regularly present work internationally, teach, create workshops, and judge competitions. *Plazm* magazine has been published since 1991.

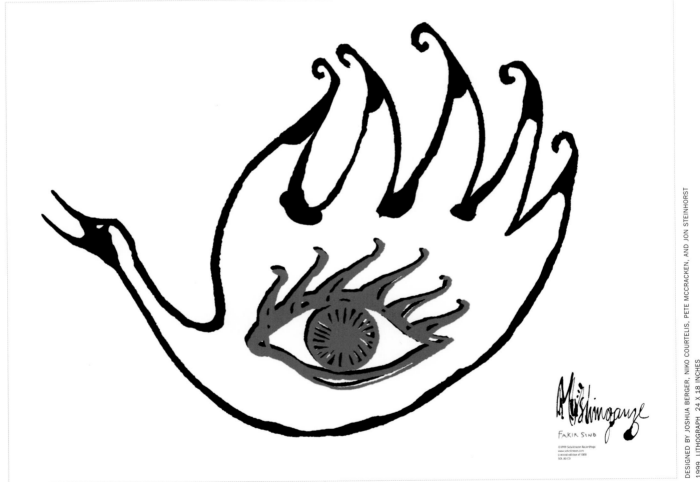

DESIGNED BY JOSHUA BERGER, NIKO COURTELIS, PETE MCCRACKEN, AND JON STEINHORST
1999 LITHOGRAPH 24 X 18 INCHES

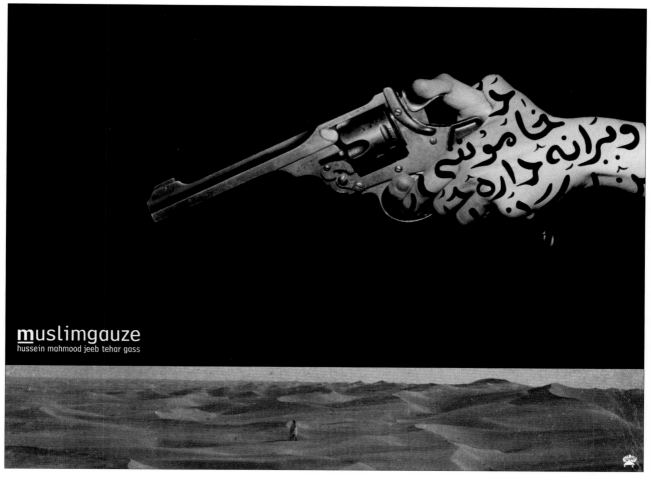

muslimgauze
hussein mahmood jeeb tehar gass

DESIGNED BY JOSHUA BERGER, NIKO COURTELIS, PETE MCCRACKEN, AND RIQ MOSQUEDA
1998 LITHOGRAPH 24 X 18 INCHES

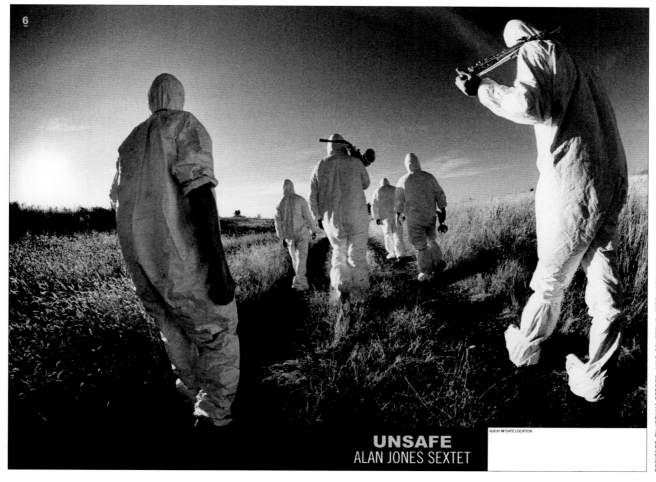

UNSAFE
ALAN JONES SEXTET

DESIGNED BY JOSHUA BERGER, NIKO COURTELIS, PETE MCCRACKEN, AND DYLAN NELSON
1998 LITHOGRAPH 24 X 18 INCHES

Sean Carroll, the creative force and physical labor behind Sandusky Bay Poster Works, has been creating concert posters since 2002. He got the idea to become a poster artist during a midlife crisis and the wish to attend rock concerts for free. In the last two years, Carroll has cranked out more than 250 posters for bands big and small, and he's become the area's most prolific producer by postering just about every venue in Cleveland Rock City. A classically trained graphic artist, he has no set style, uses a homemade press, and does all his printing by hand. While fame and fortune elude him, he works his fingers to the bone for local promoters, most of whom appreciate the effort, and he's still excited to meet the occasional rock star. Carroll can be found at many of the shows he posters, usually with his wife Linda, and he loves to chat about music, posters, and politics with bands and concertgoers alike.

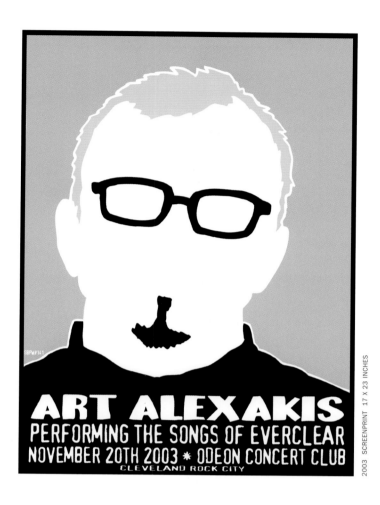

ART ALEXAKIS
PERFORMING THE SONGS OF EVERCLEAR
NOVEMBER 20TH 2003 * ODEON CONCERT CLUB
CLEVELAND ROCK CITY

2003 SCREENPRINT 17 X 23 INCHES

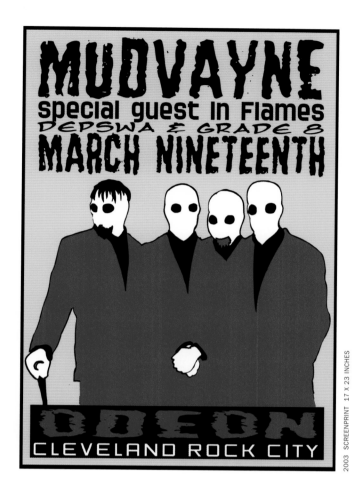

MUDVAYNE
special guest In Flames
DEPSWA & GRADE 8
MARCH NINETEENTH

ODEON
CLEVELAND ROCK CITY

2003 SCREENPRINT 17 X 23 INCHES

This one's for ALL the suckers who still believe in love...

REEL BIG FISH ZEBRAHEAD
WAKEFIELD • THE MATCHES
TUESDAY JULY 8TH • ODEON CONCERT CLUB • CLEVELAND ROCK CITY
©2003 SANDUSKY BAY POSTER WORKS

2003 SCREENPRINT 23 X 17 INCHES

After working more than a decade in prominent agencies in Pittsburgh, New Orleans, and Chicago, Carlos Segura decided to get creative by founding his own firm. The Segura Inc. mission: to blend as much fine art into commercial art as possible, in the belief that "communication that doesn't take a chance, doesn't stand a chance." Once that firm took off, Segura founded [T-26] Digital Type Foundry in 1994, one of today's leading promoters of innovative, independent font design. Promoted by the work of the Segura Inc. creative team, [T-26] offers the largest selection of unique and sought after digital fonts in the world. Expanding on that experience, Segura started 5inch.com in 2001, doing to blank CDRs what Swatch did to watches.

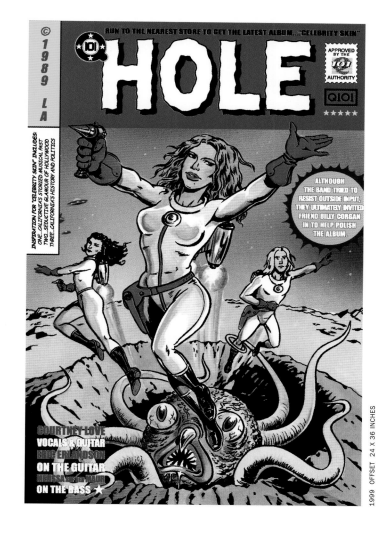

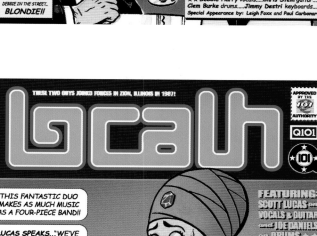

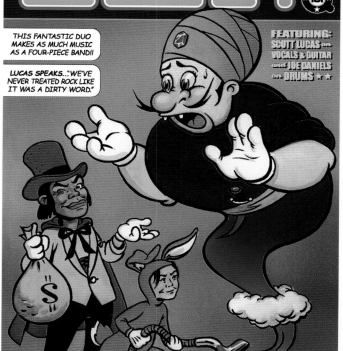

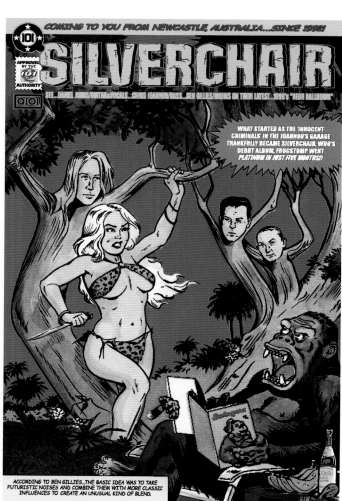

Peter McPhee, known as Uncle, started drawing rock posters and silkscreens for local and national music acts out of a garage in Cranston, Rhode Island, in 1997 after graduating with a degree in illustration from the Rochester Institute of Technology. The first poster Skidder Design designed was for a band he was a member of at the time called The Amish Alcoholics—images flowed from his brain from songs the band wrote. When Uncle is creating a poster today, he closely listens to the band's music and tries to interpret visually what he hears. His manager, Marissa, then takes his designs to a concert and shows them to the band in the hopes they'll let her sell a few. Their ways and means may be offbeat, but Uncle is extremely proud of his posters, which have been well received by the bands and their fans.

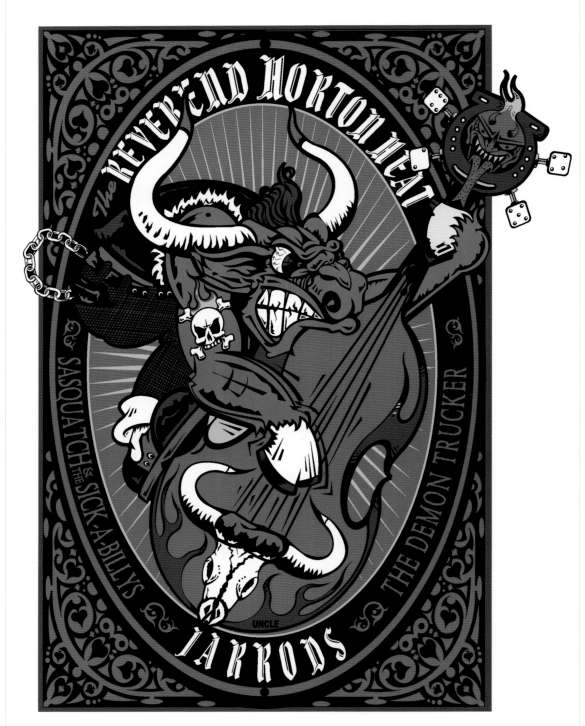

2004 SILKSCREEN 18 X 24 INCHES

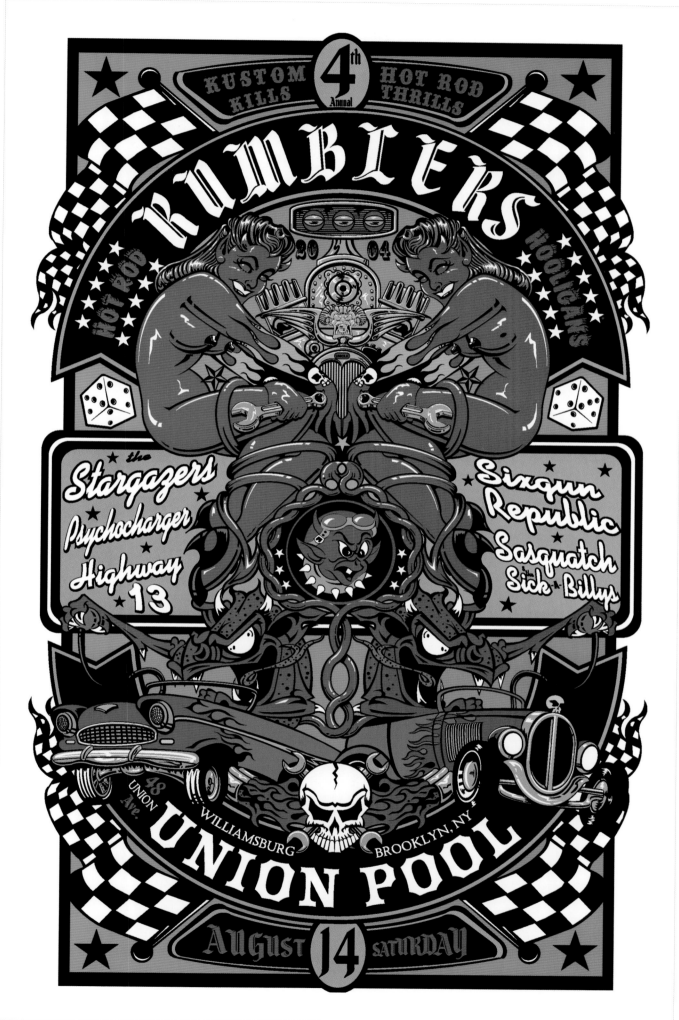

2004 SILKSCREEN 16-1/4 X 27-1/2 INCHES

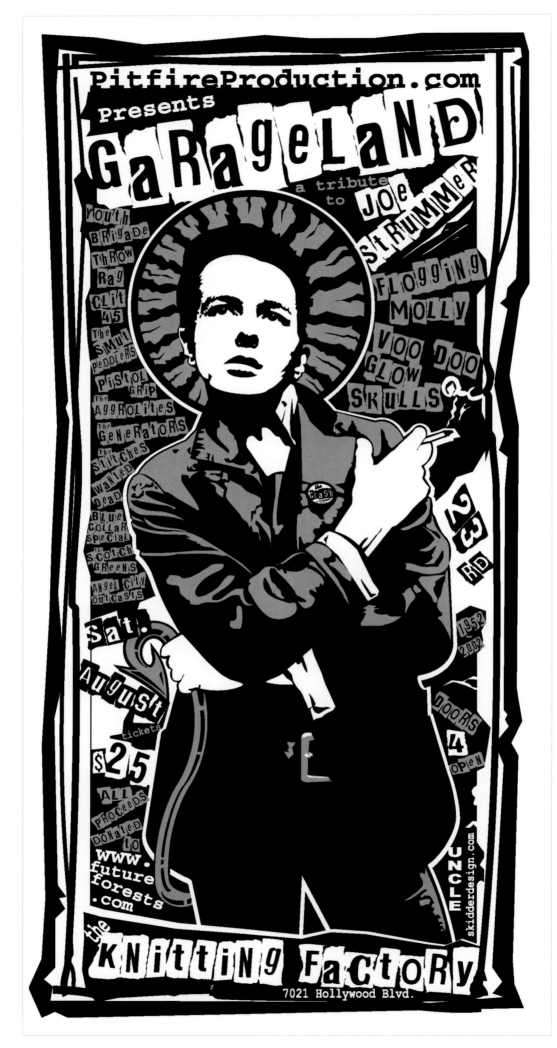

2001 PLASTICOL ON PAPER 12 X 28 INCHES

Unschooled, undisciplined, and unstoppable, Stainboy, aka Greg Reinel, carries out his assignments and other secret services for a variety of clients in sunny Orlando, Florida. In the mid-1980s, Stainboy began making posters, record/CD packages, and merchandise designs for his high-volume rock duo, Nutrajet. Trading on his ability to kick out insane amounts of cool, hand-illustrated posters fast, as well as put the smack down on unruly Kinko's employees, it wasn't long before his illustrative style attracted the attention of Orlando-area rock promoters, managers, and bands. Now published by Diesel Fuel prints, Stainboy's dossier includes a diversity of work for such clients as the House of Blues, Suicide Girls, Signatures Network, Planet Propaganda, and Gary Fisher Bikes. His rock and roll posters feature artists such as Cheap Trick, Nashville Pussy, Flogging Molly, Pennywise, Todd Rundgren, Sevendust, and Supergrass. Countless books, magazines, and fanzines continue to feature his work, which is saturated by a love of pop culture trash, hot femmes fatales, and 1970s exploitation films.

2004 6-COLOR SILKSCREEN WITH METALLIC INK 22 X 32 INCHES

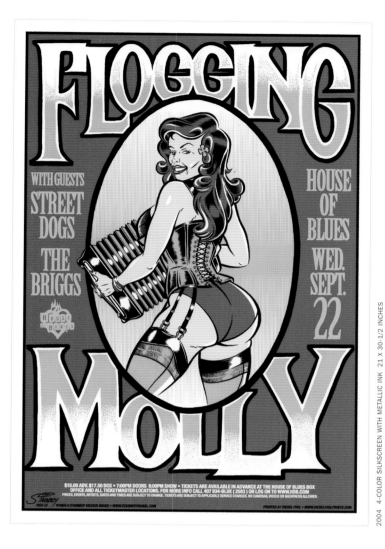

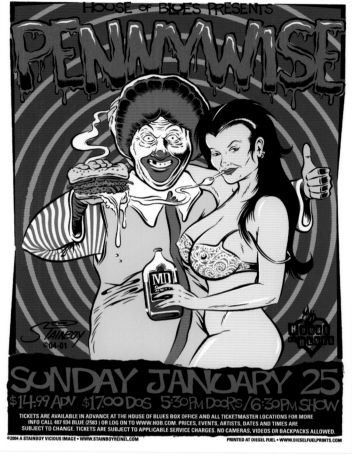

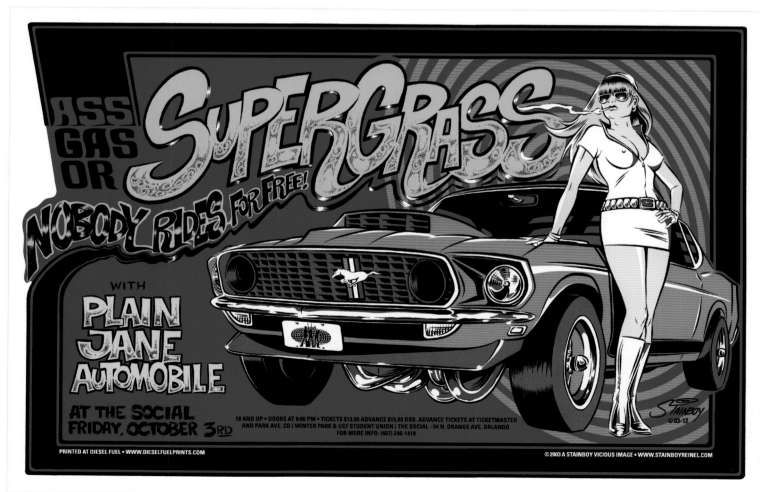

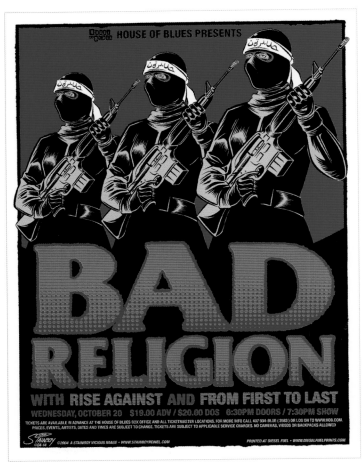

2004 4-COLOR SILKSCREEN WITH METALLIC INK 16 X 22 INCHES

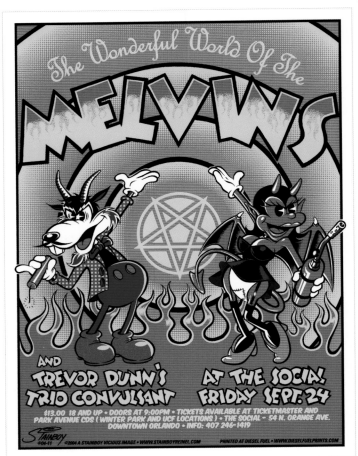

2004 4-COLOR SILKSCREEN 16 X 22 INCHES

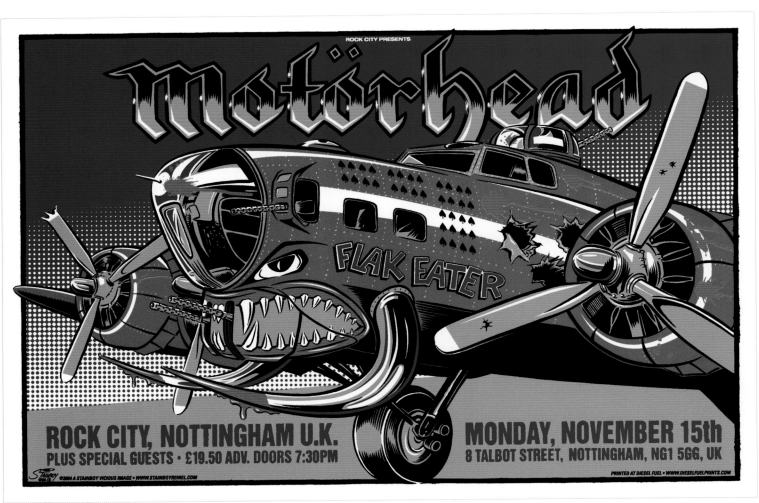

2004 5-COLOR SILKSCREEN WITH METALLIC INK 32 X 22 INCHES

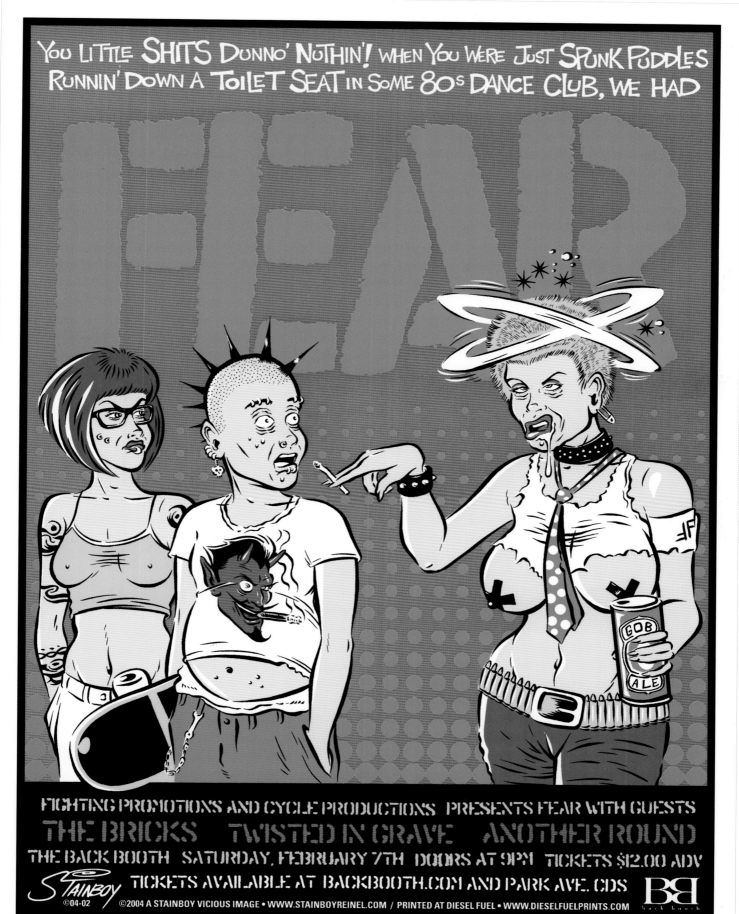

Tyler Stout was born and raised in the Watts section of Los Angeles, and his earliest artistic endeavors were heavily influenced by the Black and Latino gang graffiti or "striking" that's prevalent in Watts. Gang culture introduced Stout to the music of the streets, and as local acts like NWA, Ice-T, and MAC-10 rose to national prominence, he merged his interest in music, his connections with these groups, and his skills as an artist to create flyers for local

shows. In the early 1990s Stout became an A&R assistant at a prominent hip-hop label in New York City. There he diversified both his skill set and his subject matter by expanding from hip hop, rap, and R&B to metal, alt rock, and other genres. He then relocated to the wilds of Washington state where he got a design degree from Western Washington University, freelanced for agencies and other venues, and married Sarah. Then the couple moved back

east to Vermont, where Stout has worked for Jager Di Paola Kemp Design for the past two and a half years. His instantly recognizable style can be seen on everything from photocopied flyers to full-color silk-screened posters. His pieces figure in many prominent collections, including the Experience Music Project in Seattle, toward whose rainy intimacy, as this book goes to print, Stout is preparing to return.

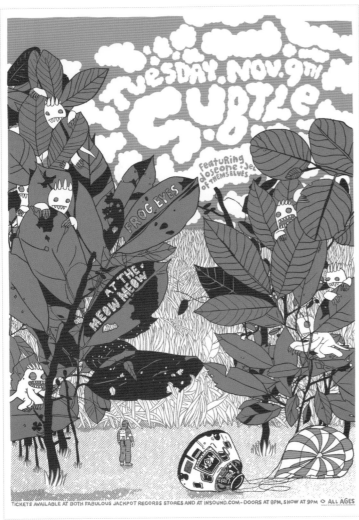

2004 2-COLOR SCREENPRINT 24 X 36 INCHES

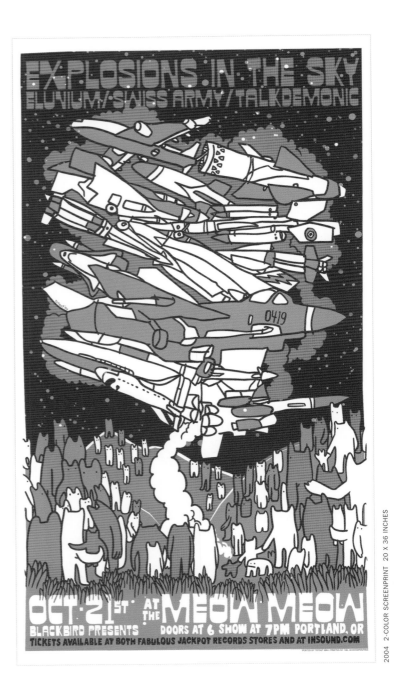

2004 2-COLOR SCREENPRINT 20 X 36 INCHES

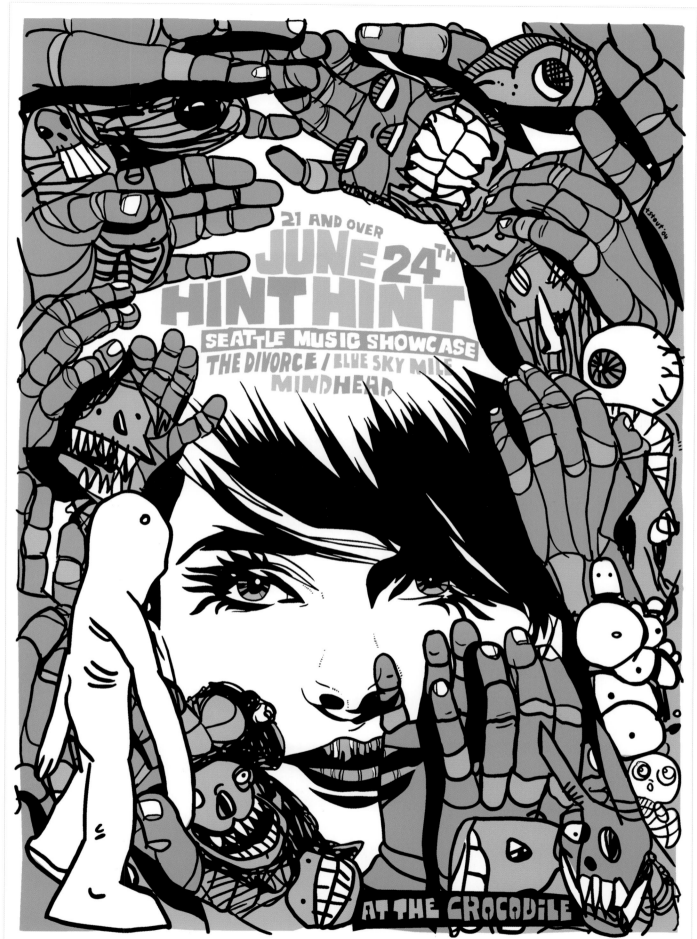

2004 3-COLOR SCREENPRINT 25 X 36 INCHES

Born in sunny southern California in 1969 and raised in the bayous of Louisiana, Jeral Tidwell now satisfies the grease lovers of Louisville with his Kentucky fried art. He started his professional art career in 1988 with airbrush and pencil sketches and now uses every tool in the trade, from pencils and paints to cameras and computers. Creating wildly imaginative art for concert posters, skateboards, duck calls, and children's books, Tidwell draws inspiration from the likes of Todd Schorr, Robert Williams, and Jim Phillips in the art scene, and from his soul mate, his close friends, tattoos, and candy. Lots and lots of candy. Tidwell's work has been featured in *Car Kulture Deluxe*, *International Tattoo*, and *Club International* magazines. Among the galleries where his work has been shown are CBGB's 313 and Kustom Kulture in New York, La Luz De Jesus in Los Angeles, and Hope in Connecticut. Tidwell is very active in the Lo Brow art community online, over the phone, and through attendance at poster and tattoo conventions. He loves to talk about art and he's never met a stranger.

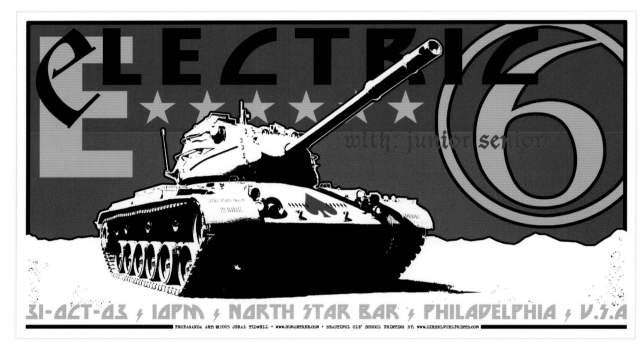

2003 SCREENPRINT 23 X 13 INCHES

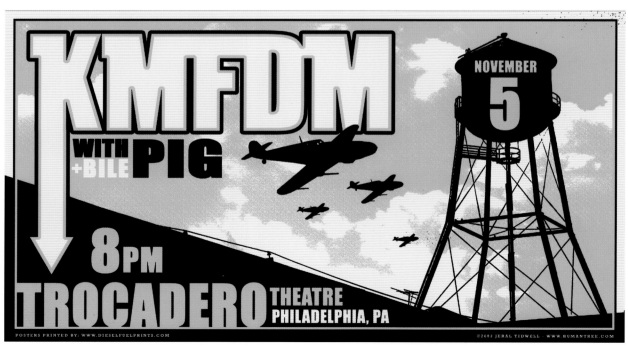

2003 SCREENPRINT 24 X 13 INCHES

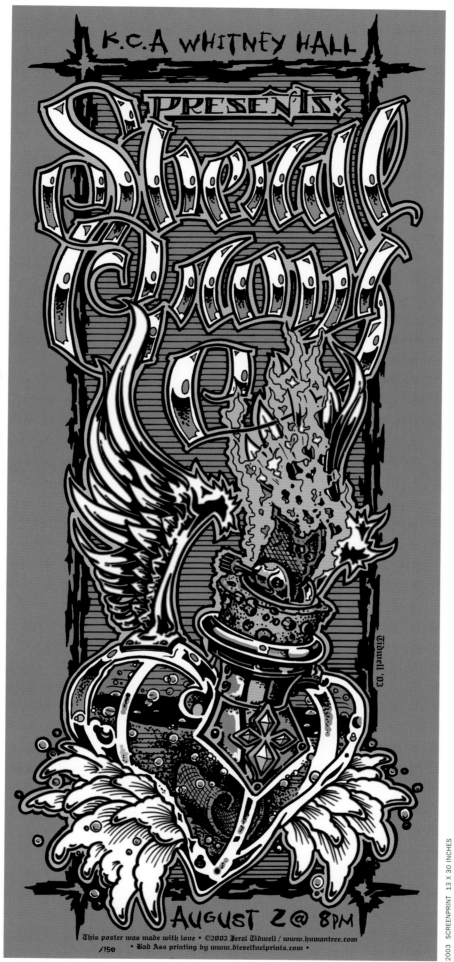

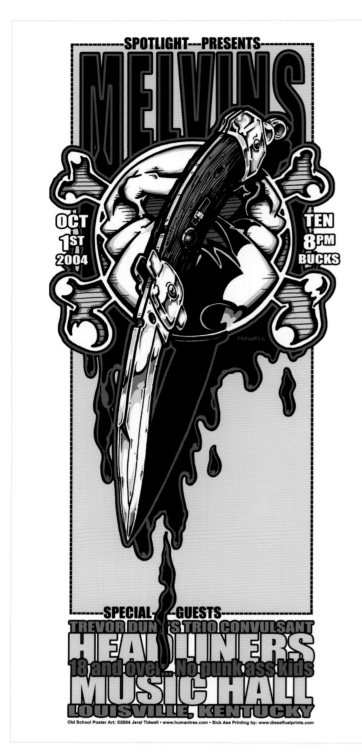

2004 SCREENPRINT 12 X 25 INCHES

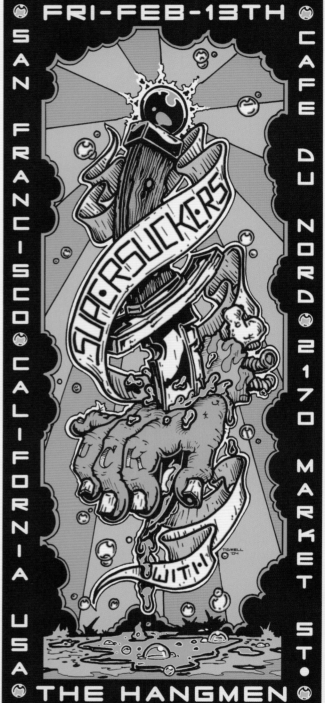

2004 SCREENPRINT 11 X 25 INCHES

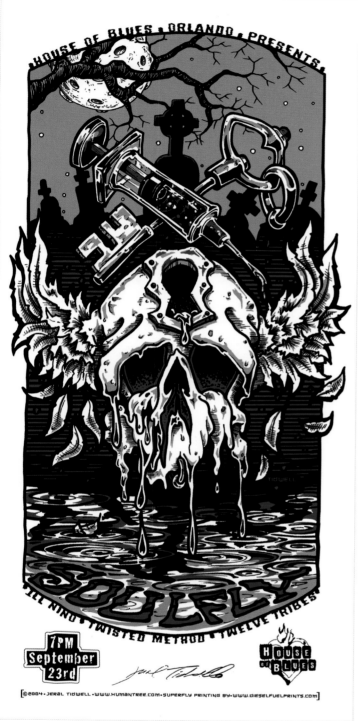

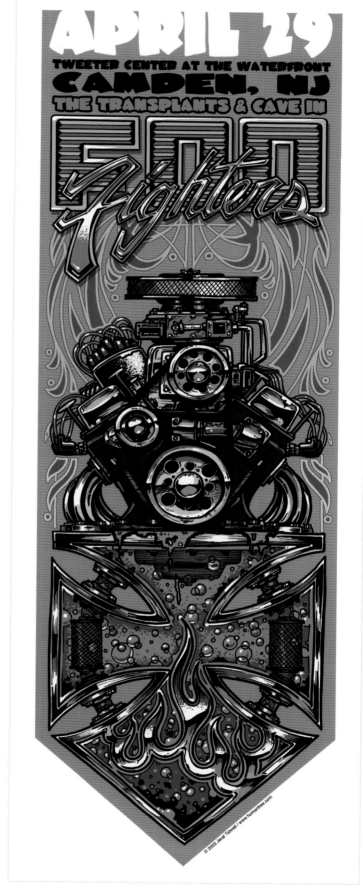

Raised in the suburbs of Milwaukee, Jay Vollmar relocated to Denver after graduating from Milwaukee Institute of Art and Design. There, in the basement bedroom of a rented house, he began printing posters for Denver's local rock clubs. Done on homemade equipment, his posters retain the look and feel of the limited-edition, hand-printed poster in edition of 60 or less. Currently working as art director for the weekly paper *Westword*, Vollmar continues to create posters on a regular basis. He also operates a small design and illustration studio under his own name. His work has appeared in publications such as *print*, and he's been exhibited in galleries nationwide.

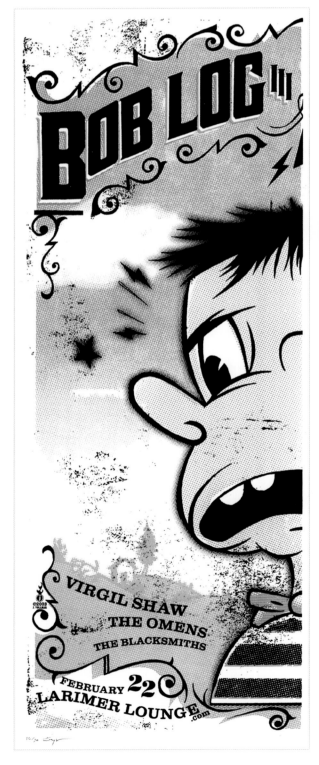
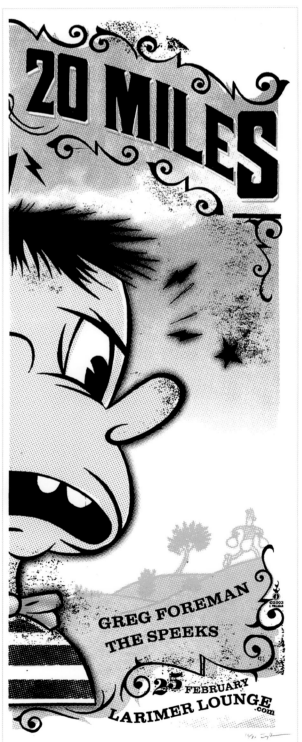

2003 SILKSCREEN 8-1/2 X 22 INCHES EACH

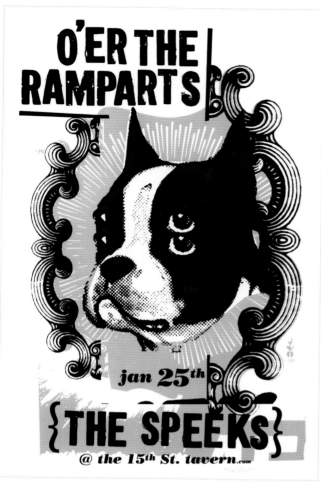

2002 SILKSCREEN 14 X 22 INCHES

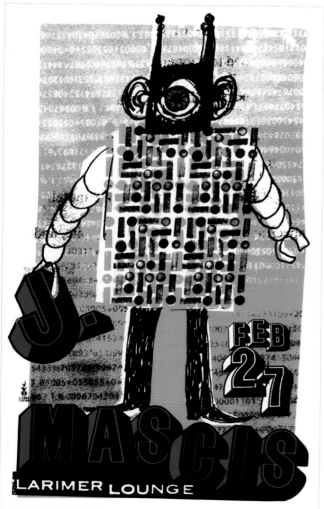

2004 SILKSCREEN 14-1/2 X 23 INCHES

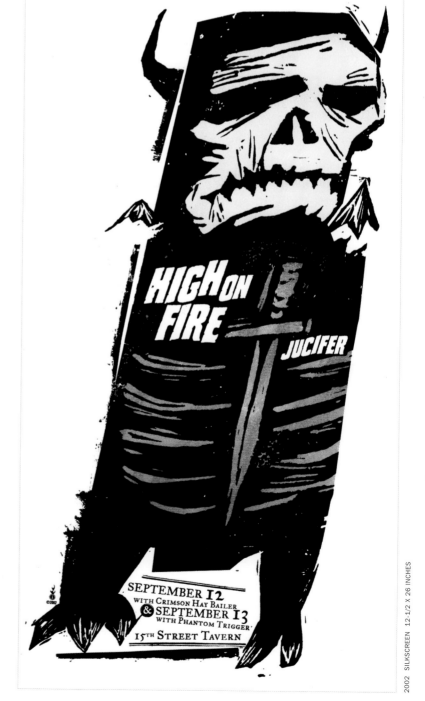

2002 SILKSCREEN 12-1/2 X 26 INCHES

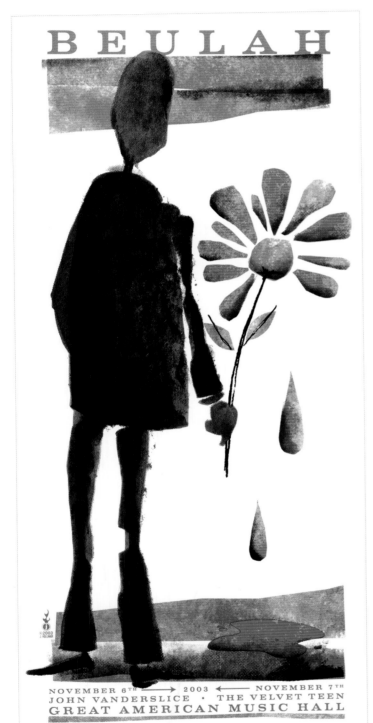

BEULAH

NOVEMBER 6TH ⟶ 2003 ⟵ NOVEMBER 7TH
JOHN VANDERSLICE • THE VELVET TEEN
GREAT AMERICAN MUSIC HALL

2003 SILKSCREEN 13-1/2 X 26 INCHES

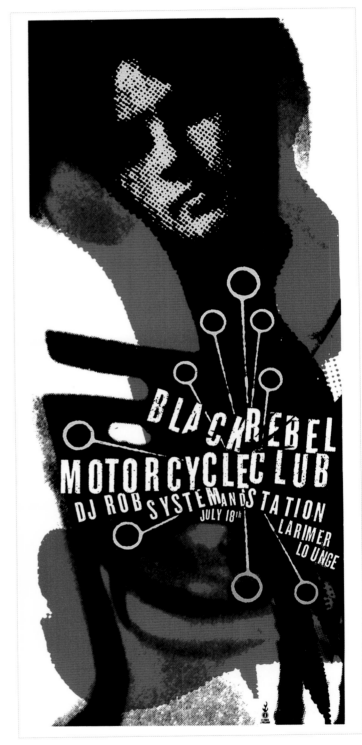

BLACK REBEL
MOTORCYCLE CLUB
DJ ROB SYSTEM AND STATION
JULY 18th
LARIMER
LOUNGE

2003 SILKSCREEN 14 X 30 INCHES

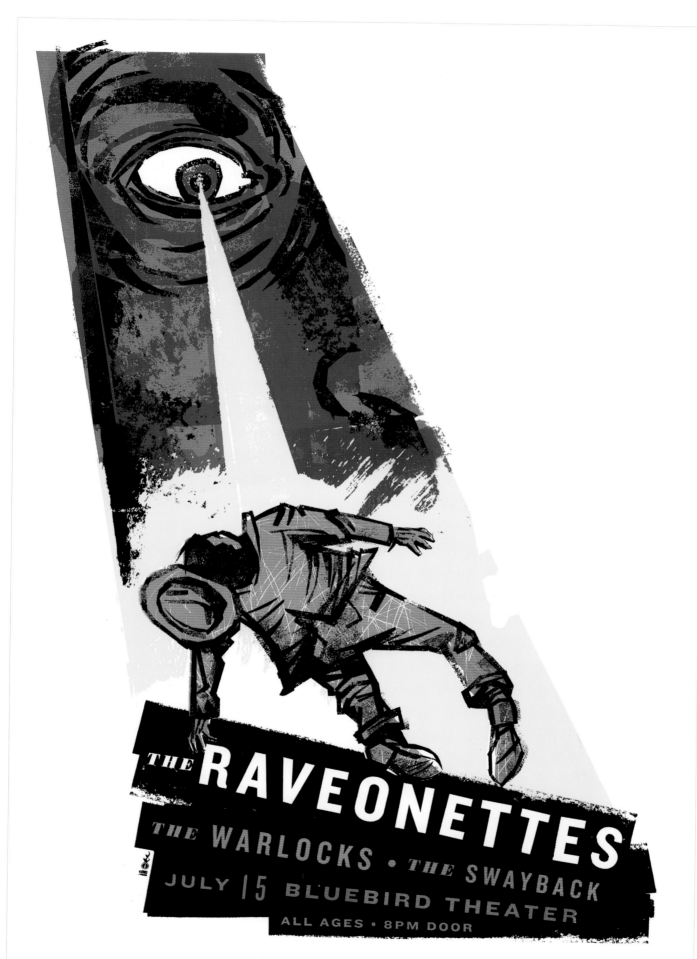

2003 SILKSCREEN 18 X 30 INCHES

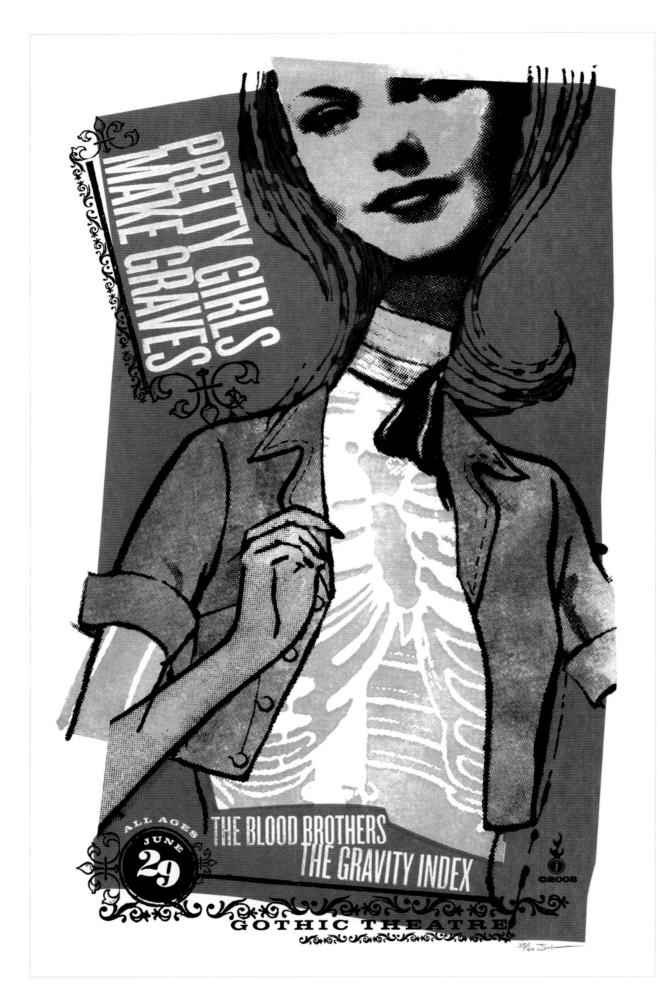

2002 SILKSCREEN 13-1/2 X 22 INCHES

Hailing from Pittsburgh and based in Berkeley, California, Justin Walsh received his BFA from Carnegie Mellon and an MFA in photography from the Art Institute of San Francisco. He is represented by the Jack Hanley Gallery in San Francisco, and his work figures in the permanent collection at the San Francisco Museum of Modern Art. Formerly print producer for the ad agency FCB, Walsh is currently a digital artist for Goodby, Silverstein and Partners. In 2001, he formed Resist Imposters to produce letterpress/screen-printed posters and other design work. His style mixes antiquated turn-of-the-century images with a modern twist of Saul Bass. His poster work has appeared in *HOW, print*, and the recently published *Art of Modern Rock: The Poster Explosion*.

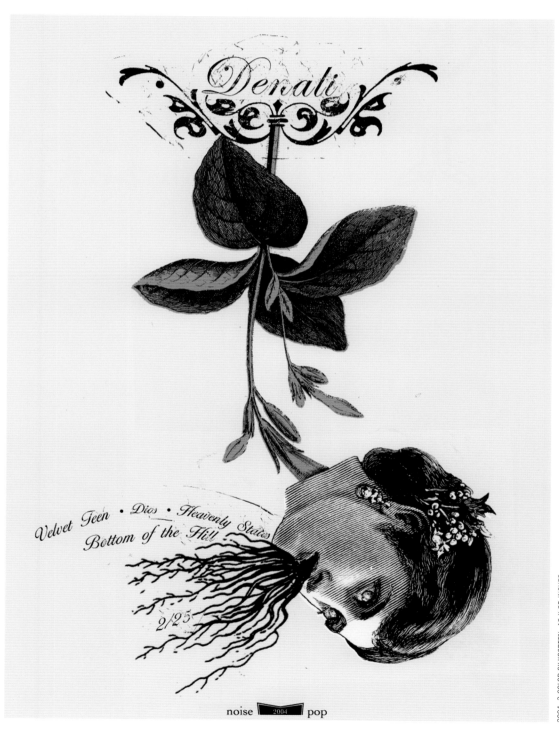

2004 3-COLOR SILKSCREEN 19 X 25 INCHES

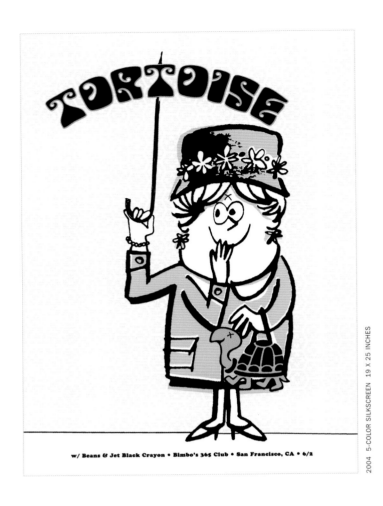

w/ Beans & Jet Black Crayon • Bimbo's 365 Club • San Francisco, CA • 6/2

2004 5-COLOR SILKSCREEN 19 X 25 INCHES

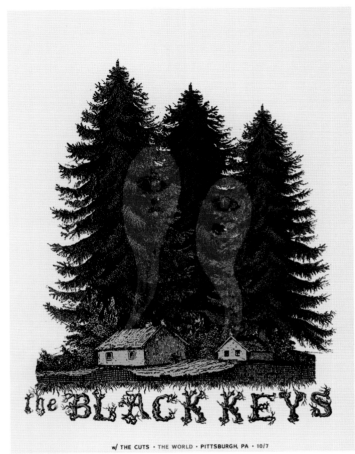

w/ THE CUTS • THE WORLD • PITTSBURGH, PA • 10/7

2004 6-COLOR SILKSCREEN 19 X 25 INCHES

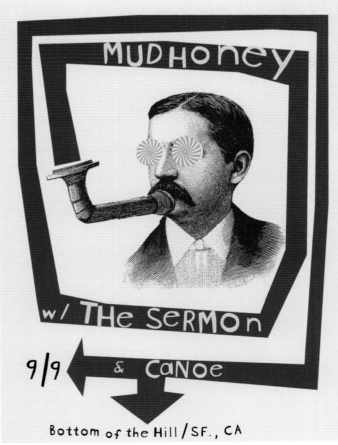

2003 4-COLOR SILKSCREEN 19 X 25 INCHES

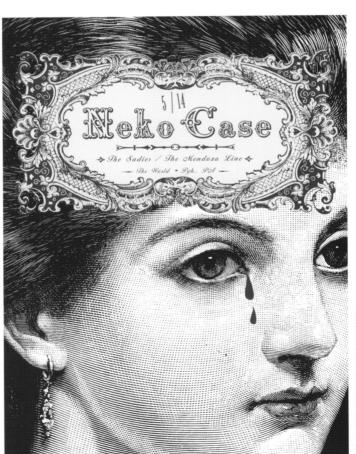

2004 3-COLOR SILKSCREEN 19 X 25 INCHES

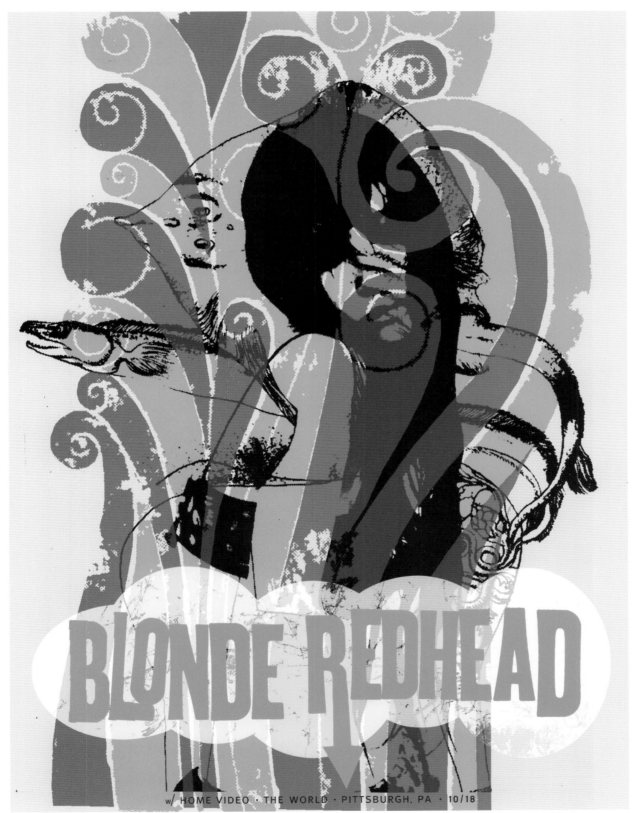

BLONDE REDHEAD

w/ HOME VIDEO · THE WORLD · PITTSBURGH, PA · 10/18

2004 6-COLOR SILKSCREEN 19 X 25 INCHES

In keeping with the cut-and-paste ethos of the deejay, his main influence, Jamie R. Ward clips, samples, mixes, and matches frozen moments, then recycles and recontextualizes them to speak visually the music his posters advertise. He does not consider himself a poster artist; rather, posters are a small part of the dialogue he uses, which also includes music and writing. That dialogue is a result of growing up in 1980s' Houston, Texas, where he absorbed the holy trinity of street cool cred: punk rock, hip hop, and skateboarding. After graduating from the High School for the Performing and Visual Arts in 1992, he moved to Austin where his focus shifted to other interests, including music and cinema. At some point he found himself making digital flyers for friends' bands. Encouraged by the growing popularity of the poster scene, he moved on, doing posters for bands outside the local circuit. Ward currently lives in Austin, Texas. He refuses to buy an iPod.

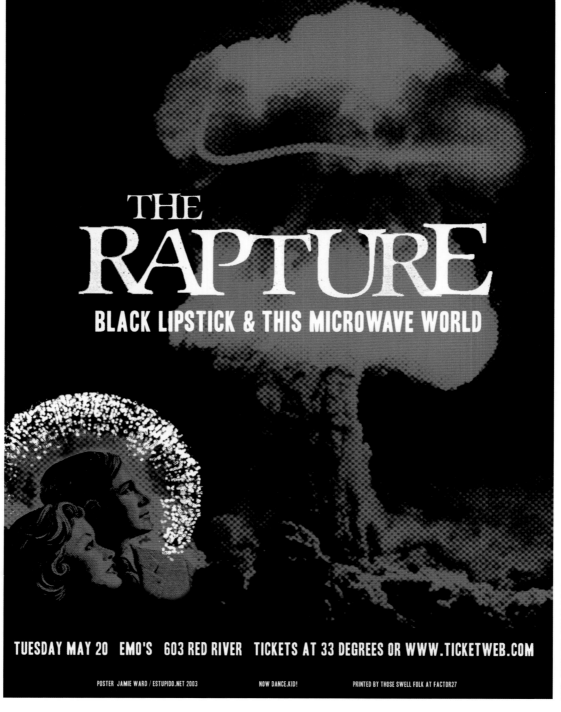

2003 SILKSCREEN 20 X 26 INCHES

STEREO TOTAL

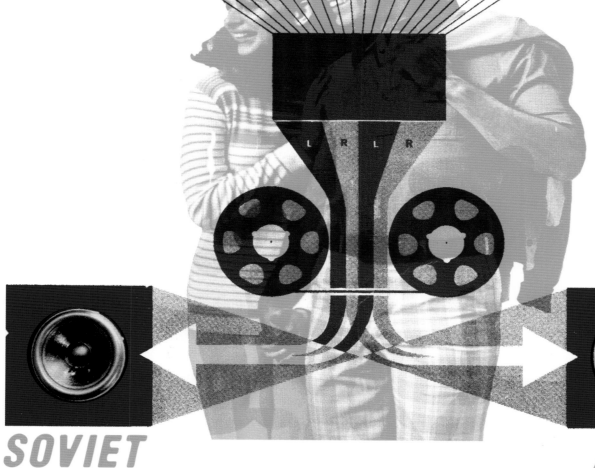

SOVIET

ARLO
(sub pop)

FRIDAY NOVEMBER 8
EMO'S 603 RED RIVER AUSTIN

POSTER DESIGN JAMIE WARD 2002 PRINTED BY FACTOR27

2002 SILKSCREEN 20 X 26 INCHES

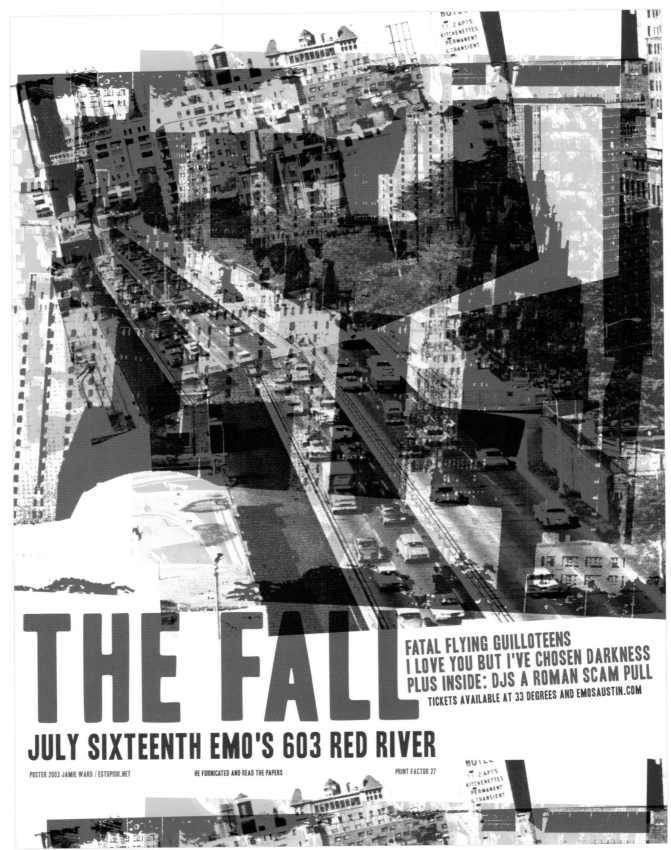

THE FALL

JULY SIXTEENTH EMO'S 603 RED RIVER

FATAL FLYING GUILLOTEENS
I LOVE YOU BUT I'VE CHOSEN DARKNESS
PLUS INSIDE: DJS A ROMAN SCAM PULL
TICKETS AVAILABLE AT 33 DEGREES AND EMOSAUSTIN.COM

POSTER 2003 JAMIE WARD / ESTUPIDO.NET HE FORNICATED AND READ THE PAPERS PRINT FACTOR 27

2003 SILKSCREEN 20 X 26 INCHES

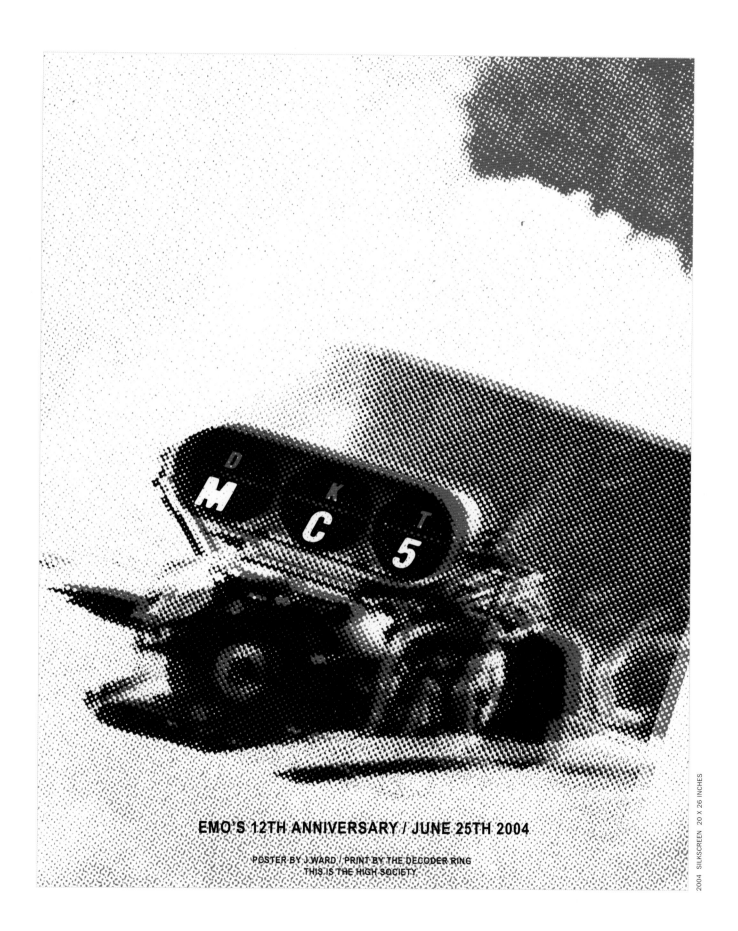

EMO'S 12TH ANNIVERSARY / JUNE 25TH 2004

POSTER BY J WARD / PRINT BY THE DECODER RING
THIS IS THE HIGH SOCIETY

2004 SILKSCREEN 20 X 26 INCHES

WRECKING CREW STUDIOS

Since mid-2003 Wrecking Crew Studios have been dedicated to creating custom art—constructed by hand and supported by quality screen-printing—for concert/tour posters, album covers, concert merchandise, set design, feature film advertising, and original commissions. You wouldn't want obsession in a boyfriend or a next-door neighbor, but Wrecking Crew Studios celebrate the trait. For them it makes sense that inner compulsion and talent, combined with perseverance, will conquer any challenge. The firm's crew—Mike Fisher, Jared Connor, Gil Wadsworth, and Mike Murphy—each contribute unique ability and combined experience from years of working in the world of rock concert posters. According to them, "We don't make home furnishings. We make rock posters. Our stuff will not match your couch or carpet. Prepare to be brutalized."

DESIGNED BY MIKE FISHER 2004 OFFSET 11 X 17 INCHES

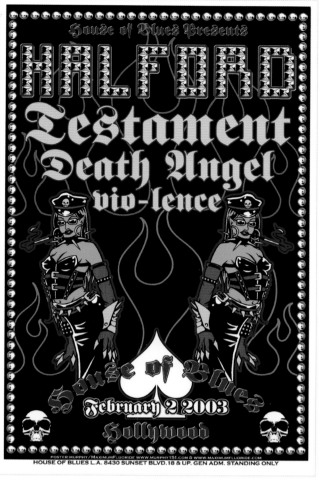

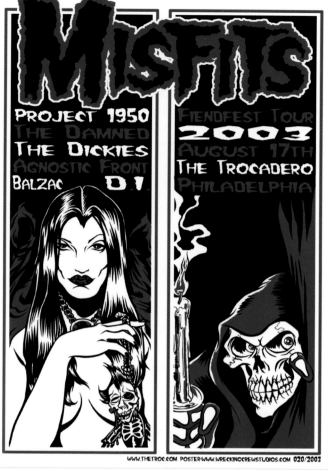

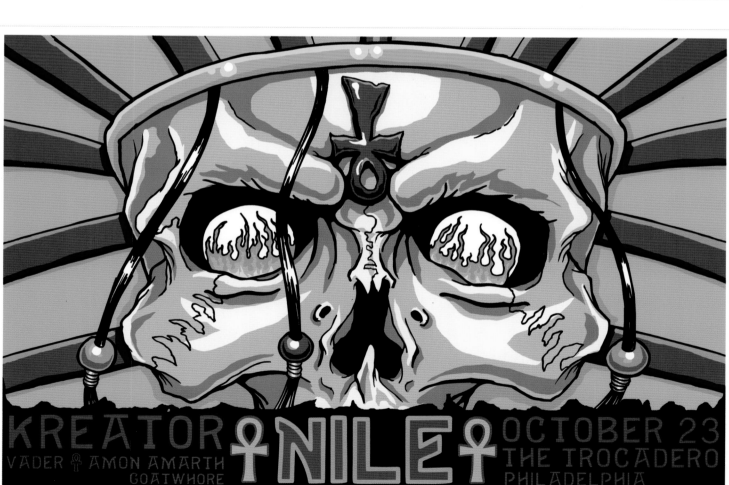

Currently based out of Pittsburgh, Pennsylvania, Bradley W. Zimmerman keeps a busy freelance design schedule under the alias of Adrenachrome-Design. Designing posters for nearly ten years, Bradley uses a combination of photocopied and hand-drawn elements to create rough-feeling paste-up compositions that are assembled and colored on his rather untrustworthy Macintosh, using ancient Adobe software leftover from the Carnegie Mellon University School of Art. He continues to do not only posters, but websites and additional print work for myriad bands, venues, and publications in Tucson, Arizona, hoping to move back to the Land of Classic Hot Rods and Quality Burritos at some point in the not-so-distant future. Bradley spends his work week doing interface design at an undisclosed location, and has been published in a number of books. Go Steelers.

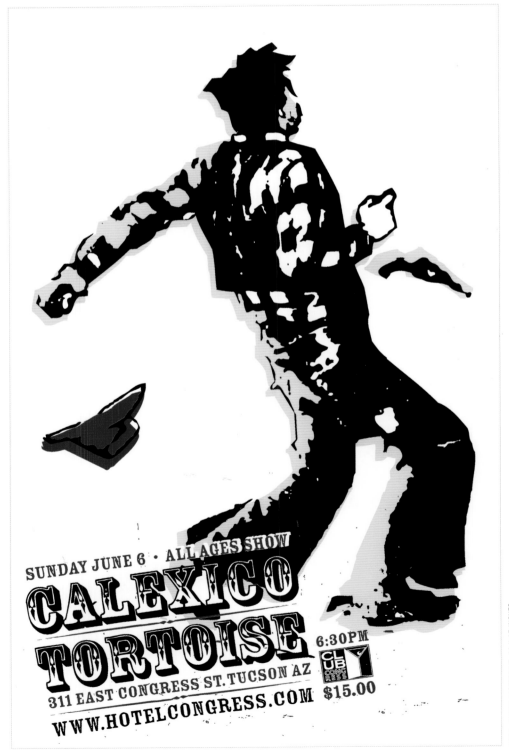

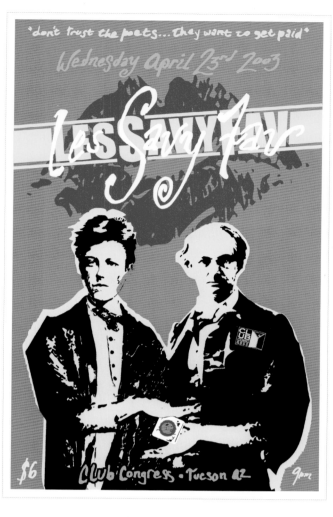

"don't trust the poets...they want to get paid"
Wednesday April 23rd 2003
Les Savy Fav
$6 Club Congress · Tucson AZ 9pm

2003 DIGITAL LASERPRINT 11 X 17 INCHES

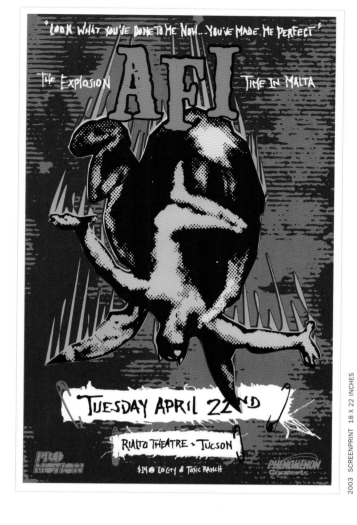

"Look what you've done to me now...you've made me perfect"
THE EXPLOSION AFI TIME IN MALTA
TUESDAY APRIL 22ND
RIALTO THEATRE · TUCSON
$14 @ CD CITY & TOXIC RANCH
PRO MOTION
PHENOMENON presents

2003 SCREENPRINT 18 X 22 INCHES

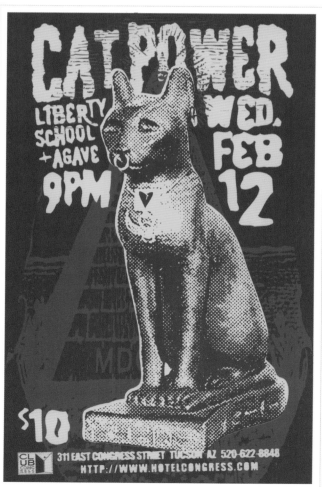

CAT POWER
LIBERTY SCHOOL + AGAVE
WED. FEB 12
9PM
$10 311 EAST CONGRESS STREET TUCSON AZ 520-622-8848
HTTP://WWW.HOTELCONGRESS.COM

2003 DIGITAL LASERPRINT 11 X 17 INCHES

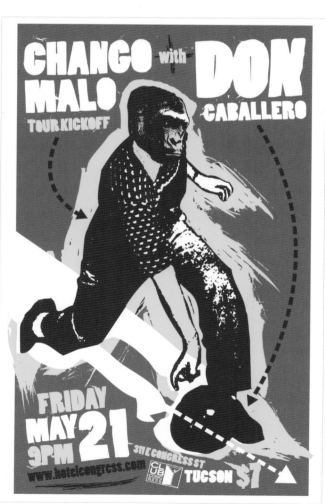

CHANGO MALO with DON CABALLERO
TOUR KICKOFF
FRIDAY MAY 21 9PM
311 E CONGRESS ST
www.hotelcongress.com TUCSON $7

2004 DIGITAL LASERPRINT 11 X 17 INCHES

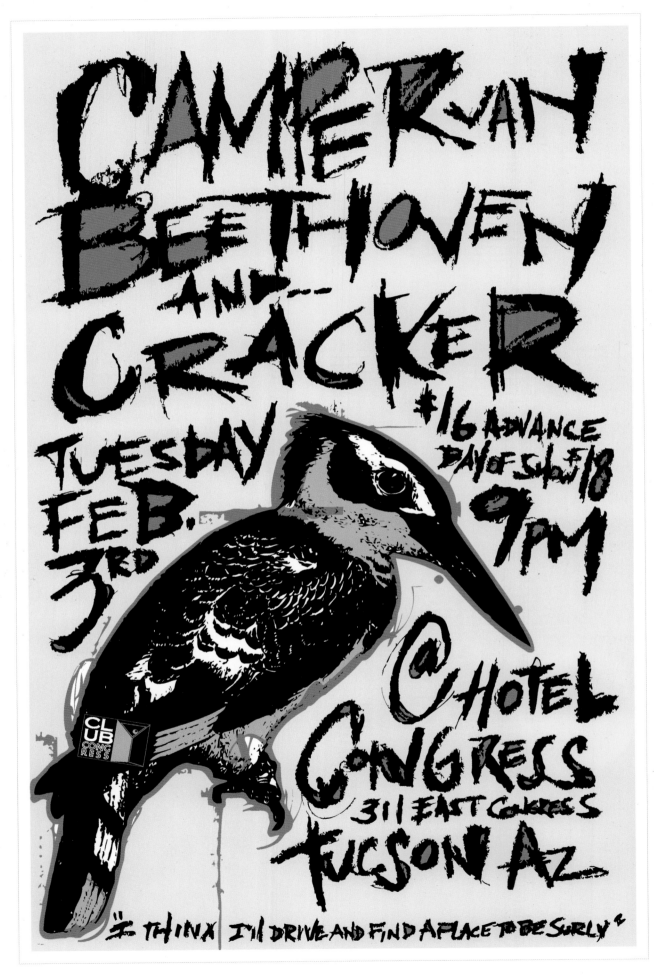

2004 DIGITAL LASERPRINT 11 X 17 INCHES